REVIEWS

Winds of Change is the first volume to comprehensively and critically address the difficult issue of assimilation into American life that many Korean women experience. Dr. Yu's account combines tireless research with skillful written presentation so that the reader is challenged by the facts without losing interest. Generous new insights regarding the struggle against patriarchal attitudes and male dominance are achieved. The intrusion of the Korean male subculture on the Americanization of women is traced from its historical and political origins.

This book makes credible the issues confronting women immigrants to America as well as elaborating the struggle which is present in contemporary Korean life. This volume is ideally suited for serious study of the conflicting aspects of Korean American assimilation. Explicit detail and comprehensive examination of individual lives through the use of interviews brings a realistic aspect to the analysis. A significant and unique contribution to the literature on Women's Studies!

Jan Brandan, Ph.D.
Consulting Psychologist

Winds of Change

BY

Diana Yu

THE WOMEN'S INSTITUTE PRESS

#24066031

WINDS OF CHANGE: KOREAN WOMEN IN AMERICA,
Copyright © 1991, 1995 by Diana Yu Tull. All rights reserved. No
part of this book may be used or reproduced without written
permission except in cases of brief quotations embodied in critical
articles or reviews. for information, address:

The Women's Institute Press
The Women's Institute of Washington D.C.
P.O. Box 6005
Silver Spring, MD 20916

First Edition
First Printing 1991
Second Printing 1995

Includes index.

Printed in the United States of America.

Cover designed by Lynn Springer - Design Lines.

Library of Congress Catalog Number 91--065430

ISBN 0-9629619-0-6

TO ORDER:

Make checks payable to DYT Books for $11.95 per copy plus $3.00
per copy for shipping and handling. Arizona residents add 80 cents
per copy tax. Mail check to DYT Books, 7498 East Sand Hills Road,
Scottsdale, AZ 85255. Quantity discount: $9.00 per copy for 6 or
more copies, plus shipping and handling.

Phone 1-602-585-2996

For fast delivery - single copies only
1-800-444-2524 (24 hrs a day, 7 days a week)

Dedication

This book is dedicated to the memories of my grandfather, Yu Kyung-Duk, my father, Yu Chin-San, and my mother, Kim Hyun-Syn. Without their continual love, guidance and encouragement from my childhood on, I would have become complacent in a male-dominant society instead of being impelled to write *Winds of Change*.

Acknowledgement

Throughout the long and challenging task of writing *Winds of Change*, many friends and colleagues have played important roles. Each of them has contributed time, expertise, and unique insights.

I want to thank the Korean-American Women's Society of Greater Washington for its support during the writing and publication of this book.

I am grateful to the Women's Institute of Washington D.C. for publishing *Winds of Change*, and especially appreciate the support of Dr. Rita Johnston, President of the Women's Institute, and her board members.

I must thank two special colleagues from Korea. Ms. Kum-Soon Park, former President of the Hankook Women's Association, provided me with valuable research materials. Mr. Hi-Kyung Kang helped me with additional research. The distance between Washington and Seoul did not deter their willingness or enthusiasm in providing assistance.

My special thanks also go to the dedicated readers of my manuscript, Dr. Christine F. Meloni, Clara Schiffer, Young-Ae Lee, and Sung-Il Kopf, and to my friends, Hope DuBusc and Geyoung Bolin for their support.

Most of all, I want to thank Daisy B. Fields, my editor. A published author herself dedicated to improving the status of women everywhere in the world, Daisy was a joy to work with.

Contents

ix

PART TWO

Introduction

Oriental men, including Korean men, apparently are fearful of competition with women. In Korea, for more than 500 years, men have been imposing on their wives and daughters to keep them in "their place." Many women are seen to cooperate in this discrimination, with the societal biases against women continuing to be passed on automatically to succeeding generations. A people trying to get ahead by maximizing the use of their human resources, however, cannot afford to waste the talents of one-half of their population.

The major purpose of this book is to examine the ways in which discriminatory attitudes against women have developed in Korea, and to discuss how these attitudes have been continued, sometimes to an even greater degree, by the Korean community in America. I have used pseudonyms in certain cases and changed personal details in order to protect the identity of some of my sources. All cases in this book, however, are factual.

In discussing the development of Korean biased attitudes against women, *Part One* deals with the

historical background in Korea out of which the attitudes arose. The chapters in this part deal with a rather comprehensive and detailed examination of the following seven major areas of Korean culture:

- The influence of women in Korean history
- The effect of religion on women's status
- Discriminatory customs and traditions
- Disabilities of women under the law
- Education for women
- Women and politics
- Women in the work force

Chapter One gives an historical background to facilitate understanding of how the biases against women have evolved in Korean society. These biases are deep-rooted, and in many cases go back five hundred or even a thousand years. Until one understands how the biases against women have arisen, it is quite unlikely that they will ever be eliminated.

Chapter Two is about the past influence of religion in Korea on the attitudes of modern-day Koreans toward women. An astounding amount of what Koreans believe today about women is in fact directly traceable to certain outdated Confucian beliefs that are out of step with modern society. Confucianism appears to have exerted a rather negative influence on present-day Korean attitudes towards women. By contrast, few biases against women have come from Buddhism or Christianity.

Chapters Three and Four discuss how customs and traditions in Korea, and later the law, became permeated with strong biases against women. Most customs and traditions can be traced back to ancient times. Unfortunately, these customary biases were later incorporated into many of today's basic laws. Because of this, much of the bias against women in Korean society at the present time has a certain amount of "legal" backing. Thus many laws need to be changed.

Chapter Five examines discrimination against women in education. Ingrained attitudes about the inherent abilities of women, for example in mathematics, science, and law, have encouraged the idea of giving Korean women only a second-class education. The existence of a large pool of inadequately educated women has probably helped to perpetuate erroneous attitudes about the natural abilities and potential of women.

Chapter Six discusses women and politics in Korea. Women have seldom been recognized as having an important place in Korean governing circles. In the Korean independence movement against Japanese oppression, however, although women like Yu Kwan-Soon were recognized as leaders, the participation of many other women who made important contributions have until recently received little attention in the literature.

Moreover, quite recently in Korean politics, women appear to have declined still more in importance. Women candidates did very poorly in the 1988 National Assembly elections; not a single one of

the fourteen women who ran was elected. As will be demonstrated, many of these women, in effect, defeated themselves by being poorly organized and by receiving only superficial support from the political parties that nominated them.

Chapter Seven deals with women in the work force in Korea. In the past, there has been a great deal of discrimination against women at work. Widespread discrimination has existed, in the professions, in science, in business and in industry. The archaic notions about women's inferiority are deeply rooted in the social fabric, and these outdated beliefs are held by many women as well as men. There needs to be a careful examination of negative feelings about women in the workplace in order to foster the idea of women working outside the home.

As in many societies, the education of women in Korea has been limited by the restrictive academic curriculum to which women have been exposed. As a consequence, jobs for women have been concentrated in certain low-paid fields such as nursing, home economics and literature. Korean society has thus been deprived of many potential political leaders, lawyers, scientists, engineers, accountants, and business managers.

Part Two of this book deals with the status of Koreans in America, describing how many of the back-home attitudes that cause so much trouble for women in Korea have been carried over to the Korean-American community.

Chapter Eight provides an overview of the growth of the Korean community in America. It

discusses the way in which immigration to America occurred, principally after the end of the Korean war in 1953, and increased sharply after 1965 when U.S. immigration restrictions were revised to encourage reuniting of families.

Chapter Nine examines the problems of three different groups of immigrants: women who married U.S. military and government personnel, students, and the relatives that the first two groups invited to join them. It is ironic that a great deal of resentment and condescension exists against Korean women who married Americans, since many Koreans now in the United States would not have been able to come to America without their sponsorship.

Chapter Ten deals with the Korean children in America, which includes children of immigrants, adoptees, and also the offspring of Korean women and American men who have now attained adulthood and are living in America. Although no scientific sample has been taken, in-depth interviews with a number of these children show some interesting and heartening aspects of the attitudes of these children towards themselves and their Korean heritage.

Chapter Eleven comments on the status of women in the organizations which have grown up to meet problems encountered by the immigrants. These organizations include the church and various other groups in which Korean-Americans have participated. When well run, these organizations have eased the transition to American life for Korean immigrants, and have helped them succeed in the new land.

In Chapter Twelve, by way of conclusion, we see that the Korean-American community is torn between two cultures. On the one hand is an ethnic culture that is valuable in many ways, but containing much that undercuts the ability of its women to maximize their lives. On the other hand, we see the American culture that, despite some shortcomings, does permit the blossoming of individuals, regardless of their sex. It is a challenge that must be met to obtain the best from each culture.

CHAPTER 1

Women and Korean History

Korea is a newly industrialized country with a 5000-year- old political, social and cultural history. As a background to understanding current Korean-American societal attitudes toward women, it is necessary to have some degree of familiarity with conditions affecting women in the society over time, both in Korea and America.

Unfortunately, to some extent, women have simply been neglected throughout the history of Korea. As a well-known Korean woman author puts it:

> No book can claim to give a full account of the subject (referring to women of Korea), partly due to the incompleteness in research and partly due to the insufficiency in historical sources. In most societies, men have deprived women of their history, and in consequence, of an important part of their identity, by the simple expedient of not telling it. Korea is a case in point. Historical records pertaining to women are scanty to

begin with, and those limited materials were mostly concerned with women closely associated with the ruler or high officials of the government. Records of women of lower status are extremely rare or nonexistent.[1]

To the extent that records are available, it is clear that women have been discriminated against in all periods, including the present. This brief synopsis will encompass six periods of Korean history: Ancient Period, Three Kingdoms Period, Koryo Dynasty, Yi Dynasty, Japanese Military Occupation, and the Period of the Republic

Ancient Period

The origins of the Koreans and the dating of their appearance on the peninsula continue to be speculative.[2] Many scholars agree, however, that the Koreans are one of the world's most ancient peoples. According to ancient Chinese records, the Korean's first king lived in 2332 B.C., at the same time as the legendary first kings of China.[3] Like the other early people of North Asia, the Koreans appear to have been tribal people whose main livelihood was fishing and hunting. Gradually they became an agricultural society under hereditary aristocratic chieftains.[4]

Three Kingdoms Period

The beginning of Korea's nationhood may be traced back to the Three Kingdoms Period between 57 B.C. and 935 A.D.[5] During this time the whole Korean peninsula was ruled by three strong kingdoms:

Koguryo, Paekche, and Silla. Koguryo occupied the northern half, Paekche the southwestern quarter, and Silla the southeastern quarter.[6]

Korea during this period was strongly influenced by China. All three kingdoms adopted certain aspects of the Chinese system of government, preserving, however, the aristocratic basis of Korean society which restricted positions of authority to the upper classes.[7]

Although there was much Chinese influence, Korean historians take pride in the fact that Koreans have been quite individualistic and even independent in the ways they imported Chinese culture:

> **The most significant fact is not that Korea adopted Chinese culture in such massive doses, but that she managed to retain her own distinctive individuality, and to adapt Chinese culture to her own purposes, while many other peoples who came under Chinese influence were completely absorbed into the body of Chinese culture, and their own cultures ceased to exist.[8]**

Around 663 A.D., with the collaboration of the Chinese T'ang Dynasty, Silla destroyed Paekche and repulsed a Japanese expedition sent to its aid. Meanwhile T'ang and Silla had turned on Koguryo, and in 668 A.D. they brought an end to Koguryo, which had lasted for almost seven centuries. Following the victory, the Chinese T'ang empire had expected to take over the Korean peninsula, but Silla, now aided by the conquered Koguryo and Paekche,

managed within a decade to force the Chinese to withdraw from the country.[9]

Following the exit of the T'ang Chinese, Silla emerged as a unified state occupying the greater part of what today constitutes Korea. Since that time, Korea has remained a basically unified country, with only brief periods of political division, and with a strong sense of political continuity. In the whole world, only China can claim a longer history as a unified political entity.[10]

In addition, the Koreans showed great artistic and literary capacity during the Silla period. Many artifacts of the Silla period are as fine as anything produced in T'ang China.[11] Down to the fifteenth century, all literary works, with certain exceptions, were written in the Chinese language.[12] One important custom that was adopted from China was the compiling of historical records.[13] In the matter of literature, a system called *Idu* was invented to record Silla songs and poems. This was the first attempt to devise a writing system for the Korean language. This system utilized Chinese characters as phonetic symbols, and Koreans were thus able to transcribe native words syllable by syllable.[14]

With its many accomplishments, even the brilliant Silla Dynasty could not avoid the natural cycle of rise and fall. In the middle of the eighth century, the golden age of Silla began to wane. By this time, the royal clan had become so extensive that it no longer gave much cohesion or organization to society.[15] After numerous statehood experiments in former Paeckche and Koguryo, Wang Koon, a

commoner from a merchant background, founded Koryo.[16] From this name comes the present name of Korea.[17]

Koryo Dynasty

The Koryo Dynasty extended from 935 to 1392 A.D. The period began with social reforms in many areas: the civil service system, nationalization of the land, the institution of a type of social security system, and also a system of universal education.[18] Most notable in this period was the growing power of the Buddhist priesthood which, however, sowed the seeds of its own destruction with its growing laxity. Although the Koryo Dynasty marks the beginning of an Age of Enlightenment, it was also a period of increasing decadence which led to discontentment of the people. Invasions, both by Japanese pirates from the East and the Chinese Ming Dynasty from the North, further contributed to its destruction.

Yi Dynasty

In 1392 the Yi Dynasty was founded by Yi Song-Gue following the defeat of the Koryo government. It lasted from 1392 until 1910, at which time the Japanese forcibly annexed Korea. The 518 year duration of this dynasty was almost twice as long as any of the dynasties of imperial China.[19]

As soon as Yi Song-Gue established the government, Confucianism replaced the corrupt Buddhism as a state religion.[20] The improvement in

the life of the people was immediate and far reaching.[21] The early years of the Yi Dynasty, particularly under King Sejong, were the most notable the country has ever known. Pearl Buck, a widely read American author who has written extensively in English about life in the Orient, has been particularly effusive about the high level of civilization achieved under the Yi Dynasty in Korea:

> **King Sejong, the fourth monarch of this dynasty, . . . was a Korean Leonardo da Vinci in the variety and magnitude of his gifts. The Koreans have always been and still are a people of superb creative talents, but King Sejong, in the thirty years of his rule, became a deathless legend. The level of Korean culture under his rule reached extraordinary heights, great progress being made even in science, and especially in mathematics and astronomy.[22]**

New astronomical instruments were made, and a rain gauge was invented in 1442. Also the first extensive use of moveable type anywhere in the world occurred in Korea in the fifteenth century. The most remarkable intellectual achievement of the age was the invention of an excellent phonetic system of writing, *hangul* (Korean letters).[23]

In Korea at this time, as in China, the route to high government office was through the civil service examination. Unlike China, however, Korean candidates for the civil service examination were limited for the most part to the hereditary ruling class known as the *yangban*. By dominating the civil

examinations the *yangban* were able to monopolize political leadership and ownership of most of the land.

In this period, the *yangban* families, collectively, had a great deal more actual power than the King. Their families included persons known as "Merit Subjects," to whom the King was required to listen. The Merit Subjects also controlled the important Censorate with its three boards of Censors.[24] Unfortunately, the Kings were too eager to win *yangban* support, and were thus too generous in creation of Merit Subjects and assigning land to them. As a result there was insufficient land to assign to new officials, income became inadequate, and tax on the peasants living on the remaining lands became oppressive.

In the seventeenth and eighteenth centuries, the government of the Yi Dynasty, although still modeled outwardly on that of China, had become in reality very different.[25] Rigid orthodoxy and narrow-minded complacency, with relentless persecution of any deviation, came to typify Korean Confucianism in the latter part of the Yi Dynasty. There was strong distrust of innovation and no adaptation of alien ideas was permitted.[26] In the second half of the 17th century, foreign influences and stirrings for change began to be felt. Through contacts with China and the West, some knowledge of both Catholic Christianity and Western science seeped into Korea.[27] Among the most shocking things to the Korean government was the fact that Christianity disapproved of the rites of ancestor worship which were among the most highly valued *yangban* family rituals. Catholicism

rejected ancestor worship as pure idolatry.[28] The monotheistic belief of Christianity and its tendency towards exclusivity were simply incomprehensible to the Koreans whose religions were always inclusive in nature. In 1785 Christianity was outlawed, and in 1791 its followers were actively and officially persecuted.[29]

The long-time resistance to foreign influences by the Yi government could not last indefinitely. Korea signed treaties which opened her ports to Japan in 1876 and to the United States in 1882. Shortly thereafter other Western nations were permitted to walk through the opened doors of the formerly "hermit kingdom."

The Yi Dynasty during the late 1800s was not at peace. Internally, a rebellion called *Tonghak* (Eastern Learning) was quickly spreading in the countryside. The philosophic foundation of this movement was anti-foreign as well as anti-government and anti-Confucian. The Yi government was desperate and requested aid from China to repress the internal rebellion, but the Japanese also decided to intervene. This triggered the Sino-Japanese War of 1894.[30]

By this time, the backward and incapable Yi Dynasty failed to arouse either indigenous nationalism or to secure international support. The Japanese capitalized on the situation and Korea fell to Japan upon the annexation of Korea in 1910. Although long-lived, the Yi Dynasty was finally over. Korea was no longer free and independent, but became subject to the harsh rule of Japan.[31]

The Japanese Occupation

This period lasted from 1910 until 1945. Dr. Helen Kim, president of Ewha Women's University during the 1950s, was one of the most eloquent Korean women writers to detail the many ways in which the Japanese tried to erase Korean culture from the face of the earth. She characterized the Japanese occupation as a black veil cast over the heads of an entire people throughout the whole peninsula.[32] In every way they could the Japanese tried to make Koreans into second-class Japanese.

In an attempt to free themselves from Japanese domination the Korean people made a peaceful bid for independence on March 1, 1919 by street demonstrations.[33] Three hundred seventy thousand Koreans marched in Seoul to protest Japanese oppression.[34] As a result of this event, the Japanese became even more suppressive. The Koreans were effectively excluded from the most important political policy-making bodies and were discouraged from participating in any organized political activity.[35] Worse still, in 1942 Japan went to the extent of incorporating Korea as an integral part of Japan and imposing on Koreans de facto Japanese citizenship.[36]

The Japanese practiced job discrimination against Korean men and women workers. They also practiced wage discrimination. Typically a Korean man made one *won* a day, which was hardly enough to cover living expenses, but wages of a Korean woman were only 59 *chon*. With 100 chon to a won, a Korean female was thus earning only 59 percent as

much as a Korean male. In contrast, an average Japanese man made about two and one-third times the wages of a Korean man, while a Japanese woman received one won a day, or the same wages as paid to a Korean male.[37] Under the Japanese increased rice production was shipped to Japan. Korean industry was developed only to aid Japan.[38] Economic improvements in Korea benefitted only the Japanese.

Another attempt by the Japanese to reshape Koreans was the forcing of Koreans to speak only Japanese and punishing them if they spoke a word in Korean. The Koreans fiercely resisted this attempt at Japanization; according to statistics of December 1943, only 22 percent of all Koreans acquired some ability in Japanese.[39]

In their thoroughgoing process of wiping out the Korean identity, the Japanese must have felt that they might make Koreans into real Japanese if their names were Japanized. There is a great deal of difference between Korean and Japanese names. Korean names, surnames as well as given names, are usually monosyllables such as Kim, Lee, Pak, Choi, Ahn; while Japanese names are of two, three, or four syllables such as No-wa, Ya-na-gi, Du-ma-moto.[40]

The forced change of name was a painful experience for Koreans. As Helen Kim tells it in her own words, referring to the potential change of her given name:

> **To me this was the most difficult thing to do. To Koreans names were special and almost sacred - only family elders' decisions. I had received my name from my**

**father who was not living to be consulted.
With me, this was not a national or patriotic
issue but a very personal one between me and
my deceased father.**[41]

Koreans under the Japanese suppression had very
few sources of emotional support. As Helen Kim
again movingly states:

> **...(W)e had no freedom even to weep when
> we felt like it; and devotion for our country
> and our people, oppressed and suppressed by
> an alien power, took deep roots within my
> being. With patriotism, hatred and
> bitterness for anything Japanese grew side by
> side, until only a supernatural power could
> help me to overcome it years later.**[42]

The Republic of Korea (1948-1990)

Upon liberation from Japan, after the defeat of
Japan in World War II, Korea was divided into two
zones which were placed under separate military
administrations by the United States and the Soviet
Union. The division into North and South Korea
along the thirty-eighth parallel was supposed to be a
temporary military measure but it still remains in force
today.[43] Free elections had been anticipated for both
Koreas, but disputes between the superpowers arose as
to how the elections would be supervised and
monitored. Finally, elections took place only in the
South. As a result, North Korea became an orthodox
socialist state and South Korea joined the democratic

nations as the Republic of Korea. Since that time, South Korea has modernized and developed its economic and political institutions largely in conformity with the Western ideology and value systems.

Rhee Syng-Man

The first president to be elected for South Korea was Rhee Syng-Man, a person known well to the Americans as a long-time anti-communist. With little organized opposition, his election was achieved with little difficulty. Considerable economic progress was made in the first two years. Perhaps the most significant development in this period was the implementation of a land reform program in South Korea. This important and popular measure redistributed about three-fourths of the cultivatable land and benefitted over half of the rural households.[44]

But trouble was to revisit this ancient and weathered country. In June 1950, the North Korean communist army launched an all-out military invasion into the southern portion of the peninsula. The United States and other allied nations ultimately were successful in pushing back the communists, who had occupied most of South Korea in less than three months.[45]

Although South Korea survived the invasion, the war was an extremely painful blow to her economy which was already far from adequate to support the people after a 36-year-long ruthless

exploitation by the Japanese. In the name of emergency, the Syng-Man Rhee government justified extremely repressive measures. Rhee's will was the will of the Republic. More accurately, he was the Republic.[46]

Opposition Parties

In the face of Rhee's authoritarianism, opposition to Rhee began to develop in the National Assembly, and in this manner a number of opposition parties began to develop. From the first, all they had in common was their opposition to Rhee's measures and various narrow regional interests. Opposed to Rhee and his central government, they could seldom unite against him. Over the years, this tendency of the opposition parties to be fragmented and be jealous of each other kept the Rhee government in control.

Rhee's manner of handling his opposition has been described succinctly by a Korean historian:

> . . . (D)emocratic institutions were disregarded, overridden, corrupted, or turned against themselves. Civil rights were often disregarded. Due process of law was more often laughed at by the officials themselves who were supposed to enforce the law. The press was often censored or freedom of expression otherwise often restricted. Numerous newspapers were closed down. Reporters, editors, and publishers were arrested, interrogated, and tried, resulting in punishment on trumped-up charges. Political opposition was in general suppressed, with all

**resources at the command of the government
thrown against opposition politicians.**[47]

It can be argued that during the early Republic
in the 1950s Korea was not yet ready for democracy.
Since democracy requires popular control over leaders,
certain conditions must exist in the social, economic,
psycho-cultural, historical, and political arenas which
are conducive to a relatively high level of political
participation on the part of the ordinary citizen. Korea
during this period lacked most of the prerequisites for
democratic development.

Not only was Korea not ready for democracy,
but with so little political or social freedom allowed to
any group, there was really no opportunity for the
emergence or development of a women's movement.
When no one had freedom, how could a movement to
grant additional freedom to women have much appeal?

As the Rhee regime became even more
autocratic the people of Korea resisted. This
culminated in the student revolt of 1960 which finally
toppled the government. The obvious irregularities in
the presidential and vice-presidential elections of
March 1960 triggered violent reactions from the
public, particularly from high school and college
students and urban intellectuals. This brought about
Rhee's resignation on April 26, 1960.[48]

After the overthrow of the Rhee regime, Korea
was briefly governed between 1960 and 1961 under
the rule of the Democratic Party (Min Joo Dang), a
long-time major opposition party to the Rhee regime.
After only a year, however, the weak and corrupt

republic under Chang Myun was overthrown by a military *coup d'etat.*

Park Chung-Hee

The May 16, 1961 *coup*, which was bloodless and met with little resistance, led eventually to the presidency of Park Chung-Hee, a former general.[49] President Park's first term of office was marked with both impressive accomplishments and internal turmoil. The Park government had to continue to cope with those fundamental problems that had existed under the previous governments. The most basic of these problems was the economic one.[50]

In Korea's long history there has always been considerable political diversity. Since the founding of the Republic in 1948, a constant loyal opposition to the governments in power has existed. One of the major parties after the 1961 military *coup* was the New Democratic Party (NDP) whose most famous leader was Yu Chin-San, a long-time fighter against the Japanese occupation and the Rhee oppression. Yu was a 20-year veteran member of the parliament, and a most influential old guard member of the NDP. Yu's untimely death in April 1974 left the party in considerable disarray with regard to opposition leadership.[51]

Yu was often criticized for his pragmatic approach to problem solving. However, to this date Koreans say, "If only Yu Chin-San were alive the opposition party wouldn't be scattered into so many different parties."

Toward the later part of the Park regime, in 1979, antigovernment demonstrations had become tense, particularly in the southern part of the country in Pusan. The Park government cracked down with a heavy hand and restored calm. The calm, however, was an uneasy one. Dissension among Park's closest advisers developed. On the night of October 26, 1979, Park was shot to death by Kim Jae-Kyu, then Chief of the Korean Central Intelligence Agency.[52]

Chun Doo-Hwan

For almost ten months following the assassination, until the relatively unknown Lieutenant General Chun Doo-Hwan was elected as president of South Korea on August 27, 1980, the government leadership remained in a state of flux.[53] In Chun's inauguration speech, he described the situation of Korea since Park's death as being like a "kite without its string." Chun noted that, while stern measures were initially required, eventually the government system best suited for Korea was the democratic welfare state, a Koreanized democracy under a strong leader.[54] Chun started out by announcing a purification campaign to clean up the official corruption that had occurred under Park's regime. One well-known government official, Kim Jong-Pil, was even forced to give back some thirty-six million dollars. When political dissidents demonstrated at Kwang-Ju in May of 1980, the government moved ruthlessly and killed a number of the demonstrators, generating a great deal of hatred by many opposition groups.

In spite of the campaign to weed out the fraud and abuse that had occurred in the Park regime, the Chun regime was also plagued with allegations of abuses by Chun's associates and relatives. To keep itself in power, the regime also committed routine violence and suppression of opposition politicians. In 1987, the situation came to the bursting point.

The year 1987 was a year of great unrest in Korea, ending with the election of a new president. The year started with the beating death of a student by the police during an interrogation. During 1987 there were many demonstrations and protests by students and dissidents, together with demands for increased democratization by all three of the main opposition parties. Under pressure, Chun resigned as president and appointed a close associate in his place, a former military man, Roh Tae-Woo. Roh was at the time serving as Chairman of the ruling Democratic Justice Party.

Roh Tae-Woo

Roh, as the government candidate for president in the 1987 elections, had to face three opposition candidates, Kim Dae-Jung, Kim Young Sam, and Kim Young-Pil, all three of whom were irreconcilably jealous of each other. In the face of this fragmented opposition, Roh was elected with only 35.9 percent of the votes. Since his inauguration, Roh has managed to continue in office by outflanking his opponents. Nothing in the present state of affairs suggests that Chun Doo-Hwan was wrong in leaning towards a

highly structured governmental system for Korea. While there is more democracy than ever before, it is too early to tell how successful the Roh government will be in leading the Korean people into democracy.

Notes

1. Yung-Chung Kim, ed. and trans., *Women of Korea - A History from Ancient Times to 1945* (Seoul: Ewha Women's University Press, 1979), p. xi-xii; see also Page Smith, *Daughters of the Promised Land: Women in American History* (Boston: Little, Brown & Company, 1970), p. 340.

2. Kim, *Women of Korea*, p. 3.

3. Charles Allen Clark, *Religions of Old Korea* (Seoul: The Christian Literature Society of Korea, 1961), p. 26; Michael Keon, *Korean Phoenix* (Englewood Cliffs, N.J.: Prentice-Hall International, Inc., 1977), p. 11; Pearl S. Buck, *The Living Reed* (New York: Pocket Books, Inc., 1964), p. 2; see also *Encyclopaedia Britannica*, 15th ed., s.v. "Korean Religion," by Tai-Dong Han.

4. Fairbank, Reischauer, and Craig, *East Asia: Tradition, Transformation, and New Impression* (Boston: Houghton Mifflin Company, 1978), p. 278.

5. In the earliest available records, Korea's nationhood can be traced back to the emergence of the Three Kingdoms: Koguryo (37 B.C. - 668 A.D.), Paekche (18 B.C. - 660 A.D.), and Silla (57 B.C. - 935 A.D.). Se-Jin Kim and Chi-Won Kang, *Korea: A Nation in Transition* (Seoul Research Center for Peace and Unification, 1978), p. 13. In 668 A.D., Silla conquered and united these three dynasties. Prolonged peace and prosperity prevailed

until Silla became the victim of decadence and power struggles. In 935 A.D. Silla, peacefully submitted to the Koryo dynasty which had been organized from the northern part of the country where the influence of Silla was relatively weak. Buck, *Living Reed*, p. 3.

6. Clark, *Religions of Old Korea*, p. 27.

7. Woo-Keun Han, *History of Korea*, trans. Kyung-Schick Lee, ed. Grafton R. Mintz (Honolulu: East-West Center Press, 1971), p. 58.

8. Ibid., p. 63.

9. Fairbank, Reischauer, and Craig, *East Asia*, p. 287.

10. Ibid.

11. A large number of Buddha images as fine as anything produced in Tang China were found all over southern Korea. Along with these Buddha images, a massive number of brick and stone pagodas of Silla date have been found. Ibid., p. 290.

12. Han, *History of Korea*, pp. 62-63.

13. Ibid., p. 63.

14. Ibid., p. 72.

15. Fairbank, Reischauer, and Craig, *East Asia*, p. 291.

16. Ibid., p. 292.

17. Buck, *Living Reed*, p. 3.

18. Ibid., pp. 3-4.

19. Fairbank, Reischauer, and Craig, *East Asia*, p. 300.

20. Roy E. Shearer, *Wildfire: Church Growth in Korea* (Grand Rapids, Michigan: William B. Erdmans Publishing Co., 1966), p. 31.

21. Buck, *Living Reed*, p. 5.

22. Ibid., p. 6.

23. Fairbank, Reischauer, and Craig, *East Asia*, p. 310.

24. Ibid., p. 307.

25. Ibid., p. 317.

26. Pyong-Choon Hahm, *The Korean Political Tradition and Law* (Seoul: Hollym Corporation, 1971), p. 10.

27. Fairbank, Reischauer, and Craig, *East Asia*, pp. 319-20.

28. *Encyclopaedia Britannica*, 15th ed., s.v. "History of Korea," by Kwang-Rin Lee.

29. Fairbank, Reischauer, and Craig, *East Asia*, p. 320.

30. In 1894, both the Chinese and the Japanese landed in Korea to aid in putting down the *Tonghak* revolt. The presence in Korea of the two powerful neighboring countries resulted in the Sino-Japanese War of 1894-95. China's defeat by Japan in this war ended China's long relationship with Korea. Japan, on the other hand, became increasingly influential, subjugating Korea as its colony officially in 1910. Yong-Ock Park, "The Women's Modernization Movement in Korea," *Virtues in Conflict*, Sandra Mattielli, ed. (Seoul: The Samhwa Publishing Company, Ltd., 1977), p. 101. See also

Vreeland, *et al*, *Area Handbook for South Korea*, 2nd. ed. (Washington, D.C.: U.S. Government Printing Office, 1975), p. 20.

31. Economic improvements brought in by the Japanese benefitted not the Koreans but the Japanese people. Increased rice production was shipped to Japan, and Korean industry was developed only to aid Japan. Shearer, *Wildfire*, p. 32.

32. Helen Kim, *Grace Sufficient* (Nashville, Tenn.: The Upper Room, 1964), pp. 26-27.

33. Shearer, *Wildfire*, p. 34.

34. Vreeland *et al*, *Area Handbook for South Korea*, p. 22.

35. Korea was administered by a middle-level Japanese colonial official with title of Governor General, an Emperor-appointed position. In reality, Korea was made into an administrative subdivision reporting to the Minister of Colonies, a lower than Cabinet level position. Andrew J. Grajdanzev, *Modern Korea* (New York: The John Day Company, 1944), p. 238.

36. Kim and Kang, *Korea: A Nation in Transition*, p. 16.

37. Park, *Virtues in Conflict*, pp. 107-08.

38. Han, *History of Korea*, p. 469; Shearer, *Wildfire*, p. 32.

39. Kim, *Women of Korea*, p. 240.

40. Kim, *Grace Sufficient*, p. 100

41. Ibid.

42. Ibid., p. 26.

43. Young-Ho Lee, "The Politics of Democratic Experiment: 1948-1974," in *Korean Politics in Transition*, ed. Edward Reynolds Wright (Seattle: University of Washington Press, 1976), p. 19.

44. Parvez Hasan, *Korea: Problems and Issues in a Rapidly Growing Economy* (Baltimore: The Johns Hopkins University Press, 1976), p. 26.

45. Lee, *Korean Politics in Transition*, p. 20.

46. Ibid.

47. Ibid., p. 21.

48. Hasan, *Korea: Problems and Issues*, p. 28.

49. *Encyclopaedia Britannica*, 15th ed., s.v. "History of Korea," by Bae-Ho Hahn.

50. Ibid.

51. Lee, *Korean Politics in Transition*, p. 100.

52. *Encyclopaedia Britannica*, 1980 Book of the Year, s.v. "Korea," by T.J.S. George.

53. *Encyclopaedia Britannica*, 1981 Book of the Year, s.v. "Korea," by T.J.S. George.

54. Ibid.

CHAPTER 2

Women and Religion

In all societies, the cultural patterns and philosophic outlook towards women have been rooted in religious practices that have prevailed in earlier periods of the history.[1] In the ancient periods, Animism, Shamanism and other indigenous religions were practiced on the Korean peninsula. Later on, Buddhism, Confucianism and Christianity came to Korea but, without exception, were greatly permeated by the indigenous religions. Now they may all be looked upon as having been Koreanized.

For a number of reasons it may be difficult for a Westerner to appreciate religion in Korea. There is no real leaning towards monotheism. In a typical Korean family, moreover, the women may adhere to the Buddhist religion while the men may be followers of Confucianism.[2] Many families, in fact, have combined the practices of several religions in their lives,[3] demonstrating how intertwined the various religions of the country have become. At times, it is difficult to tell where one religion leaves off and another begins.[4]

With the realization that religious ideas from earlier periods of Korea's history may still have significant effects on current attitudes towards women in the society, an in-depth examination of two major aspects is required. First, the characteristics and role of major religions in each historical period will be examined. Second, the effect that the religions have had in forming basic societal attitudes towards women in Korea will be discussed. Review of their historical emergence and an examination of their general tenets, beginning with the earliest periods, will facilitate appreciation for the influence of religions.

Ancient Period

The religious practices in the ancient period were mainly Animism and Shamanism, which involved nature and spirit worship.[5] Although these were separate beliefs they were more customarily practiced as one belief system centering on occult healing.[6] These religions are still strongly practiced today. Shamanism is especially prevalent with rural people, particularly among women.[7] Animistic superstitions are also common, even among the educated population, though perhaps in the disguise of geomancy or *yin-yang* doctrine.[8]

From very early times, most of the Shamans have been women. Female Shamans (also called *Mudangs*) have a long history in Korea. Scholars have speculated on the origins of the Shaman in Korea, but there appears to be little agreement. Some historians trace the origins of Shamanism back to the

neolithic period though without any specific archeological evidence.[9] It is speculated that Shamanism evolved from the animistic beliefs of the Mumun people, the makers of pottery without surface designs, who are believed to have lived in Korea during the Bronze Age.[10] Shamanism is still patronized by people mainly from the lower societal strata. The ritual carried out by a *mudang* is called a *kut* which consists of two phases: seance and exorcism.[11] Some folklorists and anthropologists agree that Korean folk music and dance originated from *mudang* performances.[12]

Three Kingdoms Period

There were numerous religions in Korea during the Three Kingdoms period. Buddhism, however, which was introduced from China into Koguryo (northern portion of peninsula) around 372 A.D. and Koreanized, was the most influential and best organized.[13] Buddhism enjoyed a long and successful reign through two major periods of Korean history before suffering a sharp decline in its influence. Buddhism was founded by a royal prince who lived in India near Nepal about 500 B.C.[14] As a young man, Siddhartha Gautama grew up at first in leisured ease, but later he began to search for the meaning of life. To continue his search, he left his home at court at age twenty-nine and traveled around as a wandering teacher. Meditating under a banyan tree, he received spiritual illumination and became Buddha, the Enlightened One. In his teaching

Buddha refused to discuss metaphysical questions.[15]
He was primarily concerned about human salvation
from suffering in this life. The principles of
Buddhism are founded on the Four Noble Truths:

I. Existence is unhappiness.
**II. Unhappiness is caused by selfish
craving.**
III. Selfish craving can be destroyed.
**IV. It can be destroyed by following
the eightfold path whose steps are:**

1. **Right views - freedom from illusions
and superstitions.**
2. **Right aspirations - desire to attain
salvation. Desire to live in love with
all men. Desire to serve all living
things.**
3. **Right speech - that which is kind,
frank and truthful. No abuse, or
angry word. No slander or gossip.
No impure or bitter word.**
4. **Right conduct - peaceful, honest and
pure.**
5. **Right livelihood - one must earn a
living without hurting any living
thing.**
6. **Right effort - self-discipline, self-
control.**
7. **Right mindfulness - be not weary in
well doing.**
8. **Right rapture - meditation upon the
transitoriness of life, the frailty of
men, the sorrows of existence, and
the certainty of the end of it all.[16]**

Embracing the Four Noble Truths and following the Eightfold Path, thereby reaching the state of Nirvana, is the final goal in Buddhism. Nirvana, however, is not only peace of mind but also the state of nothingness; yet Nirvana is not mere emptiness, for it is the state of eternal being, or "supreme bliss."[17] So far as the doctrine of Nirvana is concerned, the Buddha clearly seems to have taught that Nirvana is the natural and inevitable result of the extinction of craving.[18] With Buddhism, Koreans began to experience an entirely new world which appeared to be more enlightened than the one they had known.[19]

According to Chang Byung-Kil, Professor in the Department of Science and Religion at Seoul National University, literacy among the Koreans was relatively high when Buddhism was first introduced to Koguryo in 372 A.D., and the Chinese translation of Buddhist scriptures was easily read and understood. The religion spread quite rapidly to Paekche and Silla.

In twenty years, Buddhism was officially recognized by Koguryo, and nine large temples were built in Pyongyang, the present-day North Korean capital. There were great monks such as Uisang Hyegwan, Hyeja and Podok, who helped to systematize Buddhism academically.[20] Buddhism in Koguryo later began to decline when the politically active ruling class turned to other organized religions.[21]

Buddhism arrived in Paekche in 384 A.D., 12 years after Koguryo. As in Koguryo, many temples were built and upper class families taught their

children Buddhist scriptures. The stone pagoda remaining at the site of the now demolished *Miruk* Temple is still considered the largest in the Orient.[22] Paekche introduced Buddhism to Japan.[23]

Buddhism reached Silla in 527 A.D., about one hundred fifty years after Paekche and Koguryo. Silla was a theocratic state. Government offices managed matters concerning Buddhist rituals. There were temples and Buddhist nunneries for women. The religion and state were one, and, "As Silla prospered, so did Buddhism."[24] The enthusiasm for Buddhism in Silla, however, was unmatched by either Paeckche or Koguryo.[25] The decline of Buddhism in Silla was unavoidable as the religion exchanged its religious character for political power, and the priest-ridden government became corrupt.[26]

Koryo Dynasty

From 935 A.D., in Koryo, Buddhism flourished to such an extent that the period is called "the Golden Age of Buddhism" in Korea.[27] As had been the case with Silla, in Koryo Buddhism served as a means for a ruler to achieve political power and ambitions. The first King of the Koryo Dynasty was not particularly interested in Buddhism but he thought that the religion would be of political advantage.[28] Numerous great and lasting stone temples were built. Buddhism became the state religion. In fact, Buddhist priests were shrewd manipulators of government in the Koryo Dynasty.

During the Koryo dynasty, Buddhism reached its highest peaks. As the priesthood became corrupt Buddhism lost its influence. In the mid-period of the Koryo kingdom the Confucian philosophy was adopted as the state rule, upon which all administration, military, legal, education and protocol principles were based.[29]

In spite of its partial eclipse, however, Buddhism has never completely lost its influence. Over the years Buddhist beliefs have been incorporated into the Korean national psyche, particularly in the areas of moral conduct and education:

> **Korea owes (Buddhism) a debt of gratitude. It came to Korea in 372 A.D., and was vastly superior to the degraded spirit worship and Shamanism which it found. It gave Korea a moral code, more or less defective and yet infinitely better than nothing. It has collaborated with Confucianism all down the ages, giving sanctions to make even Confucian ethics operative. It gave education of a sort, and stood for education always.[30]**

Yi Dynasty

Under this Dynasty, beginning in 1392, Korea was transformed into an almost model Confucian society. Confucian teachings easily permeated the religious minds of the Koreans.[31] As the corruption among Buddhist monks and their followers had

increased, the Confucianists were then able to take over the dominating position held by the Buddhists.[32]

For the Koreans, Confucianism is more than a religion. It is a system of education, ceremony and civil administration, and an instilling agent for secularization.[33] Thus, Korea cannot be studied without the knowledge of Confucian ethics and the Yi Dynasty, because Confucian principles are still deeply rooted in the country.

Interpreted more literally and more fundamentally than in China or Japan, Confucianism came to influence all aspects of Korean life.[34] The official interpretations of Confucian precepts came to dominate and regulate every aspect of the people's lives from birth to death, including such seemingly trivial matters as the everyday order and seating arrangement by which family members were served at mealtime in ordinary households. Everyone had to know who he was, where he belonged, and how he should conduct himself in all conceivable circumstances.[35]

An important aspect of Korean Confucianism is its doctrine of filial piety, symbolized by the eldest son as he worships his family's ancestors. It is still common practice for most Korean families to make an annual pilgrimage to the gravemounds of their fathers and there make sacrifices of foods.[36]

Nearly everything ever written by the scholars, from the first primer in the village school to the theses in the civil service examinations, was composed of more or less stereotyped moral maxims or their explication. These were not mere copybook maxims,

either. They established universally known standards of behavior by the which the actions of all men, but especially of all educated men, were judged. The rules of "the way," decorum and propriety, were fixed. Certain things were not done in polite society.[37] The Confucian rules of manners and behavior may appear superficial, but they were extremely effective in the fundamentally Koreanized Confucianism.[38]

Confucius was born in China in 551 B.C., possibly to an impoverished noble family. He was largely self-educated and was dedicated to relieving sufferings of the people, since there was much starvation in China during his time. He was against chaos in the community. His native province, Lu, was quite chaotic during much of his lifetime. China was only nominally united and the central king was ignored. The aristocrats taxed their subjects and oppressed them at will. In bad years starvation was common.[39]

Confucius was a teacher, scholar, and political theorist whose ideas have deeply influenced the civilization of all of East Asia.[40] As many scholars of Confucianism have pointed out, it is difficult to sort out the real story of his life due to the wealth of legends, but with careful effort, it may be possible to separate the genuine information from the fables. Confucius has been called both the founder of a religion and an Agnostic. He was neither. As was the case with Buddha, Confucius would not discuss life after death. He emphasized moral perfection for individuals and social order for society.[41]

Catholicism in Korea

Foreigners repeatedly failed in their attempts at missionary work in Korea. A few Catholic priests managed to enter the country as early as 1592 - 1598, but returned without having converted anyone. In Korea a certain amount of xenophobic ethnocentrism prevailed. Foreigners were called *Yangi* (Western barbarians), and their entrance into the country was strictly forbidden. In general, conservative leaders of the government believed that they should keep the traditional policy of "respect the king and expel foreigners."[42]

In 1777 a religious movement for Catholicism was launched, but it was persecuted by the Korean government which was pursuing an extreme policy of isolation. In 1800, the Sinyu massacre occurred in which the first Korean priest, Kim Tae-gon, was killed, along with three French priests, three court ladies and a number of other adherents. A third persecution lasted for three additional years, beginning in 1865, and cost the lives of nine French priests who had smuggled themselves into the country to preach Catholicism. These massacres were excused as being due to violation of the royal policy of religions.[43] This persecution, however, did not deter the expansion of Catholicism in Korea.

The Modern Period (1948 - Present)

In the modern period both Catholic and Protestant Christianity have attained great success in

Korea. The Christians today, while not the largest religious group, perhaps have been the most activist, and have had the greatest political impact.[44] As in the past, the intermingling and Koreanizing of many religious beliefs and systems has continued. Christianity reached many Koreans through active proselytization and revival meetings, and Koreanized Christianity has had a fundamentalist tendency. Unfortunately for feminist rights, this tendency appears to have fostered a rather reactionary attitude towards women.

We have seen that in addition to various indigenous religions, there have been three major organized religions, Buddhism, Confucianism and Christianity, which have played important roles in the development of Korean society. These three religions, however, have had quite differing effects on the status of women in Korean society.

Women and Buddhism

Along with certain other great religious and philosophical leaders, Buddha was by nature masculine in psychology.[45] Buddhism itself, however, appears to have had fewer tendencies towards suppression of females than many other religions. In its native India, Buddhism gave women increased equality, respect, and authority.

Under Buddhist doctrines, women were acknowledged to be independent individuals with intelligence and will. Motherhood was not the sole reason for paying deference to women.[46] No

special preference was noted among adherents to Buddhism in India towards having a boy child rather than a girl child. Birth of a child of either sex was regarded as eminently desirable.[47]

In Korea during the period of Buddhism's ascendancy, a similar development appears to have occurred with respect to the status of women. From the time of Buddhism's introduction to Korea, women enjoyed relatively equal status with men in Buddhist practices. Under Buddhism, Korean women actively participated in various religious functions for the benefit of the general public welfare and national security. Many women of all classes became Buddhists in the old Korean society.[48]

Women and Confucianism

In many ways Confucianism has had a more profound effect than Buddhism on Korean women, but, unfortunately, this effect has been rather negative. Beginning at the inception of the Confucian Yi Dynasty, Korean women of the *yangban* class lost most of the freedom and independence they had gained under Buddhism. Watchful censors demanded that *yangban* women be banned from the streets during the daytime since there was no societal need for them to appear in public. Confucian legislators, "to rectify the womanly way" and to confine women to the domestic sphere, particularly censured women's frequent visits to Buddhist temples. In 1404, Buddhist temples were declared off limits to women except for memorial services for their parents. Not only were women

legally restricted from going to Buddhist temples and shrines, but shamans' houses were also found to have a corrupting influence. Patronizing them was forbidden in 1431.[49]

For five hundred years, all during the Yi Dynasty, women continued to be oppressed in every aspect of their lives by Confucianism. Even up to the 19th century, it has been said that the two major obstacles to the participation of women in Korean society were the restrictions of Confucian ethics and the traditional customs that affected all the fields of social life for women.[50]

Why were Confucian ethics so anti-women? Some light is shed on this subject by Confucian sayings. Confucius personally appears to have had an aversion to women. He was known to have remarked, "They get out of hand when befriended, and they resent it when kept at distance."[51] Many writers agree that, in the degradation of women's status, Confucianism played a leading role.[52] The noted existentialist philosopher Karl Jasper wrote:

> **One is struck by Confucius' indifference toward women. He has nothing to say of conduct in matrimony, speaks disparagingly of women, . . . and frequently commented that nothing is so hard to handle as a woman. The atmosphere around him is distinctly masculine.[53]**

Confucius based his whole teaching about human society upon the patriarchal family, ancestor worship, and the duty of filial piety. The function of women

within the patriarchal system could be summed up in
one four-letter word, **obey**. Women are creatures
born to obedience.[54] Confucius said that it was the
law of nature that women should be held under the
dominance of men.[55] According to Confucius,
women are made to obey, not to understand. The so-
called three obediences for a woman are: Obey her
father when young, obey her husband when married,
and obey her sons when old.[56]

Confucius was decidedly sexist in his general
attitudes towards women: Women should know their
places and act accordingly, avoid loquaciousness or
boring others, adorn themselves for the pleasure of the
opposite sex, and perform household chores with
diligence and skill.[57] Hundreds of writers and
commentators, first in China, later in Korea and
Japan, elaborated on the theme and drew up detailed
rules for a woman's behavior. All were based on the
inferior place a woman was required to accept and
maintain.[58]

Philosophically, Confucianism justified its
position with regard to women as part of the law of
nature. The following quotation from a book on
women and Confucianism indicates the type of high-
minded sophistry employed to keep women in a
subservient place:

> . . . (H)eaven *(yang)* dominates earth *(yin)*,
> and correspondingly, male has precedence
> over female. This clear hierarchical order
> between the sexes is cosmologically sanctioned
> and is imperative for the proper functioning
> of the human order. This order can be

**preserved only when human passions are kept
in check.**[59]

To further rationalize, the Confucianists drew a distinction between a woman's "inner" or domestic sphere and a man's "outer" or public sphere. This asymmetry of the sexes was necessary to restrain women and to establish the different functions of husband and wife.

The Confucianists of the early Yi dynasty, in fact, monitored all aspects of women's lives. Concerned about checking the corrupt female mores inherited from the previous dynasty, they also focused attention on reforming women's fashions. Dress style and color were convenient means for pointing up social differences.[60]

The Confucian image of woman was that she had to be modest and submissive but also strong and responsible. On the level of Confucian idealism, a woman was supposed to be virtuous; on the level of daily life, however, this often meant bondage.[61]

Confucianism presented Korean women with a vicious circle. By the Confucianist philosophy a woman was denied what are now regarded as elementary human rights. Then the fact that she did not have such rights was taken as proof that she was by nature unworthy of them. This then translated into man's contempt and disdain for woman's narrow-mindedness and stupidity.[62] With this type of attitude and perception, it is little wonder that Korean women were highly susceptible to the new religious ideas offered by Christianity.

Women and Christianity

The first pioneer Christians, the Catholics, helped to break down class barriers in Korea and also eventually the barriers between the sexes. The Korean Catholic Church began its mission work both among the *yangban* and among the people of lower social levels. One of the most important aspects of Catholic worship was that men and women could gather together in order to worship. Prior to this, particularly under the Confucian rule, most Korean women never dreamed of sitting next to strange men.[63]

The propagation of Christianity brought about important changes in attitudes with respect to the relationship between the sexes. Although not a major intended purpose, the idea of equality between husbands and wives was promoted by the church and gradually became accepted in Christian homes.[64]

The Korean woman had everything to gain and nothing to lose by becoming a Christian. Her circle of social contacts was immediately widened and enriched. Christianity taught a higher status for women than what she had known.[65] The teaching of early Catholic missionaries about Heaven and Hell was listened to with interest by Korean women. Christianity offered a new view of an afterlife for those women who had already been familiar with the Buddhistic Heaven and Hell.[66] For women who had to lead unrewarding lives, the hope of a joyous Christian afterlife was indeed a consolation.[67] In contrast, Confucianism offered no vision of an

afterlife. Further, women's roles were insignificant in Confucian ritual observances.

In terms of actual headway with the masses, more progress was made by the Protestants than by the Catholics. Mary Fitch Scranton, the first missionary of the Women's Foreign Missionary Society of the Methodist Episcopal Church of the United States, landed in Korea on June 20, 1885. She was also important, as will be discussed later, in the field of education for women.[68]

Having learned from the Catholic experience, the Protestant missionaries were cautious not to offend Koreans by irreversible mistakes which were made as a result of ignorance. For example, in order to respect the custom of those days, a curtain was hung between men and women during worship services. In the 1890s, for this purpose, some church buildings were also built in the form of the letter "L". Men and women sat apart in the two sections facing the preacher at the corner. Sunday schools were held in the evening to accommodate the old Korean tradition which forbade women's appearance outside the home in broad daylight.

Also in order to accommodate common people and women, Christian doctrines were simplified. The emphasis on the Bible as "God's word" encouraged many women to take the Bible literally. The Korean preachers impressed the women greatly with the ideas of Heaven and Hell.

Many contributions were brought about by these pioneer Christian missions. Christian churches in the community often began to furnish centers for

social activities for women outside the home. The use of *hangul* (Korean letters) in the Bible and in the hymnal helped to promote literacy among women. Overall, Christianity brought about an increase in social class consciousness and contributed to the women's discovery of themselves as well as to the raising of their status.

By 1922, one group of women church workers from the Southern Methodist Church had become assertive enough to challenge discriminatory wage policies in the church itself. This was one of the earliest instances of women seeking equal rights with men. The pay level for male preachers was from four to five times that of the women. Beginning with the church campaign the demand for equal rights for women in church matters continued to be a serious issue from the 1920s through the early 1930s.[69]

Although progress was made through Christianity toward obtaining sexual equality for women, there is current recognition within the Korean Christian community that attitudes and perceptions in this area are still limited by male-dominant perspectives which victimize women by male chauvinism.[70]

In summary, Buddhism, Confucianism, and Christianity have been the three major beliefs with the most significant impact on attitudes and perceptions towards women in Korean society. Under Buddhism, before the Yi Dynasty, women had a great deal of freedom and independence. Throughout the Yi Dynasty, however, as a consequence of the so-called Confucianist reforms, a full-fledged assault on the

rights and privileges of women was successful. Christianity came as a challenge to the two earlier religions in the late 1800s, and was accepted eagerly by many women who sought an increase in basic personal freedom and dignity.

Notes

1. Pyong-Kil Chang, *Religion: Korea Background Series* (Seoul: Korean Overseas Information Service, 1974), p. 5.

2. *Encyclopaedia Britannica*, 15th ed., s.v. "South Korea," by Chan Lee.

3. Roy E. Shearer, *Wildfire: Church Growth in Korea* (Grand Rapids, Mich.: William B. Erdmans Publishing Co. 1966), p. 31.

4. Charles Allen Clark, *Religions of Old Korea* (Seoul: The Christian Literature Society of Korea, 1961), p. 113.

5. The earliest Koreans were tribal people led by hereditary aristocratic chieftains of a semi-religious character. Their living came from fishing and hunting, later agriculture. Shamans were called in to perform *kut* (religious rituals) to drive malevolent spirits away on sickness or death. Fairbank, Reischauer, and Craig, *East Asia: Tradition, Transformation, and New Impression* (Boston: Houghten Mifflin Co., 1978), p. 278.

6. *Encyclopaedia Britannica*, 15th ed., s.v. "Korean Religions," by Tai-Dong Han.

7. *Encyclopaedia Britannica*, 15th ed., s.v. "South Korea," by Chan Lee; See generally, *Encyclopaedia Britannica*, s.v. "Korean Religion," by Tai-Dong Han.

8. Confucian rites of marriage and ancestor worship, as well as Buddhist funeral rites, contain many animistic elements, and a majority of Korean people today, without regard to religious affiliation or educational level, continue to observe such practices. Dong-Wook Lee, "Korean Women's Education: Yesterday and Today" (Ed.D. Dissertation, University of Tulsa, Oklahoma: 1974), p. 58. Many women even today embrace animism as their personal religion, even while at the same time being devout believers in Christianity. Helen Kim, *Grace Sufficient* (Nashville, Tenn: The Upper Room Press, 1964), pp. 8-12.

9. Young-Sook Kim Harvey, *Six Korean Women - The Socialization of Shamans* (New York: West Publishing Company, 1979), p. 6.

10. Ibid., pp. 6-7.

11. Chang, *Religion: Korea Background Series*, p. 11.

12. Cho Cha-Yong, *Guardians of Happiness: Shamanistic Tradition in Korean Folk Painting* (Seoul: Ethnic Arts Council of Los Angeles, and Welton Becket and Associates, 1982), p. 31.

13. Chang, *Religion: Korea Background Series*, pp. 5-6.

14. Wanne J. Joe, *Traditional Korea: A Cultural History* (Seoul: Chungang University Press, 1972), p. 113.

15. Some Western scholars believe that Buddha was an agnostic but Buddha's position might be better described as avoidance of commitment to answers of metaphysical questions. While alive, Buddha refused to discuss metaphysical questions such as: Is the world finite or not? Had it a beginning, and will it have an end? Is there a God? Is personality eternal? None of these questions interested him. He saw world full of suffering. He only cared about curing the suffering which is so much part of human existence. No other matters interested him. E. A. Burtt, *The Teachings of the Compassionate Buddha* (New York: New American Library, 1955), p. 32ff. See also Clark, *Religions of Old Korea*, p. 88.

16. Burtt, *Teachings of the Compassionate Buddha*, p. 28; Clark, *Religions of Old Korea*, p. 86; Joe, *Traditional Korea*, p. 113.

17. Joe, *Traditional Korea*, pp. 113-14.

18. Burtt, *Teachings of the Compassionate Buddha*, p. 85.

19. Yung-Chung Kim, ed. and trans., *Women of Korea - History from Ancient Times to 1945* (Seoul: Ewha Women's University Press, 1979), p. 20.

20. Chang, *Religion: Korea Background Series*, pp. 24-25

21. Joe, *Traditional Korea*, p. 120; Chang, *Religion: Korea Background Series, 28-29*.

22. Chang, *Religion: Korea Background Series*, p. 25.

23. Ibid., p. 6.

24. Ibid., p. 26.

25. Joe, *Traditional Korea*, pp. 120-21.

26. Shearer, *Wildfire*, p. 26.

27. Shearer, *Wildfire*, p. 26; Clark, *Religions of Old Korea*, p. 32.

28. Clark, *Religions of Old Korea*, p. 32.

29. Chang, *Religion: Korea Background Series*, pp. 28-29.

30. Clark, *Religions of Old Korea*, p. 89.

31. Koreans accepted Confucianism because the theory of heaven in Confucian philosophy was virtually identical to the Korean attitude towards heaven. Chang, *Religion: Korea Background Series*, p. 23.

32. Ibid., p. 7.

33. Confucianism is thought by a respected authority on eastern society to be largely responsible for the secularism of the Chinese, Korean and Japanese societies. Confucianism had revered texts, but no concept of deity, no priesthood, and very little religious ritual. There was no worship, only right thinking and right living, as shown particularly through loyalty to the ruler, filial piety to one's father, and strict observance of proper social ritual and etiquette. Edwin O. Reischauer, *The Japanese* (Cambridge, Mass.: The Belknap Press of Harvard University Press, 1977), p. 213.

34. Sandra Mattielli, ed., *Virtues in Conflict* (Seoul: Samhwa Publishing Company, Ltd., 1977), p. ix.

35. Harvey, *Six Korean Women*, p. 254.

36. Shearer, *Wildfire*, p. 27.

37. Clark, *Religions of Old Korea*, p. 107.

38. In spite of all the modernization in Korea in recent years, the old Confucian values show up at beneath scratch. Harvey, *Six Korean Women*, p. 253.

39. *Encyclopaedia Britannica*, 15th ed, s.v. "Confucius," by the editors.

40. Ibid.

41. Wing-Tsit Chan, "Confucianism," *Living Schools of Religion*, ed. Vergilius Ferm (Littlefield, Iowa: Adams and Company, 1958), p. 97.

42. Kim, *Women of Korea*, pp. 195-97.

43. Chang, *Religion: Korea Background Series*, pp. 33-34.

44. Although Buddhism might claim most members, it is common knowledge that Christians are most active and assert the greatest political influence in Korean society. Vreeland et al., *Area Handbook for South Korea*, 2nd. ed. (Washington, D.C.: U.S. Government Printing Office, 1975), p. 105.

45. Karl Jasper, *Socrates, Buddha, Confucius, Jesus*, ed. Hannah Arendt, Trans. (New York: Harcourt, Brace and World, Inc., 1962), p. 90.

46. Under Buddhism in India, women were not required to marry men of their parents' choosing, but their own input was respected in selecting husbands for themselves. Married women were encouraged to be companions to their husbands with considerable authority at home. A

Buddist widow was free from any suspicion of ill-omen. Under the influence of Buddhism, women were very much in command of their own lives. I. B. Horner, *Women Under Primitive Buddhism - Lay-women and Almswomen* (Delhi: Motilal Banarsidass, 1975), pp. 2-5.

47. Ibid., pp. 21-22.

48. Kim, *Women of Korea*, pp. 19-20.

49. Martina Deuchler, "The Tradition: Women During the Yi Dynasty," *Virtues in Conflict* (Seoul: Samhwa Publishing Company, Ltd., 1977), p. 22.

50. *Women in Korea 1980* (Seoul: Ministry of Health and Social Affairs, circa 1980), p. 1.

51. Lynne B. Iglitzin and Ruth Ross, ed., *Women in the World: a Comparative Study* (Santa Barbara, Ca.: Clio Books, 1976), p. 346.

52. David and Vera Mace, *Marriage: East and West* (Garden City, N.Y.: Doubleday and Co., 1960), p. 61.

53. Jasper, *Socrates, Buddha, Confucius, Jesus*, p. 47.

54. Mace and Mace, *Marriage: East and West*, p. 62

55. Ibid., p. 68.

56. Iglitzin and Ross, *Women in the World*, p. 346; Deuchler, "Women During the Yi Dynasty," *Virtues in Conflict*, p. 4.

57. Iglitzin and Ross, p. 346.

58. Mace and Mace, *Marriage: East and West*, p. 62.

59. Deuchler, "Women During the Yi Dynasty," *Virtues in Conflict*, pp. 3-4.

60. In order to control women, the Confucian legislators insisted that when the upper class married women, who were always primary wives, went outside of their houses they were required to wear a veil or screen hat to cover their faces completely and were not allowed to lift it. Ibid., p. 23.

61. Ibid., p. 4.

62. *Mace and Mace*, Marriage: East and West, p. 71.

63. Kim, *Women of Korea*, p. 197.

64. Ibid., p. 211.

65. Charles Allen Clark, "The Korean Church and the Nevius Methods," p. 234, cited by Rhim, "The Status of Women in Traditional Korean Society," *Korean Women: In Struggle for Humanization*, eds. Harold Hakwon Sunoo and Dong Soo Kim (Montclair, New Jersey: Korean Christian Scholars Publication, No. 3, Spring 1978), p. 28.

66. Kim, *Women of Korea*, p. 206.

67. Ibid., p. 198.

68. Ibid., pp. 203-04.

69. In 1930s in Korean churches, women were discriminated against with regard to holding titles and positions in the church hierarchy. For example, the title "elders" was refused to women on the ground that the time was not right. Ibid., pp. 208-09.

70. Sunoo and Kim, eds., *Korean Women: In a Struggle for Humanization* (Montclair, N.J.: The Korean Christian Scholars Publication, No. 3, Spring, 1978), p. 2.

CHAPTER 3

Customs and Traditions

As with the area of religion, customs and traditions have had a deep-seated effect on the attitudes and perceptions towards women in Korean society. Various customs and traditions have also had a profound effect on the attitudes of women toward themselves. For purposes of analysis, the materials in this section are arranged in a loosely chronological manner: Childhood and Adolescence, Marriage, Family, Name, Freedom, Divorce and Remarriage, Ancestor Worship, and Perspectives in Modern Times.

Childhood and Adolescence

In Korea, a female's chance of being welcomed to the world by her family is normally increased if a number of male siblings have preceded her. There is often disappointment in a family if the first baby, or subsequent babies, are girls.[1]

Even before a child is born, parents sometimes resort to superstitious practices to make the birth of a son more likely than the birth of a daughter. For example, a midwife who has herself had three or more sons would be in great demand, as if the deliverer could determine the sex of the infant.[2]

This type of prebirth attitude is rather common in Korea, even today. A woman who has been lucky enough to have had sons is asked to sew stitches on the expected baby's blanket. In 1986, Mrs. Bang-Ja Lee, a mother in Seoul with three college age children, was asked to help in this way. She postponed a planned trip to America for two weeks so she could participate in the sewing ritual. Mrs. Lee had had three sons followed by one daughter, an ideal order and combination of children. Thus the expectant mother felt that if Mrs. Lee would participate in the ritual, her good luck would perhaps rub off and the expectant mother would bear a son.

After giving birth to a son, the mother is encouraged to rest in bed for two or three weeks, for she has earned it; but if she had borne a girl and were to lie in bed even a week, she would draw shame and insults from neighbors and family members.[3] In one recorded instance, following the birth of a girl child, the baby's paternal grandmother blatantly expressed her disappointment by leaving the house immediately and not returning for almost a week.

Yet another old custom related to celebrating the sex of a baby at birth is the hanging of the traditional rice straw birth rope at the main gate of the house when a baby is born. There is always a ready

public display if the child is a male. To show the family's good fortune, the birth rope is left up for three weeks if the baby is a boy. A family that finally has a son after a long wait might even leave the birth rope up for as long as four or five weeks. The birthrope for a male child might also be decorated with symbols of male genitalia such as red peppers, cut-up pieces of rope, or even a small knife. All these objects are supposed to symbolize a penis. And in certain isolated areas the attached objects are two round pebbles, suggesting testicles.[4] Having many daughters, on the other hand, is considered a bad omen. A girl child's birth rope is left barely one week,[5] for there is no reason to rejoice. The birth rope for a baby girl is decorated with pine needles to indicate her future success as a seamstress.

This customary boy preference was related to the belief that the worst male sin was to die without male progeny, which would effectively sever the patrilineal family line.[6] There is, however, at least one other practical reason behind the rejection of girl children, namely the economic burden. A daughter will not only be a financial expense while growing up but there will be an additional expense to marry her off, since a woman is expected to come to her husband's home with a dowry. For a poor peasant, the economic burden of having a girl child is often too much and can be a guarantee of deep debt.

Even today some Koreans tell a story such as "Poor Mr. Park and Thief Choi," which carries the message that daughters are inferior to sons. Here is the story, as it was recently told to me:

> Once upon a time there was a thief named Choi who was well known among the local villagers for his clever way of getting into houses, and also for his ruthlessness in stealing, even from poor people who could not afford any loss. One night Thief Choi quietly unlocked Mr. Park's wooden gate with his "master key" and entered the house where Mr. Park and his family were sleeping. In one corner of the bedroom Mr. Park was sound asleep with his wife next to him. In the other corner Thief Choi saw the three children sleeping -- all daughters. "What a poor man with three daughters!" Thief Choi said quietly to himself. Feeling sorry for the poor man, he stepped out of the house as quietly as he had sneaked in and walked away without taking anything.

This is one of the many Korean folk tales with the message that having daughters was pitied, even by a thief.

Girls who grow up today in Korea's highly male preferential society are conditioned to believe from an early age that they are worth less than boys, simply because they are females. The girls also are convinced by the culture that this is an unchangeable fact of life. Inexcusable situations are created in Korea today because of the continued existence of outdated Korean male preference customs.

A tragic case in 1989 drew worldwide attention to the detrimental effect of Korea's male preference attitudes when four young sisters between the ages of 6 and 13 apparently entered into a mutual suicide pact to improve the economic chances for their 2-year old

brother. While the parents were out of the house, the 13-year old sister prodded her three younger sisters to join with her in taking rat poison. Attracted by their shrieks of pain, the police found the four girls lying on the floor in the dim lit basement of their house, while their two-year-old brother lay next to them on the floor, crying. Under questioning, Yang-Sun Mi, the oldest girl and leader of the four, confessed that her desire had been "to lighten the load on our parents of school fees and other expenses." Her statement to the police was, "Our parents would have more for our brother if they didn't have to raise us four girls." The tragedy of this situation is that the parents had obviously tried to have a boy for a long time, and kept on trying until they finally had one as the number five child. It is reasonable to speculate that the four little girls had each been brought up to feel that their combined lives didn't mean as much as the life of their one little brother.[7]

With all the prejudice against female children, daughters in modern day Korea are still better off than in the past when a girl's fate was absolutely determined by her parents. One may read about the practice in former times of the parents' selling off a daughter in marriage and then using the money to buy a wife for their son. A daughter could also be sold as a permanently indentured servant, (or as a slave before this was prohibited), or as an apprentice for the *kisaeng* role.[8] In other reported cases a daughter could be sent away to become a Buddhist nun when the family was too poor to marry her off.[9]

In addition to the economic burden of having a girl child, the boy-preference attitude in Korean society has also been encouraged by the existence of the patrilineal family system and the definite Confucian bias towards male superiority. In families, great emphasis is naturally placed on having males since only males will be able to carry on the family lineage and carry out Confucian ancestor worship rites. Even today, these aspects of Confucianism are still a powerful cultural force in Korea.[10] Sons, especially the oldest sons, occupy a special place in their parents' lives. A mother is careful always to avoid negative thoughts about anyone for fear that unkind thoughts would somehow adversely affect her oldest son's future.

It is difficult to list completely all the repressive customs and traditions that have had an adverse effect on the attitudes of Korean women about themselves. In order to survive a Korean girl must grow up fast. By her third or fourth birthday, a girl is socialized to believe that women are inferior to men and that she is an inferior being. Custom convinces females that men are right by virtue of their maleness, while women are wrong just because they are women.[11] A smart girl will be familiar with the cultural roadmap of the realities of Korean society by the time of her puberty.[12]

To conform to social expectations a girl child finds that she must sharpen skills for monitoring a social situation by being sophisticated in manipulative strategies, i.e. being "quick in *nunch'i.*"[13] By the time of puberty hopefully, she will have accepted the

following set of propositions:

1. **Women are inferior to men.**
2. **Women must expect and acquiesce to the preferential treatment accorded males.**
3. **Women are subject to constraints in movements.**
4. **Women must maintain proper social distance from men in their household, and practice social avoidance with unrelated men.**
5. **Women must conceal emotions which are incompatible with their roles.**
6. **Women must cultivate covert strategies for goal realization.**
7. **Women must accept the idea of being married out to strange households where their reception is uncertain.**
8. **Women who are valued by men and the society are those who uphold cultural values by their conformity and commitment to their female role, and therein lies the traditionally most reliable social security for women.**[14]

Brought about by Confucianism, a practice of rigid sex segregation has laid the base for much discrimination against women. When boys and girls reached the age of seven, they were not allowed to sit next to each other, even if they were first cousins. In the home they were not permitted to use the same towels, clothes hangers, or other commodities. No girl could use a towel designated for her brother.[15] These practices continue to be prevalent.

As a result, if a young Korean woman desired to develop or expand her abilities, she ran the risk of making herself unpopular. She was not supposed to

have talents, in rhetoric or otherwise, or be beautiful. Instead she was taught that she should always be restrained in her speech, quiet and serene, chaste, and disciplined with a clean and simple appearance.[16]

In Korean society, accordingly, there continues to be little room for self-assured and assertive females. In order to conform to social expectations, a young girl must be painfully shy and modest in public. This is mainly to protect herself from being considered a prostitute and thus an "unperson,"[17] and above all, ultimately risk not finding a husband from a good family. A girl who practices Western dating customs must do so discreetly or run the risk of being a social outcast.

Even sophisticated Korean women students in America today are most reluctant to speak in class when Korean males are present. I conducted a two-week seminar for twenty-eight Korean men and women who were learning to organize seminars. This group would later be setting up workshops for people working in the administration of the upcoming Olympic Games, to be held in Seoul, Korea, in 1988. We were focussing on various leadership techniques and the seminar was structured to encourage oral participation from the attendees.

The seminar was conducted completely in English. On the first day very few people spoke in class. The ones who spoke up were men. On the second day a few more people spoke up but still only the men. One day, however, during a morning recess, Mrs. Jung, one of the six women in the class, followed me out to the hallway and talked to me in

rather fluent English.

> "Your English is excellent, why don't you talk in class?" I asked with curiosity.
>
> "Men don't like it if women speak better English than they do," said Mrs. Jung, while staring at her purse under her left arm.
>
> "Are you sure?" I asked, then continued, "You shouldn't be too concerned about that. Come on, speak up in class."
>
> "If I speak up in class in English, the men folks would think I am trying to show off and they would phone my husband in Seoul and tell on me," revealed Mrs. Jung. "Then, my husband would make me come back before my trip is even over."

Marriage

In traditional Korea, getting married was considered the single most important event for a woman. Marriage had priority over all other alternatives. It was culturally difficult for women to remain unmarried. Women who failed to marry were pitied.

Beginning with the Confucian reforms in the Yi Dynasty, the custom of patrilocal residence was adopted. This meant that the bride had to move to the home of her husband's family, which might be in a village different from where she had grown up. Even if she remained in the same village, she was now surrounded by strangers and vigilant in-laws and typically lost contact with all her childhood friends. Accordingly, marriage was often a traumatic experience for the young bride.[18]

In the strictly patrilineal culture in which the lineage has been traced only through males, marriage has largely served the need to provide male children to perpetuate the family line. Marriage between people of different social levels was prohibited, and equal social status between the two concerned families was considered of prime importance in marriage.[19]

Marriage founded on a "love" relationship has been discouraged. In fact, with Confucianism as the state religion, the Code of the Yi Dynasty, which prevailed in Korea until 1910, declared a "love" marriage to be illegitimate and subject to punishment.[20] Even today pure love marriages are often looked upon with great skepticism on the ground that they do not work. In Korea there is still a perception that too much emphasis on love in a marriage may make the parties blind to what is considered the more important aspects of marriage.

In Korea the term "love marriage" includes any marriage not arranged or consented to by the parents of both the parties. A significant number of love marriages are probably entered into because of a discovered pregnancy.

An example of a love marriage between the eldest son of an old and prominent Korean family with a middle-class hospital nurse shows concretely how "love" marriages may founder because the wife cannot fulfill all the demands of the husband's exacting and basically antagonistic extended family. Jung-Ki and Hyun-Oak had met at a hospital in Taejon where Jung-Ki was a patient and Hyun-Oak was a chief nurse. After a year of courtship, Hyun-Oak discovered she

was pregnant. On the insistence of her family, the couple got married immediately. Jung-Ki's family was never asked for advice or consent with regard to the marriage.

After the marriage Hyun-Oak moved in with Jung-Ki's extended family, which included Jung-Ki's grandfather, grandmother, father, mother, three younger brothers, and a younger sister. There was a large household staff which the eldest son's wife was expected to learn to direct under the tutelage of Hyun-Oak's mother-in-law.

Every year the family would hold an ancestral memorial ceremony in which food had to be prepared for hundreds of extended family members. Other ceremonies on major holidays also required the whole clan to be invited. Each time, just before the ceremony or holiday, Hyun-Oak would get sick and return to her parents' home. Sometimes she would not come back until well after the event had passed. When the daughter in-law was most needed, Hyun-Oak was not available at Jung-Ki's home.

This situation was embarrassing, not just to Jung-Ki, but to Jung-Ki's mother, who happened to be an unusually kind woman for a Korean mother-in-law. It was embarrassing to the whole extended family. This particular marriage could never have materialized through a carefully researched arranged marriage route. The groom's special home events were too much for the bride's capability. When the marriage ended, as it had to, many people blamed the fact that the marriage had been based only on "love."

Whether there is a love marriage or an arranged marriage, the new bride's life in Korean society is, nevertheless, going to be bound by her expected social role. A well-known proverb says she should remain dumb three years, deaf another three years, and blind still another three years to weather the trials and tribulations of married life. Sometimes, this advice is passed on in the form of a story from ancient times, as follows:

> Once upon a time a man said to his daughter when she was setting out to go to her wedding, "A daughter-in-law's life is very bad. She must pretend that she does not see the things that are to be seen, that she does not hear the words spoken around her, and she must speak as little as possible." So for three years after her marriage the girl spoke never a word. Her husband's family thought she was deaf and dumb, and so they decided to send her back to her father's house. As she went back riding in a palanquin, she chanced to hear a mountain pheasant call, and she said, "Dear pheasant! I have missed your voice these long years." Her father-in-law, who was walking beside the palanquin, was overjoyed to hear her speak and took her back to her husband at once.[21]

A newly married bride in Yi Dynasty Korea could not expect much companionship from her husband. The situation has not changed much. Even today, many Korean husbands attempt to safeguard their male superiority by displaying a certain aloofness to their wives. This is the approved behavior of

Korean men in their social relationships to women other than *kisaeng* (women entertainers). Koreans have tended on both sociological and psychological levels to carry the ideal of male superiority to a point of pseudo-isolation, even from their wives.[22] On this point, it appears that Korean women married and continue to marry commandants rather than men and companions.

Because a wife did not spend much time with her husband, however, the personal compatibility factor was of no great consequence.[23] Even today, outside the city of Seoul, a Korean wife is usually not a social companion to her husband in a Western sense. At cocktail parties or other Western-style functions, for example, the husband may be accompanied by a "little wife" (mistress), but the real wife stays home with the children.[24]

Even a highly educated wife is often left at home in modern-day Korea while her husband socializes late into the night with his friends. One such wife, a 42-year old biochemist, Dr. Jung Oak Nahm, had earned her Ph.D. from an American university. When she and her husband returned to Korea to live, she had some severe adjustments to make. Among the most difficult things to get used to, she says, was the sudden change in her husband's attitude toward her, personally. "We had been more like friends back in the U.S., but his relationship with me changed after we moved back."

"What do you do when he is out all night?" was my question to Dr. Nahm.

"I am not a very social person, so I just stay

home with the children and wait for him to return. In America, we would usually go out together to friends or shopping, and if there was anything to discuss, we would always talk until we came up with a mutually agreeable solution. He is different now. Since we came back to Korea, my husband spends too much time out with his friends. I don't like it," revealed this educated and unfortunately quiet mother of two teenage children who finds too much to adjust to since returning to Korea.

The typical Korean wife remains a very private person who is usually isolated both from her husband and often from the general public. One of the traditional words for wife is *anae*, (inside person), which refers to the fact that she was once expected to remain within the confines of the family compound. In olden times, a wall surrounded almost every Korean home and the wife stayed out of sight inside the wall.[25]

The isolation of an upper-class wife may be offset by a certain degree of security and social respect, but after marriage the lower-class wife may just have a thankless and backbreaking role to perform. Apocryphal stories abound in Korea which on their face superficially purport to be true. Here is an old but still useful example on the subject of the meager appreciation some Korean men have for their wives. It appeared in a book written for Westerners:

> Once, on a walk by the city wall, we saw a man sitting on a stone weeping. His was a fullmouthed, heart-broken cry, as though the world had given way under him.

"Why," we asked. "Why all this fuss?" He looked vacantly at us for a moment, and then resumed where he had left off. We found that the trouble was about a woman, his wife; she had left him. "How he must have loved her to cry like that," remarked a lady in the party. When the lady's remark was translated and communicated to the man, he resented it. "Loved her? I never loved her, but she made my clothes and cooked my food; what shall I do? Boo-hoo-oo," he cried, louder and more impressively than ever.[26]

Place of Women in the Family

Although there is some opinion that the Korean family structure may be changing in recent times, a great deal of importance is still placed on the performance of familial duties and obligations by all persons. Confucian tradition remains the norm with regard to the proper roles of males and females, and an individual's status depends quite simply on his generation, relative age, and sex. Within a given generation, sex, and then age, are the determinants. A wife is inferior to her husband, a sister to her brother, (whether older or younger), and a younger brother to his older brother. Because of the Confucian tradition, there is still virtually no concept of equality in the Korean family system.

In Korea rights and responsibilities are distributed in a very lopsided way. While the husband and his sons have most of the rights and privileges, the wife and the daughters have most of the duties and

the obligations.[27] The husband is the ultimate master of the wife in everyday life. The husband is introduced as "our master of the house." The word "master" is used here as a translation of the Korean word, *juin,* "owner" or "commander," connoting leadership.[28]

Throughout the Yi dynasty, Korean women were subordinated to men. The major characteristics of this traditional family system were:

1. **Only the paternal line relatives were recognized as relatives.**
2. **Social class and rights were transmitted only from fathers to sons.**
3. **The sole authority in the family rested with the father, who held control over the children.**
4. **Marriages were allowed only with those outside the blood clan.**
5. **First-born males held the right to lineal succession.[29]**

In this context, the women were made into mere tools for attaining men's objectives. Although the wife or mother could be an object of respect in a family, the fundamental status and role of women under the patriarchal system has, overall, been subhuman.[30]

In traditional Korean society, a wife's principal role was considered to be procreation. In the course of the first year of her marriage the wife would hope to become pregnant. The wife almost always accepted the responsibility to become pregnant as hers alone. Until she gave birth to a son, the wife felt as if she

"sat on a cushion of needles." With the birth of a son, her duty was fulfilled in perpetuating the ancestral lineage, and she found her sole protection and security in the future of her son. If a woman were childless or failed to bear sons, this was attributed to her own unforgivable "sin."[31] If she had no son, unfortunate for her! Better that she had never been born. Not only would she be condemned by her husband and every member of the clan, but she would condemn herself, and "no ray of sunshine (would) ever gladden her broken soul."[32]

A sterile wife may consult many advisers such as Shamans, herb practitioners, and doctors, and visit all kinds of shrines, hoping to have a son. She may even counsel her husband to have a child with a servant girl or with one or more concubines.[33] In distinguished *yangban* families in the past, if the wife did not or could not give birth to a son within a reasonable time, the husband almost inevitably felt led to take a concubine.[34] Even today, for this reason, men can still take concubines without serious public censure.[35] For a wife to suggest that her husband take another woman under such circumstances has long been regarded as a "noble gesture" for which the wife is respected. Under the traditional Confucian rules, the wife has no choice but to accept her lot with personal sorrow. She is not even allowed to show jealousy.

The sacrifices made by wives to satisfy the desires of their husbands for male heirs sometimes produce tragic results for all concerned, especially for the wives. This is best illustrated by an example.

Mrs. Bok-Kum Yoon is now a woman of seventy years. She came from an old and respected family in Choong Nahm Province. She had married at age nineteen to a well-to-do local businessman. It was an arranged marriage, and her husband was an only son in his family. At first, all things worked as anticipated, and both sides of the family were happy about the marriage. Two years went by, however, and the couple was still childless.

Feeling responsible, as most Korean women would in her situation, Mrs. Yoon arranged for her husband to have a child by their housemaid. The maid, however, gave birth to two girls in succession. The continued lack of a male heir forced Mrs. Yoon to seek an alternate solution. This time, Mrs. Yoon carefully selected a woman named Jung-Yae from a small town nearby who would be willing to bear her husband's child.

Jung-Yae seemed quite suitable, Mrs. Yoon thought. She did not seem so pretty that she would be likely to captivate her husband's affections. Although Jung-Yae was not a member of the lowest class of society in her town, she was still no *yangban*. The woman was simply a healthy female, nineteen years of age. Jung-Yae was willing to participate in this convenient arrangement with Mrs. Yoon's husband to produce a son.

Within one year after the arrangement was consummated, Mr. Yoon finally had the son he needed for his lineage to continue. Although, Mrs. Yoon felt a tinge of jealousy sometimes, thinking about her husband's intimate moments, she was still well

satisfied. After all, she had herself selected the woman; her husband had got the son he needed; and the much sought-after family goal had finally been achieved.

But Mrs. Yoon was to face a problem that she had not anticipated. Mr. Yoon and Jung-Yae had gotten along too well together. Now they wanted to establish a permanent relationship. This development was a severe blow to Mrs. Yoon, who had only planned to use Jung-Yae for bearing a son for her husband. She had intended to send her back home with an agreed compensation. Though Mrs. Yoon tried, she could not break Mr. Yoon and Jung-Yae apart. During the Korean War in 1950, Mr. Yoon and Jung-Yae fled the communist invasion together and left Mrs. Yoon living alone. Infuriated and insulted, Mrs. Yoon refused to sign the divorce paper that Mr. Yoon later asked for, which would have made his marriage to Jung-Yae legal.

In 1987, when I met Mrs. Yoon, she stated, "I will not sign the paper. He wants to give me some property if I sign." She continued, "What would I do with property? I am 70 years old. If I don't sign the paper, at least I will get the satisfaction of having all the children under my name."

Given Name

One's name is considered of the highest importance in Korean society. Historically, a date of 32 B.C. has been given for the adoption of Chinese surnames in Silla, but we know that in the third

century A.D. in Koguryo, commoners still had only given names.[36] Although in the feudalistic Yi Dynasty, male commoners were finally granted surnames, the privilege of bearing surnames was not granted to women until 1909.[37] Before that time, in official documents such as the *hojok* (family register), the wife was recorded merely by the surname of her own family and the place where she was born.[38]

Even though women had personal names, their names were not regarded as important. Unlike the personal names given to sons that consisted of one or two *Chinese* characters, the girls' names were composed of single *Korean* elements, and frequently ended with the diminutive "*i.*"[39] Until marriage, a female was called simply by her childhood nickname, such as *Koptani* (pretty), *Poksili* (happy), *K'unnyon* (big one), or *Jakunnyon* (little one).[40]

In contrast, it was imperative to select a good name for a boy because the name was thought to have an influence in determining his future success.[41] Families spent time and money going to professional namers who resorted to zodiac signs and mysterious combinations of the *yin* and *yang*, the mystical negative and positive forces in all creation.

Sometimes the name given to a girl child would reflect the disappointment of the parents in not having produced a boy. Unfortunately this name might easily cause a psychological scar which would last for the rest of the girl child's life. In the case of a girl child who did not have at least three or four male siblings, common names which often were given include such names as *Sopsophabi* (regrettable),

Sopsop (pity), *Pu.nt'ong* (anger), and *Yukam* (regret). The child might narrowly escape this harsh condemnation if she were the first born. Though less welcomed than a son, she could be tolerated, since her birth had at least demonstrated the mother's ability to fulfill her major expected function which was to bear children.

After marriage the wife's childhood name or nickname was discarded, and she was known to the community only by the surname of her husband's family, for example, Kim-ssi (Mrs. Kim), Lee-ssi (Mrs. Lee), or Choi-ssi (Mrs. Choi). In the home she was addressed by a kinship term denoting her position in the family organization, or by her children's name plus the word for mother, for example, "Happy's mother." In her husband's genealogical record, the wife is simply recorded as *pae* (spouse). In the genealogical records of her father's family, lacking a respectable name, and of little use to her own family's lineage, a girl was rarely even mentioned.[42]

This custom of female anonymity sometimes created practical difficulties. As recently as seventy years ago, when women had to appear in court, they were given certain convenient names to suit the purposes of the particular lawsuit to facilitate court procedures.[43] Even today, some elderly women have trouble remembering their names. One book recounts experiences of health program workers in rural areas who ran into problems trying to construct health records for elderly patients. Finding the name of the patient was often difficult. Asked what her

name was, an elderly woman initially responded, "What did you say?" Asked again for her name, she replied, "My name, well, just what is my name? H'mm." She had for so many years been called someone's mother and then simply "Grandmother" that she was unaccustomed to thinking of herself as having a name.[44]

Freedom and Women

By examining the topic of women and freedom in Korean society, one gains an understanding of the attitudes toward women working outside their homes. In former times, women were allowed outside the wall around the home only at night. In some villages or towns, the town gates were closed at sunset after all the men had returned home, but were reopened after dark so that women could come and go unseen for a certain period and pass freely through the streets.[45] During this time a curfew was in effect so that no men were permitted on the streets except those who were blind, or who were public officials. Any male who dared to trespass on the streets during what might be called the women's hour ran the risk of being caught and having his head chopped off by the public executioner![46] The women carried paper lanterns as they strolled, but even in so little light they hid their faces with their silk jackets.[47] A *yangban* grandmother of Seoul once remarked that she had never seen a train or a rice field until she fled with her family to Pusan during the Korean War in the 1950s.[48]

A woman's freedom varied according to the social status of the family. Wives of farmers and workmen who were obliged to work in the fields and the shops, were of necessity permitted much greater freedom than their higher-born sisters. Commoners and low-born women probably had more equality with their men than upper-class *yangban* women.[49]

The lower-class woman, however, had less control over her treatment in her husband's family. Many lower-class women were sent away from their husbands' houses if they did not please their husbands and in-laws. Although divorce was seldom resorted to, marriages tended to be much less stable in the lower classes than among the upper classes. In general, a wife's treatment was related primarily to the respect in which her own family was held and the desire of the husband's family to maintain a good relationship with the wife's family.[50]

Overall, in Korean society, an ironic trade-off has prevailed. The upper-class woman who is permitted less freedom is more highly regarded than the lower-class woman who is permitted greater freedom. The greater a woman's degree of seclusion, and the less she has to do with men, the greater is her class status. The favorite consort of the upper-class male, the articulate, multi-talented *kisaeng* or courtesan, occupied a low rung on the social scale precisely because she was so free and accessible. But she was far more companionable than the respectable, though dull, wife. Therefore, in Korean society freedom for women was not necessarily an advantage, and women became accustomed to not desiring it.

Women's Place in Ancestral Worship

In Korea, death is regarded as more important than birth. But in the patrilineal system of ancestor worship, a woman has no important role in funeral or memorial rituals, which were considered the most important ceremonies in the society.[51] The ritual of ancestor worship can be looked at as an extension of filial piety to living parents. It has served the purpose of solidifying clan consciousness and the bond between members of the household.[52] A double standard between the sexes existed, however, with regard to the rules for mourning for deceased parents. A wife was required to mourn for three years for her parents-in-law, whereas for her own parents she was expected to mourn for only one year.

Funeral ceremonies and annual ancestor worship ceremonies play an important role in supporting male superiority in Korean society. By carefully laying out the rules designating the proper role of each family member, with all important ceremonial roles going to the males, superiority of the males is established. Typically, females are excluded from the ceremonies themselves, but are expected to provide all the necessary background work so that the ceremonies can actually take place. Women take part in ancestor worship mostly by preparing the food and the garments.

My personal experience illustrates the roles of women and men at the time of death. While a student at Ewha Women's University, Yu Kyung-Duk, my paternal grandfather passed away. Grandfather's

funeral was elaborate and large. Guests came from nearby towns by the hundreds, and chartered buses brought in hundreds more from Seoul. There were so many people that one could not see the end of the line of people from the *mahroo* (veranda) of the house. For five days after Grandfather's death and before the funeral, the duty of the family was to look grieved, receive condolences, and feed the people. Receiving condolences was primarily the job of the men, while the women were entirely responsible for preparing and serving the food. At funerals, even the most educated and socially prominent female members of the household are made to feel unnecessary.

The size of one's funeral in Korean society is determined by the kind of position one has held, or how successful one's children have been. In grandfather's case, both factors came into play. Grandfather himself was a self-made wealthy land owner, and his only son, Yu Chin-San, had been elected a member of the national parliament. This entitled Grandfather to an elaborate funeral of which his descendants would be proud. I still remember the white-clad people pouring into our old country home, and the endless amount of food and beverages, including rice wine, which had to be prepared to feed all the people who came to pay their last respects.

The kitchen was full of women, both relatives and village folk, who had come to lend a hand. Mother was busy trying to supervise various matters such as taking care of the kitchen and preparing proper mourning garments for all the immediate family members of the deceased, while simultaneously

performing her daughter-in-law duties.

One of these duties, incidentally, was to wail with grief for three nights before the hearse would take Grandfather's body away from the house. Mother had the highest possible regard for Grandfather, but she never completely believed in all the Korean customs, and she refused to wail, even though that act was required by custom of the wife of the eldest son. In fact, Mother was not only the wife of the eldest son, but actually of the only son. "I don't have any tears, nor do I have the energy!" I overheard Mother saying in the kitchen where the other women could hear. Thus, we didn't have the loud wailing of a woman at Grandfather's funeral because mother was the only daughter-in-law, and she refused to abide by this rather archaic custom.

Following breakfast on the fifth day of our mourning, the pallbearers started chanting to draw people's attention, and the headman at the far front of the pallbearers started ringing the funeral bell. The males of the family lined up behind the pink and white flower-covered hearse. Father first, then the oldest brother, followed by my next two older brothers. My younger brother and I were standing next to father at his request. I was immediately next to Father, and Han-Yul was behind me. Father just wanted to keep his two youngest close to him. But as the hearse was about to leave the main gate of our country home, an elderly kinsman left his place in the procession and began arguing loudly with Father. The kinsman's face was red from anger. He addressed Father in a scolding voice, rebuking him with obvious scorn. I

was about to witness my first dramatic confrontation regarding sex discrimination in Korean society!

"You are not taking her to the grave, are you?" demanded cousin Young-Chang loudly, while looking straight into Father's face, which was tired from the five-day funeral ordeal. Father ignored this angry outburst. Father was five years younger than the cousin, so was required to be deferential to him.

"She is a female!" continued the cousin, impatiently. At this, Father gave cousin Young-Chang a look of disapproval and disgust. "You don't know anything, because you have been away from home too long, politics, and all," shouted the elder kinsman. It was too much for Father to stay silent any longer.

"She is the only granddaughter of the deceased," said Father, gesturing toward me. "He treasured her very much." Still looking his cousin directly in the eye, Father said emphatically, "That's a good enough reason for her to be here! Please go back to your place in line." At this, the angry man retreated to the place in line accorded him by the Confucian tradition. Cousin Young-Chang was literally steeped in Confucianism. He had one wife and three concubines and didn't like any deviations from Confucian principles, especially at such an important occasion as a funeral ceremony.

Standing quietly next to Father, I felt triumph, and was glad that Father had the last word. Cousin Young-Chang had succeeded only in arousing my consciousness, as well as my curiosity and interest in participating. Because of the argument between father

and the cousin I wanted even more now to go with the procession to grandfather's grave.

As cousin Young-Chang fumingly settled in line along with the other cousins, Father didn't say anything to anyone, nor did he even look at me. This was the first time I had ever actually recognized an attempt at discrimination against me. Later in life, of course, I found out how common it was in Korea and elsewhere, but I always remember that my father considered it wrong for such a custom to discriminate against his daughter.

After a two-hour procession through the towns of Chinsan and Setuh, we arrived at our ancestral cemetery where the geomancers had been carefully preparing grandfather's grave site for five days after his death. The grave was on a gentle ridge of a mountain overlooking my hometown of Chinsan. Proper burial of one's ancestors is one's single most important duty. In the Korean custom, the burial site brings a good omen or bad omen for future generations. Having witnessed the earlier argument between Father and cousin Young-Chang about my coming to Grandfather's grave, I purposely looked all around the endless crowd of white-clad men. I was the only female among the hundreds of people there.

Discriminatory customs against women at funerals and annual memorial celebrations still exist in Korea. Although my father broke the taboo to include his daughter in the funeral procession to his father's grave, and even had to publicly fight off a cousin to do it, my brothers have not followed Father's footsteps toward gender equality.

In 1987, I attended Father's own 13th memorial service held in Chinsan at his grave site. Father's grave is on top of a small mountain behind our family's country house. Each year, at least 3,000 people have paid a visit to the grave ever since he passed away in 1974. To visit this grave, one must walk up eighty-eight steps. According to Buddhism, one must experience 88 hardships before reaching enlightenment in life. The eighty-eight steps up to Father's grave signify that he finally reached enlightenment.

Father spent all his life in behalf of the Korean people, first as an exiled patriot in China fighting the Japanese, and later fighting a succession of domestic Korean dictators. The Korean people had much respect for him. Father was serving as chairman of the major opposition party, Shin Min Dang (New Democratic Party) before he died, and was, expected to be its next presidential candidate.

In Father's 1987 memorial service, my younger brother, Han-Yul, now a congressman from our home district of Kumsan, showed that he was not as enlightened as Father about gender equality. As a part of the ceremonies, Han-Yul was greeting guests at the graveside as a representative of the family, and I was also present, but at some distance away. After greeting several guests, I decided to move closer to join my brother at the graveside. I was going to relieve him from having to greet everybody all by himself. Little did I know how this action would provoke him.

Back in Seoul the next day, Han-Yul gave a formal breakfast for some twelve congressmen and their wives. He also invited me and some of my friends, as well, including Ms. Kim, who is President of one of Korea's major women's organizations. The affair was held at New World Hotel in Kang Nahm, an affluent section of Seoul. The soft gray room was decorated with fresh pink flowers. The atmosphere was definitely a formal occasion. Han-Yul apparently had decided to use this occasion to teach me a lesson about how I, a member of an inferior sex, should behave in the future.

He began by talking to Ms. Kim in a voice loud enough for everyone to hear. "Please teach her a lesson," he said, glancing at me, "because if I tell her myself, she gets angry with me." He continued, "Yesterday, she did something she was not supposed to. She looked directly at male guests at Father's memorial service, and also shook their hands. I was embarrassed by her behavior," he told Ms. Kim.

At this point, to my utter surprise, but perhaps to be polite, Ms. Kim actually agreed with Han-Yul. She agreed that according to Korean custom a female should not have been so bold as to look directly at the arriving male guests or to shake hands with them. This infuriated me! It still angers me whenever I think about it! With this sort of attitude among the leaders of the women's equality movement, how will women ever take their proper place in Korean society?

Perspectives for Women in Modern Times

Women continue to be oppressed today by the discriminatory content of Korean customs and traditions. Customs of a society change slowly. Unfortunately, there has been little improvement even in recent years.

Wife beating, for example, is rather common in Korea even today. In 1989, in Seoul, 30% of all domestic cases reported were assaults on wives by their husbands. When the husbands are asked to explain their behavior, they frequently answer that the wives have done something to deserve to be beaten up. Some husbands even claim that they beat their wives out of love. They say they want to teach them a lesson and make the wives into better persons.[53]

Another serious problem relates to the widespread tendency of Korean married men to stay out at night rather frequently without providing reasons to their wives. Usually the wives suffer silently. The reverse practice, however, would not be tolerated by the husbands or the society if the wives wanted to stay out at night themselves.

A recent case reported in a major Korean language newspaper involved a 30-year-old Mrs. Lim, who had been married for three years:

> I knew before we got married that my husband loved playing cards. But he goes too far. I didn't realize he would do this. Sometimes he stays out all night to gamble. Sometimes he invites his friends to our small apartment and plays poker all night.

Because of his gambling and staying out, he neglects his family at home and his work at the office. Each time I find out about it, he swears to me that he will not gamble again, but he always gambles again anyway. Sometimes he just brings his empty pay envelope home.

I don't know what is the right answer. I cannot divorce him, cannot move out. I have tried to move out, but that does not seem to be the answer. I quietly comforted myself saying, "At least he doesn't fool around with another woman." One time however, he showed up in the morning looking like wilted green onion *kimchee* (a Korean pickle). I thought he had gone out gambling again. But then I noticed that his trousers didn't have any wrinkles, as when he squats down all night. It was obvious that he had not spent the night gambling. When I think about my husband, I grit my teeth, just thinking about the way he looked.

Another case is twenty-seven year old Mrs. Park who had been married for about one year.

I am still busy answering people asking, "How is married life?" My husband and I had dated for two years before getting married. Until several months ago, my husband couldn't wait to come home after work from the office. I was just extremely happy. But lately my husband has also stayed out all night. He doesn't even give me good reason for it. "It got late drinking with friends at the bar," or "I didn't know what

time it was because I was playing cards with friends," etc. These were his excuses. He doesn't even show too much emotion. This makes me angry, I can't help it.

When I got angry with him, he said, "What's the big fuss? A husband can stay out. Not only that, husbands have prerogatives to stay out!" I tried to ask my husband, "then can a wife also stay out?" This questioning developed into a big fight. I just grieved about the Korean women's fate, where they have to put up with the double standard of Korean custom.

Mrs. Hong also has a problem with her husband's excessive drinking.

We have been married for eight years and during that time, he swore in writing that he would not drink. He would even write a note to himself and place the note on a wall board. But finally, he confessed, "I can live without a wife and kids, but I cannot live without drinking."

When he drinks, he often stays out all night. I am thirty-six years old now. It's my *palcha* (fate). When he is sober, he says he won't do it again, but he never keeps his promises.

Mrs. Moon, thirty-three, lives with her mother-in-law, and has the problem of her husband staying out:

My husband is the only child, and his mother lives with us. My mother-in-law and

I don't think alike. She never says anything in front of me, but she criticizes me behind my back. I cannot stand it when she interferes and always takes my husband's side if there are any squabbles between me and my husband.

One day, I went to see a doctor because I felt sick to my stomach. The doctor told me that it was my nerves. I decided not to keep quiet about all the things that were happening at home. I decided to speak up to my mother-in-law and to tell her all the ways in which I felt I was being mistreated by her. When I finally told her, she didn't say anything, but decided to get sick in bed. When my husband came home that night, she told my husband that I had mistreated her, and that she couldn't live with such a daughter-in-law.

My husband didn't say anything to me, not a word, but I noticed a change in his behavior. Without any particular reason, he started to stay out. Whenever his mother or I complain, he avoids the problem by staying out. Sometimes he explains his absence by saying, "I was too busy at work, or I had to attend a funeral, etc." The home atmosphere now is definitely cold. His way of handling his problem is to not take sides, but to stay out.[54]

Although wife-beating and husbands' staying out are serious problems on the surface, the underlying cause of this and many other unreasonable

male behaviors may be the strong preference shown for Korean boys. It is this attitude which a child learns in his early years that starts him off in the wrong direction psychologically. Korea, along with India and Taiwan, is reported to be one of the three countries in the world with the highest boy-preference attitudes.[55]

Being subjected to male preference attitudes from an early age can have a lasting psychological impact on Korean females as well, harming their self-concepts. Eun-Young, a graduate student in Seoul, recalls some common childhood experiences that she thinks tended to undercut her self-image.

Eun-Young's parents were both medical doctors with degrees from elite Korean universities. But discriminatory practices exist at all levels in Korean society, including the most educated. There were four children in the family -- two girls and two boys. The oldest two were the girls.

"Whenever meal time came, we four children were served together by our maid at our own table. Mother would soon come to our table, and start moving the better dishes toward my brothers." Eun-Young continued, "Although, my sister and I are the oldest, Mother would always serve the rice and soup to my brothers first. I knew that my parents valued my brothers more, simply because they were boys."

According to a study conducted by the Research Institute of Behavioral Science in Seoul in the 1970s, fifty percent of all pregnant Korean women said in a survey that if they could not bear a male child, they would even try to have a son through

another woman.[56] There are at least two psychological reasons for this:

1. A mother may not want to keep having daughters who will be burdened by the heritage of suffering and insult.
2. A mother may actually be convinced that she deserves humane treatment only when and if she bears a son.[57]

In a 1973 study, the boy-preference attitudes of 1,845 fecund Korean women were investigated. Nearly ninety percent of them intended to keep having babies until they had one or two boys. And fifty-three percent of the sample reported that they would keep having babies until they got at least one boy, no matter how many daughters they might first have to "tolerate" having.[58]

Boy-preference in this study was not completely uniform among all members of the group studied. The results of the study may give some hint as to the direction of these attitudes in the future. There was a significantly greater degree of boy-preference among those women whose current residential area and place of upbringing were rural, who were older, and whose socio-economic status and educational levels were low.[59] Perhaps the less rural Korean society becomes, the less tendency there will be for the boy-preference attitude to prevail.

The outdated preference for male children is, however, still reflected in many customs and traditions that have come from earlier times. One example

relates to the custom that the parents are supported in their old age by the oldest son or one of the other sons, but not by a daughter. Another such custom is that after marriage a daughter is no longer part of the family in which she was born. These old ways are no longer appropriate. Today it should be possible for any one of the children to support the parents, according to whose circumstances are most favorable. Certainly it should no longer be thought a sad and shameful thing to be supported by one's daughter or son-in-law.

Other sexist attitudes which need changing are the stereotyped and traditional concepts relating to women in society. Official prizes are awarded annually by both the government and civic organizations to women who are selected for being models of the "wise mother" and "good wife." The ideal of the "wise mother" and the "good wife," however, was criticized even in the 1920s by some women in Korea as anachronistic, and was defined as a picture of the slavery into which the three traditional virtues of women -- obedient wife, self-sacrificing mother, and submissive female -- have been incarnated.[60]

Until the 19th Century, the major obstacles to the participation of women in Korean society were the traditional customs and Confucian ethics that affected all fields of social life.[61] The Korean woman today feels much less confined than previously by Confucian demands. This is evident in talking to young working women and it is also confirmed by statistics. But traditional standards and biases remain as obstacles in

the course of national development and, for some women, as precipitants of serious mental conflict.[62] Even today with a sharply reduced family size, Korea continues to have a high boy-preference attitude.[63]

Notes

1. If a girl child is a first born, she is tolerated because the baby's birth has at least demonstrated the mother's ability to bear children. If her birth has followed a succession of only daughters, the baby's arrival could be met with open hostility and/or outright neglect. Minimally, it would have embarrassed mother. Young-Sook Kim Harvey, *Six Korean Women* (New York: West Publishing Company, 1979), pp. 260-61. In the early 1900s, a Christian missionary speculated that the rejection of female children was a natural consequence of the system of ancestor worship. Since a girl child would be unable to play any part in the family's sacrificial rituals, and would also not be able to carry down the family line, there was a natural tendency to regard any girl child as an unsatisfactory potential family member. James S. Gale, *Korea in Transition* (New York: Education Department, Board of Foreign Missions of the Presbyterian Church in the U.S.A., 1909), p. 77.

2. During the Yi Dynasty, when a royal child was to be born, the minister who had the most number of sons would be asked to pray to the stars for a male child. Another ritual to make birth of a male child more likely was to put the skin of a rat which had had a large male litter under the mattress of the queen or princess so that she might bear a son. Jae-Ho Cha, Bom-Mo Chung and Sung-Jin Lee, "Boy Preference Reflected in Korean Folklore," *Virtues in Conflict*, ed. Sandra Mattielli

(Seoul: The Samhwa Publishing Co., Ltd., 1977), p. 123.

3. Soon Man Rhim, "Status of Women in Traditional Korean Society," *Korean Women*, Sunoo and Kim, eds. (New Jersey: The Korean Christian Scholars Publication No. 3, Spring 1978), p. 23.

4. Cha, Chung and Lee, *Virtues in Conflict*, p. 123.

5. Ibid.

6. Even today, if the wife cannot give birth to male heirs, the husband can still take a concubine without public censure. Moon-Jee Yoo Madrigal, *The Role of Women in Korean Society with Emphasis on the Economic System* (Palo Alto, California: R & E Research Associates, Inc., 1979), p. 14.

7. *The Washington Post*, March 3, 1989; *Dong A-Ilbo* Washington, D.C. edition, March 3, 1989.

8. Rhim, *Korean Women*, Sunoo and Kim, eds., pp. 14-15.

9. The burden of having a female child was most felt at the time she married. A bride was expected to come to her husband with household supplies and a wardrobe. This custom often put a poor family into debt. When a family was very poor, the young girls often had to remain single, and sometimes were sent away to become nuns. Yung-Chung Kim, ed. and trans., *Women of Korea: A History from Ancient Times to 1945* (Seoul: Ewha Womans University Press), p. 52.

10. Cha, Chung and Lee, *Virtues in Conflict*, p. 113.

11. Harvey, *Six Korean Women*, p. 263.

12. Ibid., p. 265.

13. Ibid., p. 263.

14. Harvey, *Six Korean Women*, p. 265. A similar listing of women's duties is given by John W. Stanley, *The Foreign Businessman in Korea* (Seoul: Kyumoon Publishing Company, 1972), pp. 76-80:

 1. Women should not speak unless spoken to, nor rebut a man.

 2. They should not turn their backs on men, but gracefully bow their way out of a room.

 3. It is impolite to show their teeth to anyone and they should cover their mouths with a hand when the mouth is open. They must stand when a man enters a room.

 4. A woman is not supposed to smile on her wedding day (This is thought to cause her first born to be a girl.)

 5. A wife should not show emotion or affection for her husband in public.

 6. Young women have no rights over men and are taught from an early age to be obedient to, and to be segregated from, the men of the household. Women eat, sleep and entertain independently from the men and should always be in attendance for their needs.

 7. A woman's importance is greatly increased when she bears sons, and when her eldest son marries her role as the submissive wife changes as she now has her own servant, the son's wife.

15. Rhim, *Korean Women*, Sunoo and Kim, eds., p. 21.

16. Martina Deuchler, "The Tradition: Women in the Yi
 Dynasty," *Virtues in Conflict*, Sandra Mattielli, ed.
 (Seoul: The Samhwa Publishing Company, Ltd., 1977),
 p. 6.

17. Paul S. Crane, *Korean Patterns* (Seoul: Kukje
 Publishing Company, Ltd., 1974), p. 36.

18. Soon-Young S. Yoon, "The Role of Korean Women in
 National Development," *Virtues in Conflict*, Sandra
 Mattielli, ed. (Seoul: The Samhwa Publishing Company,
 Ltd., 1977), p. 162.

19. Kim, *Women of Korea*, p. 91.

20. Mace and Mace tell of a boy and girl were members of a
 Christian church in Korea and fell in love. When their
 relationship was discovered they were not allowed to
 attend church anymore. What was wrong in this case
 was that the two young people were in love and wanted
 to get married. The pastor refused to give them a
 Christian wedding. This can only be comprehensible
 when one is aware that a romance between a boy and
 girl in some Korean communities is regarded as most
 disgraceful and sinful. Any type of love that would lead
 to marriage is supposed to be unfilial to the parents.
 David and Vera Mace, *Marriage: East and West*
 (Garden City, N.Y.: Doubleday & Company, Inc.
 1960), p. 121.

21. Harvey, *Six Korean Women*, p. 258.

22. Osgood points out that Koreans have naively carried
 their conception of Confucian ideals (on sex segregation)
 to a heroic level which would surprise the Chinese and
 astound Confucius himself. Cornelius Osgood, *The*

Koreans and Their Culture (New York: The Ronald Press Company, 1951), p. 330.

23. Because of the strict sex segregation, husband and wife had little opportunity to meet during the day, and the presence of elders made it impossible to much talk. With a permission of the father-in-law, the young couple spent about two nights a month. Sandra Mattielli, ed., *Virtues in Conflict* (Seoul: The Samhwa Publishing Company, Ltd., 1977), p. 25.

24. Crane, *Korean Patterns*, p. 34.

25. Ibid., p. 29.

26. Gale, *Korea in Transition*, p. 105.

27. Harvey, *Six Korean Women*, p. 257.

28. Madrigal, *Role of Women in Korean Society*, p. 23.

29. Kim, *Women of Korea*, p. 89.

30. Hyo-Chai Lee, "Changing Korean Family and the Old," *Korea Journal*, 13 (June 1973): p. 22.

31. Rhim, "The Status of Women in Traditional Korean Society," Sunoo and Kim, eds., *Korean Women*, p. 23.

32. James S. Gale, *Korea in Transition*, p. 104.

33. Crane, *Korean Patterns*, p. 33.

34. Osgood, *Koreans and Their Culture*, p. 147.

35. The worst sin was to die without male heirs to continue the family lineage. This is enough reason by the husband, and sometimes with agreement of the wife, to take a concubine. Madrigal, *Role of Women in Korean Society*, p. 14.

36. Osgood, *Koreans and Their Culture*, p. 242.

37. Rhim, "The Status of Women in Traditional Korean Society," Sunoo and Kim, eds., *Korean Women*, p. 21.

38. After marriage, the woman was entered into her lineage's genealogy with her husband's name. In her husband's lineage she was recorded as "spouse" (*pae*) and identified with her father's surname and her natal lineage. Deuchler, "The Tradition: Women During the Yi Dynasty," Mattielli, ed., *Virtues in Conflict*, p. 26.

39. Ibid.

40. Rhim, "The Status of Women in Traditional Korean Society," Sunoo and Kim, eds., *Korean Women*, p. 20.

41. Helen Kim, the former president of Ewha Women's University in Seoul, reveals that her family was better than others simply because they, at least bothered to give daughters' names, unlike many of the Korean families in her days. Helen Kim, *Grace Sufficient* (Nashville, Tennessee: The Upper Room Press, 1964), p. 3.

42. Deuchler, "The Tradition: Women During the Yi Dynasty," Matielli, ed., *Virtues in Conflict*, p. 26.

43. Rhim, "The Status of Women in Traditional Korean Society," Sunoo and Kim, eds., *Korean Women*, p. 21.

44. Cha, Chung, and Lee, "Boy Preference Reflected in Korean Folklore," Matielli, ed., *Virtues in Conflict*, p. 124.

45. Crane, *Korean Patterns*, p. 29.

46. Hyn-Tay Kim, *Folklore and Customs of Korea* (Seoul: Korea Information Service, Inc., 1957), p. 90.

47. Osgood, *Koreans and Their Culture*, p. 146.

48. Crane, *Korean Patterns*, p. 29.

49. Kim, *Women of Korea*, p. 56.

50. Lower class women had little control over treatment by their husbands' families. Their marriages were less secure than those of upper class women; they were more often sent back to their families for being unsatisfactory wives. Vreeland et al., *Area Handbook for South Korea*, 2nd. ed. (Washington, D.C.: U.S. Government Printing Office, 1975), p. 81.

51. Mattielli, ed., *Virtues in Conflict*, p. 29.

52. Lee, *Korea Journal*, pp. 22-23.

53. *Dong A-Ilbo,* Washington, D.C. edition, May 24, 1989.

54. *Dong A-Ilbo,* Washington, D.C. edition, August, 5 1989.

55. Cha, Chung, and Lee, "Boy Preference Reflected in Korean Folklore," Mattielli, *Virtues in Conflict*, p. 113.

56. Stanley, *The Foreign Businessmen in Korea*, p.79.

57. Dug-Soo Son, "The Status of Korean Women from the Perspective of the Women's Emancipation Movement," *Korean Women*, Sunoo and Kim, eds. (New Jersey: The Korean Christian Scholars Publication No. 3, Spring 1978), pp. 276-77.

58. Lee and Lee, "Boy Preference and Family Planning," *Psychological Studies in Population/Family Planning* (Seoul: Korean Institute for Research in the Behavioral Sciences, 1973), Vol. 1, p. 8.

59. Ibid., pp. 9-10.

60. Son, "The Status of Korean Women from the Perspective of the Women's Emancipation Movement," *Korean Women*, Sunoo and Kim, eds., p. 277.

61. *Women and Saemaul Undong* (Seoul: Ministry of Health and Social Affairs, Republic of Korea, 1980), pp. 9-10.

62. Mattielli, *Virtues in Conflict*, p. x.

63. "Bad Year for Girls," *Newsweek*, 16 April, 1990, p. 81.

CHAPTER 4

Women and the Law

The importance of law to the social and economic status of women in Korea has been well stated by a distinguished lawyer, scholar and respected advisor to the Korean government:

> **Without an understanding of the functioning of law in any society, an analysis of the history, traditions, and present conditions of that society cannot be undertaken with any significant degree of accuracy, analytical acumen, or competence.**[1]

In particular, Korean family law cannot be properly understood without reference to *yangban*-inspired legislation enacted at the beginning of the Yi Dynasty to take from women the relative equality they had enjoyed under the preceding Koryo Dynasty. Since the Yi Dynasty, however, women have been treated in family law as second-class persons -- always

under the control of one or more men. The attempt to control women during the Yi Dynasty was furthered by setting up special rules of behavior for women in certain situations. During this period, women's acts concerning legal matters were strictly controlled by requiring the consent of the husband, whether for the wife's protection or not. For her part, the wife was regarded as an incompetent who was unable to engage in legal acts.[2] From the first years of the Yi Dynasty, the Censorate also demanded legal provisions which would restrict women in their daily activities.[3]

During the Koryo Dynasty, polygamy had been the prevailing mode of married life, and all wives and their children stood on an equal footing.[4] During the Yi dynasty, however, the Confucianists frowned on unrestricted sexual relationships. The new rules which they promulgated worked more against the female sex than against the male.[5] Until fairly recent times, for example, Korean family law has permitted men to take concubines in addition to their legal wives. Concubinage, therefore, became institutionally rationalized in the Yi dynasty as a new social norm replacing polygamy.

Korean society did not condemn those *yangban* males who had sexual relationships with concubines. Instead it excluded the illegitimate offspring from those privileges and immunities pertaining to *yangban* males.[6] Under the approach taken, therefore, *yangban* males maintained the purity of their line at the expense of females, and even at the expense of their own offspring, for the illegitimate children of the concubine had to face many societal discriminations.[7]

Concubines were often treated by the society with contempt and humiliation. Regardless of age, they were completely subordinated to members of the husband's family.[8] Strong ideological and legal considerations barred a concubine from ever advancing to the position of primary wife.[9] Under the law, the life of a concubine was worth much less than the life of the wife. For example, if a man killed his wife, the penalty was death by hanging. But if he killed his concubine, the penalty was flagellation and exile.[10]

The children of *yangbans* by concubines were effectively barred from attaining *yangban* status through the civil service, since they were not allowed to take the examinations. The qualifications of candidates for the *kwako* (civil service examination) were scrutinized closely. Passing the *Kwako* was necessary to become a *yangban*. Applicants needed to specify the names of their ancestors, both maternal and paternal for eight generations back.[11] Any falsification, if discovered, was severely punished.

Even after concubinage was banned in 1922, there were lingering problems caused by past relationships. Also, since concubinage had dominated the family life of the Korean people for so long, the law abolishing it was not always enforced. It was, therefore, to some degree ineffective. Thus in 1928 a decision rendered by the Chosun Higher Court took the "lenient" view that the single fact of concubinage did not constitute a serious affront to the objecting wife.[12] By 1951, however, the Seoul District Court finally declared concubinage to be a serious affront to the wife that justified legal action for divorce.[13]

The stigma against children of concubines is still prevalent in Korean society. Sung-Jin, now age 35, remembers:

> **When I got married to a woman from a fine family in Seoul, everything appeared to be going well until one day my wife left me. My wife had gone to one of the best schools for girls in Korea. Her family liked me, and they also appreciated the fact that I had come from a good family. All of this turned out to be irrelevant. After a member of my wife's family poked around my background and found out that I was not a son of the legitimate wife, my wife just took off. The fact that my father was from the *yangban* class and had wealth didn't matter. My mother was a concubine, and nothing will ever change that. I have to live with that stigma in this society. I would rather be a leper than a son of a concubine.**

The concubinage system is an example of how all of Korean society is affected adversely by giving men the unrestrained license to do as they please sexually, while hypocritically expecting a higher degree of sexual morality from the women. The existence of concubinage has led to marital discord and unhappiness not only for legal wives and their children, but also for the concubines and their children. The benefits of the concubinage system, if any, appear to have accrued only to the men, who were allowed freedom at the expense of others.

In the 1900s, during the first decade of the Japanese rule, legal provisions regarding the status of

women were only slightly improved.[14] In 1922, during the Japanese occupation, concubinage was formally abolished by written law.[15] This was perhaps the chief reform of the family laws during the Japanese occupation that may be said to have benefitted women generally. Of course, banning of legal concubinage did not benefit existing concubines, but it avoided the creation of others in the future. This was a benefit to women generally because the practice of concubinage had encouraged men to degrade both their wives and their concubines. The practice also imposed a great deal of pain on the innocent children from of such alliances.

During the period of Japanese influence, Korean social norms, including those connected with the status of women, showed little propensity for change.[16] Discrimination against women in Korean law was probably no worse than in Japan. In neither society was there much societal pressure to improve the status of women. Even after the defeat and ouster of the Japanese in 1945, the government in Korea was still run by men, and there was, accordingly, little interest in expanding the legal rights of women.

In 1948, when Korea adopted its first written constitution, a provision was included to guarantee equality under the law between men and women. For some years, this constitutional provision was a dead issue. A great deal of discriminatory legislation remained on the books, and only in the 1970s and 1980s, when women began to have a certain amount of political influence, were there any serious revisions made to family law.

Although a detailed analysis of Korean family law is beyond the scope of this book, an analysis of the main areas shows extensive discrimination against Korean women. In many areas, however, much of the discrimination is in the process of being removed.

Following is a list of some areas of family identified as being discriminatory against women:

a. **Initial choice of mate.**
b. **Family headship system.**
c. **Marital duties of wife during marriage.**
d. **Divorce rules for wives.**
e. **Parental authority during and after marriage.**
f. **Wife's property rights during and after marriage.**
g. **Inheritance system at death of husband and wife.**

Initial Choice of Mate

Traditionally in Korea, marriage has been a family affair. The family arranged the marriage through a matchmaker. The prospective groom and bride had no role in the arrangement. Typically they never saw each other until the wedding night. Unlike an American woman, a Korean woman had no will of her own. When she was a little girl, her life was in the hands of her father. When she married, her life belonged to her husband. When he died her son became her master.[17] As one Korean woman politician educator told her mother, "The only one who can profit from this marriage is the family.[18]

In arranging marriages, the family backgrounds of both groom and bride were most thoroughly checked. In the case of *yangban* family, one of the most important factors was to make sure that the records for both families showed no defects for over four generations. No relative on either side during that period could have been the child of a concubine.[19] Even today, Korean people consider arranged marriages very desirable. A great deal of care continues to be given today to family background, even when a marriage involves a love relationship.

Underage marriages. In the current law, when males are below eighteen and females are below sixteen, they require the consent of both sets of parents in order to get married.[20] The parents may petition the court to annul a marriage by underage children,[21] as long as either of the children is still less than three months over his or her majority, or unless the girl has become pregnant.[22]

Technical widow marriages. In connection with the traditional treatment of widows in Korea, the so-called "technical widow" should be mentioned. This used to happen occasionally as result of the custom of pre-birth betrothal. As one book on marriage customs in Korea states, it was even possible in early Korea to be born a widow! As in China, a pregnant mother might betroth her still unborn child to a desirable male, subject to the condition that the child would be a girl. If the prospective groom died before the child was born, however, the baby girl would technically become a widow at birth. If she married

later in life, her status under the law would be that of a remarried widow and not that of a maiden.[23]

Same-family-stock marriages. Some of the current family laws can be traced back to social conditions under the Yi Dynasty. These laws sometimes still operate in Korea to prolong practices which discriminate against women.[24] For example, a prohibition continues in Korean family law against marriages between certain persons with the same family name and same family place of origin.[25] The rule extends even to relatives by affinity within the eighth degree of relationship. By focussing on the family surname this law necessarily applies only to relationships within the male line. A *Newsweek* article has recently labeled the law "anachronistic" and it has stirred up a storm among conservative Confucians.

According to the *Korea Herald*, most people, especially women, regard it as irrational to forbid marriage between adults simply because they share a surname and have a common ancestor, generations removed. Based on the spirit of equality between men and women before the law, feminists have worked hard for repeal of this provision. Confucianists responded, "As long as men are not beasts, we cannot accept marriages between youngsters who have the same grandfathers." An increasing number of Koreans, however, agree that the marriage ban is illogical and that the law needs to be modified.[26]

A recently introduced bill demanded that the law be amended to prohibit only those marriages closer than fifth cousin.[27] Finally, a compromise bill

passed in mid-December, 1987, but it excluded couples even as distantly related as third cousins from the benefits. Under this compromise, qualifying couples were able to report to the authorities by the end of 1988 to make existing marriages with common surnames and places of origin legal. The law also cleared the way for children of such couples to have their names listed on their family registers.[28]

Marriages to concubines (old practice). Before concubinage was outlawed, when a *yangban* took a concubine, he would usually go through a modified form of marriage ceremony. A few rituals would be omitted from the standard ceremony, or a modification would be made in the costume of the bridegroom. The concubine or concubines would usually be given a separate house to live in. None of this made a concubine equivalent to the legal wife, however, and she had literally no rights at all under the law.[29]

Family Headship

The family headship system was firmly grounded in the traditional notion of male superiority within the patrilineal system. Until 1989, there were few actual situations in which a female was allowed to serve as a family head. The family head was usually entitled to make all important decisions for the family. The patrilineal system has always placed a high emphasis on succession to the family headship by the paternal male descendants.[30] The eldest son was first in line to succeed his father.

If the eldest son died, the next in line to succeed as family head would be the son's eldest son, irrespective of the son's age. This provision caused a lot of resentment, since it would often operate to prefer a baby son of the eldest son over the second eldest brother.

Under the old customary law, when the head of a family died without leaving any sons or sons' male issue, the daughter usually was not allowed to succeed to the family headship. Instead, the ordinary practice in this situation was for the family to adopt another son, who would precede the daughter.[31] The law permitted adoption of a male from another branch of the same family, even one who was quite remotely related. Sons of concubines, however, even if adopted into the family, were discriminated against under the family headship rules. They could not succeed to the family headship.

The power of being family head was greater in the past than it is at present. The family head was given the power to make many important decisions for the family as a whole. Other members of the family were required to consult with him on many matters and pay him due deference. In modern times, the family headship power has been eroded by other members of the family setting up their own branch families.

In 1989, the family headship rules were amended to remove some of the defects. For example, the eldest son of a deceased family head is no longer required to serve as successor family head. He is permitted to waive his right to serve. He can

still elect to serve, however, if he wishes. Adoption of a remote male relative has now been outlawed as a method to continue the office of family headship for a male. Finally, the often-infant eldest son of a deceased eldest son no longer has priority to serve as family head over his older living uncles. It should be noted, however, that although the way is now cleared for daughters to serve as successor family heads, this will only happen with the consent of their living brothers, who still have preference over her if they choose to exercise it.

Marital Duties of Wife

Under the current family law wives are expected to cohabit with their husbands. When husband and wife do not live together temporarily for some reason, both parties must tolerate it.[32]Until recently the law has provided that the cohabitation should normally take place at the husband's place of abode. In 1989, this was modified to provide that the place of cohabitation should be decided by mutual agreement, or at a place decided by the family court in case of disagreement.[33]

Divorce and Remarriage

The traditional idea of the superiority of men over women completely deprived a woman of any right to divorce her husband. Divorce was granted only to men; more accurately, it was usually left to

the discretion of a man's parents. The term for
divorce is *ki-cho,* meaning abandoned wife.[34] In
case of divorce, the children were sent to the father,
regardless of supporting capability.[35]

Until very recently, a wife could not under any
circumstances initiate divorce, but could be divorced
by the husband on any one of the following grounds:

1. **Being rebellious towards her parents-
 in-law**
2. **Failing to produce a son**
3. **Being unfaithful to her husband**
4. **Showing jealousy**
5. **Having an incurable disease**
6. **Being given to tale-bearing and
 pernicious talk**
7. **Being found to be a thief.[36]**

Besides the "Seven Deadly Sins," traditional
family law stipulated another ground for divorce:
When any of the wife's relatives, particularly the head
of the family from which she came, was condemned
for treason, the husband could legally demand a
divorce on the grounds that he might be tainted by the
unfortunate association.[37]

However, a wife would be protected from
divorce under three limited circumstances:

1. **If she had shared with her husband a
 three-year mourning period for one
 of his parents**
2. **If the husband had become rich or
 had attained a high position since the
 marriage**

3. If the wife had no home to which she could return

The above three restraints, however, would be invalidated if the wife had committed adultery or had an incurable disease.[38]

In the past, laws on adultery, divorce, and abandonment were highly discriminatory against women. If a wife left her husband even with just cause, the legal penalty was death by hanging.[39] Korean society appears to have been more lenient towards an adulteress, however, than traditional Chinese society where the adulteress was expected to take her own life. In Korea, a wife who committed adultery was not put to death but she lost her status as a wife and became a slave.[40] She was never allowed to remarry.[41] Adultery by the husband was overlooked, however, unless he had committed the act with a married woman.[42]

During the period of the Japanese occupation, as in the Yi period, the husband with his parents' consent could obtain a divorce. The wife could never do so, even in the case of the husband's flagrant misconduct.[43] Current family law, however, adopts the mutuality of causes for divorce, with the supreme goal being the attainment of harmonious wedlock.[44]

Divorce provisions did not apply to concubines, who, because of their lower class, were discarded at the man's discretion.[45] A concubine had no parental authority over her children. Such authority was vested in her husband as long as he was alive.[46] If the husband desired, he could recognize

his children by his concubine as his own, even against the wishes of his legal wife. Or he could simply abandon them in the same manner as he could abandon their mother.

The problems associated with divorce are similar to those for remarriage. From early times in Korea, remarriage for women was often looked upon as being almost adulterous. Even though the revised edition of the *Kyongguk Taejong* of 1485 did not ban remarriage, the law stipulated that the sons and grandsons of both adulteresses and remarried women would not be eligible for civil or military office. Together with the descendants of secondary marriages, they were not allowed to compete in the lower or higher civil service examinations.[47]

In Korean society, remarriage for women was stigmatized in all circumstances, even following divorce from one's husband or after his death. Widowers might remarry at any time but widows were not free to do so.[48] The commoner's widow might sometimes remarry, often out of economic necessity,[49] but the widow of a respected *yangban* could seldom, if ever, remarry. Current law still forbids widows to remarry for six months after the death of their husbands, although there is no waiting period for widowers.[50]

Parental Authority

The rules on parental authority were intertwined with the rules on family headship. Until 1989, parental authority was given by law to the

family head, but the mother could exercise this primacy only after her husband had died. In the latter case, the mother retained parental authority only so long as she was a member of the family. Once remarried, she lost the authority.[51] Likewise, if she returned to her natal family after her husband's death, she lost the right to parental authority.[52] If before her husband's death she was divorced, she also lost any future claim to parental authority.[53] If the husband remarried, his wife was given the right to exercise parental authority over her stepchildren.[54]

Since 1989, the law has not favored the father over the mother. Parental authority is now to be exercised jointly by the mother and father. If there are disagreements, the family court will resolve the differences at the request of the person concerned. Likewise, in the event the father and mother are divorced, or if they cannot reach an agreement about parental authority through consultation with each other, the family court will make the decision.[55]

Wife's Property Rights

Originally, the husband took complete control of his wife's property when he married her. Changes to the law in 1989 have considerably enlarged the property rights of women. A kind of community property rule for property acquired during the continuance of the marriage has been established. The property settlement has often been the single most important issue in divorce. Previously the property issue was grossly unfair to women because property

obtained during marriage was usually deemed to belong individually to the husband. The law did not acknowledge the right of the wife to a portion of the property accumulated during marriage through the common efforts of the husband and the wife. Consequently the wife, who was socially and economically the weaker party, was forced to relinquish almost everything at the time of divorce. The law now recognizes, however, that the property acquired during the marriage is presumed to be held in joint ownership, unless it is traceable to invested income earned from separate assets of the spouses.[56]

Inheritance

During the Koryo Dynasty, male and female offspring were both entitled to inherit the father's property. This practice continued during the first part of the Yi Dynasty.[57] In this regard, the inheritance law of the time was a step ahead of the law in China and Japan which discriminated against women.[58]

Unfortunately during the latter part of the Yi Dynasty inheritance laws pertaining to women discriminated against them. There was never true primogeniture in Korea,[59] but in *yangban* families the custom developed to give the eldest son the headship of a household. He also was given a larger share of the inheritance and the duty to perform rituals of ancestor worship.[60] In 1700, the overall law was changed to conform to the *yangban* practice by which sons, particularly the eldest, were given a favored position in inheritance.[61]

Until recently, family law continued to follow the *yangban* tradition and defined all inheritances in terms of a "son's share." Sons other than the eldest son would each take a single son's share. The eldest son would receive fifty percent of a son's share in addition to his normal share. But the wife and unmarried daughter each received only fifty percent of a son's share. If a daughter married, her share was reduced to twenty-five percent of a son's share.[62] Thus the inheritance law in Korea until quite recently, was actually discriminatory against wives and daughters to a degree unprecedented in earlier times.[63]

The wife was particularly discriminated against under the inheritance law at the death of her husband. She was forced to share his property with both his ascendants (his parents) and his descendants (his and her children, grandchildren, etc.).[64] However, in the event that the wife preceded him in death the husband was not required to share her property with her parents but only with their children.[65]

After 1948 the inheritance law was very much in violation of the sex equality clause in the new constitution, since it provided that surviving wives received less than surviving husbands, and that daughters, both single and married, took less than sons. In 1989, however, the law was amended to speak in terms of a "child's share" rather than a "son's share." Equal shares now go to sons and daughters. The share of the surviving spouse of either sex has been increased to 150 percent of a child's share. Furthermore under the current law if there are no

children, the parents of the decedent spouse will take a child's share no matter which spouse dies first.

Of course, children of concubines are barred under the law at this time from inheriting any property of the father. In 1989 the father lost the power of forcing the wife to recognize his illegitimate children for purposes of inheritance.

Conclusion

There is still a long way to go until the attainment of full-fledged equality for women under the law. The patriarchal family system, handed down from the old feudalistic society, remains unchanged in some important respects. As a result, the current law still includes many irrational provisions which run counter to the principles of the Constitution.[66] A revision is still needed for all articles in the Civil Code which discriminate against women.

Notes

1. Pyong-Choon Hahm, *The Korean Political Tradition and Law*, 2d ed. (Seoul: Royal Asiatic Society, 1979), p. iii.

2. Sex segregation was rigid during the Yi Dynasty. A Married woman had few legal rights. She was dominated by her son and his ascendants. The inferior status of women was particularly visible among the *yangban* class. Ibid., p. 91.

3. Martina Deuchler, "The Tradition: Women During the Yi Dynasty," *Virtues in Conflict*, ed. Sandra Mattielli (Seoul: The Samhwa Publishing Co., Ltd., 1977), p. 22.

4. Beginning of Yi Dynasty, a drastic change in marital customs of the nation had come about. Hahm, *Korean Political Tradition and Law*, p. 112.

5. Ibid., p. 117.

6. Unlike the Hindus, the Korean privileged *yangban* did not condemn their men to have sex with inferior class women. They, on the other hand, try to maintain the purity of the *yangban* class by excluding the offspring of mixed marriages from its ranks. Ibid., p. 111.

7. Ibid., pp. 110-11.

8. Nena Vreeland et al., *Area Handbook for South Korea*, 2d ed. (Washington, D.C.: U.S. Government Printing Office, 1975), p. 85.

9. Deuchler, "The Tradition: Women During the Yi Dynasty," *Virtues in Conflict*, p. 32.

10. Hahm, *Korean Political Tradition and Law*, pp. 112-13.

11. Ibid., p. 111.

12. Tai-Young Lee, *Legal System of Korea*, ed. Shin-Yong Chun (Seoul: International Cultural Foundation, 1975), p. 91.

13. Ibid., p. 96.

14. Yung-Chung Kim, *Women of Korea - A History from Ancient Times to 1945* (Seoul: Ewha Women's University Press, 1979), p. 267.

15. Lee, *Legal System of Korea*, p. 91.

16. Under the Japanese occupation, Korean women's social and legal position improved very little. She depended on her husband's permission and discretion on all her public activities, particularly in dealing with financial matters. Deuchler, *Virtues in Conflict*, p. 42.

17. Louise Yim, *My Forty Year Fight for Korea* (Seoul: Chungang University Press, 1964), p. 42.

18. In her autobiography, Yim Young-Shin recounted the battle she had within her own family over the subject of arranged marriages. Yim had opposed the attempted social climbing of her parents when they tried to arrange a marriage between her sister and son of a prominent non-Christian family. When Yim was told by her mother not to interfere, Yim pointed out that it was not the mother's business either to choose a spouse for her daughter, but a choice for the daughter herself to make. Ibid., p. 45.

19. In order to be qualified to take the *kwako*, four generations of an applicant's ancestors on his paternal and maternal sides had to be specified. Only a descendant of a *yangban* could take the examination, that is, only a son of a *yangban* could himself become a *yangban*. Hahm, *Korean Political Tradition and Law*, p. 111.

20. Laws of the Republic of Korea, Civil Code, Article 808.

21. Civil Code, Article 817.

22. Civil Code, Article 819.

23. David Mace and Vera Mace, *Marriage: East and West* (Garden City, N.Y.: Doubleday & Company, Inc., 1960), p. 228.

24. *Women and Population* (Seoul: Korean National Council of Women, circa 1975), p. 11.

25. Civil Code, Article 809.

26. *Korea Herald*, Seoul edition, circa 2 December 1986.

27. *Korea Herald*, Seoul edition, circa 20 November 1986.

28. *Korea Herald*, Seoul edition, circa 1 November 1987.

29. Hahm, *Korean Political Tradition and Law*, p. 112.

30. Lee, *Legal System of Korea*, pp. 96-97.

31. Ibid., pp. 93-94.

32. Civil Code, Article 826.

33. Civil Code, Article 826.

34. Byong-Soo Lee, *Ch'osenno kongingho [The Marriage and Divorce Laws of Korea]*, p. 50, cited by Soon-Man Rhim, "The Status of Women in Traditional Korean Society," *Korean Women In A Struggle For Humanization*, ed. Harold Hakwon Sunoo and Dong-Soo Kim (Montclair, N.J.: Korean Christian Scholars Publication, No. 3, Spring, 1978), pp. 18-19.

35. *Women and Population*, p. 18.

36. Lee, *Legal System of Korea*, p. 88.

37. Ibid.

38. Byong-Soo Lee, *Ch'osenno kongingho [The Marriage and Divorce Laws of Korea]*, p. 51.

39. Mace and Mace, *Marriage : East and West*, p. 225.

40. Ibid., p. 214.

41. Lee, *Ch'osenno Kongingho (Marriage and Divorce Laws of Korea)*, p. 49.

42. Lee, *Legal System of Korea*, p. 92. Also see generally, Deuchler, "Women During the Yi Dynasty," p. 44.

43. Kim, *Women of Korea*, pp. 267-68.

44. Lee, *Legal System of Korea*, p. 98.

45. Ibid., p. 89.

46. A secondary wife (concubine) was not fully acknowledged as a member of her husband's family. She was to maintain the relationship with her husband's family only during his lifetime. She was not supposed to form a social unit that had to be perpetuated into her husband's family. Deuchler, Virtues in Conflict, p. 33.

47. Ibid., p. 39.

48. Dong-Wook Lee, "Korean Women's Education: Yesterday and Today" (Ed.D. Dissertation, University of Tulsa, 1974), p. 51.

49. Cornelius Osgood, *The Koreans and Their Culture* (New York: The Ronald Press Company, 1951), p. 148.

50. Civil Code, Article 811.

51. Lee, *Legal System of Korea*, p. 94.

52. Ibid., p. 106.

53. Ibid.

54. Civil Code, Article 912.

55. Civil Code, Article 909.

56. Civil Code, Article 830.

57. During the Koryo Dynasty, a daughter inherited the same share of her parents' property as her brothers' portion. Deuchler, *Virtues in Conflict*, p. 28.

58. Lee, *Legal System of Korea*, pp. 89-90; Rhim, *Korean Women in a Struggle for Humanization*, p. 20.

59. Hahm, *Korean Political Tradition and Law*, p. 88.

60. Kim, *Women of Korea*, pp. 101-02.

61. Deuchler, "Women During the Yi Dynasty," p. 28; Lee, *Legal System of Korea*, p. 86.

62. Dug-Soo Son, "The Status of Korean Women from the Perspective of the Women's Emancipation Movement," *Korean Women In A Struggle For Humanization*, ed. Harold Hakwon Sunoo and Dong-Soo Kim (Montclair, N.J.: The Korean Christian Scholars Publication, No. 3, Spring, 1978), p. 278; *Women and Population*, p. 19; Civil Code, Article 1009.

63. Women and Population, p. 20.

64. Civil Code, Article 1003; Lee, *Legal System of Korea*, p. 100.

65. Civil Code, Article 1002.

66. Lee, *Legal System of Korea*, p. 96.

CHAPTER 5

Women in Education

It is ironic that education in Korea has for centuries been recognized as a top priority, but because of Confucian bias against women, was only available to men. Korean women, particularly those from the upper classes, received no education at all beyond learning how to accomplish and direct the doing of household chores in their own homes.

Education for women was at first regarded as an outrageous and strange idea and was not seriously considered by most Koreans.[1] Indeed, education for a daughter was a certain liability to the family. The more educated a daughter was the less desirable marriage material she would be. A respected family did not want to have a daughter-in-law who had been seen in a public place like a school. Rather they preferred a lady who stayed quietly at home learning embroidery and other necessities of homemaking.

With such a background, women in Korea have not only generally been denied the benefits of formal education, but also have been discouraged from

developing any natural abilities or talents. "A woman's lack of talent is in itself a virtue," was a proverb frequently used to discourage any worldly ambitions of a woman. The result was a general lack of professional skills among women, and an incomparably higher percentage of illiteracy among females than among males.[2]

Before American missionaries came to Korea, it was believed that arts and letters should be taught only to boys. For girls, household skills were considered sufficient.[3] If a girl wanted to be educated beyond this, she had to put in extra effort, and might even face opposition from her parents. As revealed by Dr. Helen Kim, the late president of Ewha Women's University:

> ...(M)other's father was so violently against her learning to read that she had to hide her text in his presence. She could study only after he had gone away. Many times she was found studying and was punished by him severely, but she never gave up.[4]

Centuries of Confucian tradition made this bias against education for women seem natural. Remnants of these attitudes have persisted throughout Korean society down to the present day, even among educators.

Historical Background

The beginning of women's education in Korea was the result of the interrelated efforts of progressive

Korean leaders and American Christian missionaries.[5] In 1883, the Korean government appointed Min Yong-Ik as its minister and sent him to the United States where he met with John F. Goucher, the dean of Goucher Women's College in Baltimore, Maryland. Through Goucher's efforts in 1884, a Methodist missionary from Japan, Robert S. Maclay, came to Seoul to initiate work related to education and medical service. This opened Korea to a new kind of education which paved the way for the liberation of women.

The road to success in women's education, however, was not to be an easy one. In the wave of conflicts within the Korean community over women's education, the American missionaries proceeded cautiously. Many conservative Koreans were suspicious of the motives of the missionaries, fearing that they were trying to undermine Korean values. If the intention was not to make Koreans throw away whatever was truly Korean, the conservatives asked, "Why were the missionaries attempting to overturn the most basic social custom which forbade women's education?"[6]

In pursuing their objectives, however, the Protestant missionaries had learned a lesson from the Catholics who preceded them. Instead of preaching the Christian faith which often conflicted with conservative Confucian tradition, the Protestant missionaries set up and taught Christian love through providing education and medical services.[7]

The first attempt at modern education for women in Korea began in 1886 in Seoul. It had its

beginning when Mary Scranton, a pioneer missionary, purchased an unsightly strip of land containing nineteen straw huts. On this land she founded *Ewha Haktang* (Pear Blossom Institute).[8] The early days of Ewha were described quite interestingly:

> ...(A) few days after the founding, (Mary Scranton) realized that she could not find a student for her school. Though food, clothing, and lodging were provided by the school and tuition was free, Mrs. Scranton found it difficult to get students. Confucian culture did not allow sending girls outside of the house. Women themselves were not prepared to go against such a tradition. The fact that Ewha was founded by a Christian missionary was another reason. It had been only twenty years since Catholics were killed *en masse* by the government. People still remembered the terrible incidents whenever Christianity was mentioned.[9]

Finally, after a year of patient waiting, Mrs. Scranton enrolled her first student, a high official's concubine. The girl needed to learn English so she could serve as an interpreter for the queen.[10] Ewha has since grown into Ewha Women's University, the world's largest women's institution of higher education. With an enrollment of 13,452 in the 1980s,[11] Ewha now occupies a unique position in Korean society. It is one of the most prestigious institutions of higher learning in Korea.

Although the contributions of foreign missionaries have been significant, other forces were

also at work. The area of education was an important part of the *Kabo* reforms of 1894. These mandated expansion of the Korean educational system. The reforms were supposed to benefit both male and female students. Following these reforms, one of the major voices in support of female education in 1896 was a radical bilingual newspaper called *The Independent (Tongnip Sinmun)*. Through its pages, Koreans for female education demanded equal educational opportunities for both sexes.[12]

At this time, a newly reorganized Korean government was beginning to carry out the reforms by establishing a new school system. The government founded the *Hansong* School of Education, the School for Foreign Languages, and also a nationwide system of elementary schools. None of these, however, included any provision for education of women. The article in *The Independent* complained bitterly about the unfairness of not treating girls exactly as well as boys:

> ...(T)hough the government just started to teach the children, girls are still neglected. How could they discriminate against girls in the future programs for the education of the coming generations...? It is proper to match a school for girls whenever they found a school for boys.[13]

The argument that most attracted people's attention was that the root of women's inequality lay in their lack of education. Some liberals asserted that, as a practical matter, women's education should really

be even superior to that of men. As stated in 1896 by *The Independent*:

> If women are educated and develop interests
> in society, they would realize that their rights
> as human beings are equal to men's. They
> would also find a way to stop the brutality of
> men. We ask, therefore, that women be
> educated even better than men in order to
> educate other women and become an example
> of behavior to men.[14]

However, even louder and more fearful voices were heard from the opposite camp. Not only the common people, but most ministers of the government, had negative views about women's education. In 1896, for example, the conservative Minister of Education, Sin Kison, presented a formal message of threat to the throne:

> To cut the hair and wear Western clothes is
> to become savages, and using the Korean
> alphabet instead of Chinese characters is not
> desirable.... That is equivalent to making
> men beasts and destroying Confucian society.
> Under these circumstances, I plea (sic) to be
> relieved from my duty.[15]

For the next several years, the women's education movement was faced with a big setback even though a pro-women's organization called the *Yangsongwon* was founded by forty *yangban* women. In 1899, a petition was drawn by Confucian scholars to dissolve the *Yangsongwon* for being too closely

associated with "anti-government activities." This petition was accepted by the King. The same year, *The Independent* was also dissolved through government pressure.[16] Thus, at the beginning of the twentieth century, the issue of education for Korean women was caught up in social and political feuds.

By 1900, another subject began to seem more important than the education of women. This was the growing economic and political power of Japanese colonialism. By 1905, the backward, inefficient, and corrupt Yi government had surrendered to Japanese military power and had agreed that Korea should become a protectorate of Japan.

Under the 1905 Protectorate Treaty, the conservative Yi government gave in officially to Japanese military power. The Korean people reacted in a wave of patriotic self-strengthening against Japanese militarism, as well as against their own corrupt government leaders. Part of the move to inspire an intensive national consciousness resistant to the Japanese was to establish modern schools.

Widespread opposition to Japanese influence and to the Yi government itself began to build after the 1905 treaty. According to an historian of the women's modernization movement in Korea, more than three thousand private schools were opened in Korea between 1905 and 1910, mostly on the primary and secondary levels. Western science, history, geography, political science, music and gymnastics were taught.

As mass education expanded, the demand for women's education increased.[17] However, Korea in the early 1900s was not ready for higher education for women, even though Ewha by that time had become a very successful high school for girls.[18] When the college program was started at Ewha in 1910, Lulu E. Frey, who succeeded Mary Scranton in 1909 as principal, faced great opposition. Many people thought that it was too soon to establish college-level education for women. When there were thousands of girls who never went to school at all, to spend money and human resources on a few students was considered too extravagant and wasteful. Even some of Lulu Frey's missionary associates argued that the time was not yet ripe for a women's college.[19]

In 1910, Korea was formally annexed by Japan, and education for Korean women had to take a back seat. Equal education for females had not yet had a chance to become established. After 1910, the suppression of females in Korea by the Japanese was just as severe as it had been under the Confucianists.

Japan had definite goals for women's education. As the article in the Revised Educational Ordinance in 1922 defined, the secondary school education aimed at giving girls moral education, fostering their womanly virtues, and cultivating in them the character of good subjects by teaching them knowledge and art useful for life. The ideal woman was well-educated and obedient to her superiors -- men and the colonial government.[20]

It appears that the Japanese ideal of a well-educated woman was really a woman who accepted a subordinate position in life as compared to men. Under the Japanese, the progress of women's education began to be much slower than that of men.[21] This was certainly the case in the public schools supported by the Japanese government. During the thirty-five years of Japanese occupation, whatever higher education existed for women was provided primarily by private institutions such as Ewha Girls' School, which was run for and primarily by Korean people. Ewha was upgraded to a junior college in 1925. With the elevated status the school changed its name from Ewha Girls' School to Ewha Women's College. This was the first women's college in Korea.[22]

After the liberation from Japanese rule in 1945, education became a national priority. In 1948, the first National Assembly was elected, a new Constitution was promulgated, and a comprehensive education law was enacted in one of the first legislative acts of the National Assembly.

Between 1945 and 1989, the educational system has been subject to numerous changes by way of expanding the system, making it more democratic and more conducive to national economic growth. By unanimous agreement, the national education system is one of the foundations on which Korea's long and successful period of economic expansion has been based.

Although democratization of the educational system, which began with the first five-year plan in

1962, has benefitted Korean females greatly, it has not eliminated the serious sex segregation which still exists at all levels of the educational system. Because practically all the remaining discrimination against females is based on deep-rooted societal traditions, it is regarded by most men, and by too many women, as simply a natural course of events.

There is a growing need for women to participate actively in Korea's emerging high-tech society as Korea steps into the circle of advanced industrial nations. But Korean women will not be able to do their part unless there are changes in the Korean educational system which will give females equal educational opportunity with males.

Since 1948 there has been a constitutional provision against discrimination by sex but the main problem in the Korean educational system today is a result of societal attitudes which put women in a subordinate position in society. Such attitudes are first implanted in the children by their parents. Later, traditional sexual stereotypes are reinforced by the actions of teachers and school administrators.

If the educational system in Korea is to become fairer for women, certain changes need to be made. Ideally, all the changes should be made immediately. As a matter of strategy, some areas such as higher education may have a natural priority. The basic need, however, is for a broad change in societal and personal attitudes at all levels of Korean society.

Boy-preference Attitudes

The attitudes and expectations of the parents have much influence on children's educational progress. Often the parents discriminate against daughters and favor their sons without even realizing that they do so.

In a 1972 survey, seventy-three percent of the parents in the study, believed that they did not discriminate in favor of their sons and against their daughters. Although 98% of the parents had aspirations for their sons to obtain an elite university education, only 66.7 percent had similar aspirations for their daughters.[23] Without realizing it, they were discouraging their daughters from fulfilling their potential.

Positive mental attitudes about education often are inspired in daughters by other relatives. In my own case, the primary educational influence definitely was my Grandfather, Yu Kyung-Duk. He was a progressive and erudite landlord for whom education had the highest value. For him education was not just for males. He believed, and often expressed, that women should read newspapers and know what was going on in the world, rather than spending their time on the mindless housework in which most of them were so interested.

When I was six, Grandfather taught me and my 5-year-old brother from a Chinese classic, the *Chunja*, (the Book of 1,000 Characters). For an hour in the morning after breakfast and about an hour in the evening following dinner, seven days a week, he

would teach us the meaning of the pictographs and how to write them with a brush. Each pictograph had a set of lessons connected to it on Confucian rules of behavior and ethics. We would recite to Grandfather during the first part of the lesson and practice calligraphy for the next part. By the time I was seven, I knew the whole book by heart, and can still write the Chinese characters.

I was always praised by Grandfather as the one with considerable common sense, as compared with my younger brother, who was more interested in playing than in learning the Classics. Grandfather always told me I should be like Yim Young-Shin, the well-known daughter of another local landowner, who had gone to America to study, and had come back to Korea with a college education. Grandfather said, "You will someday go to America, and become a *bahksa* (holder of a doctoral degree.)" To this, I would always reply, "Yes, Sir!" Frankly, I had no idea what *becoming a bahksa* entailed, but I knew that it must be something good and important.

Ironically, I never used the Chinese characters in America, but certainly the positive reinforcement and encouragement I received from Grandfather had a lot to do with my being able to progress through all those years of schooling in Korea and America.

Sex Segregation in School

Although at the level of primary schools some sex-integrated education occurs, there are many

private schools that are segregated by sex. The result of this, of course, is that boys and girls are given subtly different educational experiences. Evidence of these differences is highlighted by a study of the school mottoes in single-sex primary schools.[24] As Professor Jung at the Ewha Women's University points out in the study, the school mottoes appear to represent the philosophy which the schools wish to inculcate in the minds of the students.

Examples of mottoes in schools for boys:

(1) If you earnestly attempt something, you will succeed, using faith, creativity and effort.

(2) On to victory, having set forth with ambition.

(3) Let us explore and develop.

(4) Let us practice one good deed a day.

(5) Let us seek truth, create civilization and work for self-cultivation.

(6) Let us become workers who lead the way to progress.

(7) Be honest, be able and be hard-working.

(8) Fairness and justice, fight for your country and never retreat.

(9) Exploration, development, cooperation and patriotism.

(10) Build a realm of peace and prosperity.

(11) Let us be honest and become men of high caliber.

(12) Sincerity, bravery and service.

Examples of mottoes in schools for girls:

(1) Be tolerant, be patient, be helpful and be sacrificial.
(2) Be gentle, be beautiful, and be soft of voice and deft of hand.
(3) Enhance the virtue of women.
(4) Purity, sincerity and diligence.
(5) Love, faith and chastity.
(6) Mother of wisdom, wife of wisdom and citizen of wisdom.
(7) Love, purity and sincerity.
(8) Be humble, sincere and loving.
(9) Be a faithful woman and a gracious woman.
(10) Be a pious woman. Be a perfectionist in all details.
(11) Be upright, courteous and wise.
(12) Be a truthful worker, an obedient daughter and a good mother.
(13) Become a kind person, a person of wisdom and a person of beauty.
(14) Let us love, be upright and serve others.
(15) Be a cheerful woman.

The differences in philosophy incorporated in these mottoes in the schools for boys and the schools for girls exemplify the reality of today's education. The respective mottoes show that boys are indoctrinated in their sex roles by themes of progress and of achievement, whereas the girls are guided by the attributes of purity, endurance, and service which are included in the traditional image of women.

In addition to these school mottoes, girls are drilled on traditional virtues during the school principal's weekly speeches as well as continuously in the classrooms.[25] Having conditioned their pupils thoroughly through these mottoes in the early grades, the Korean schools continue the conditioning process throughout the middle and high schools and carry it on through the college level. Not only do teachers in the lower grades focus on maintaining the *status quo,* the professors at the college level do the same.

Convinced by the respective male and female school mottoes of the virtue of becoming certain types of individuals, both sexes are further conditioned through the contents of their textbooks. Most of the textbooks that are used in elementary schools suggest that boys achieve dominant roles, for example, by depicting men as medical doctors and women as nurses. This implies that men are skilled professionals with authority, whereas women are only subordinates who take orders from the male doctors. Men are featured as school principals, but women are only teachers who take orders from the men.

Ever since childhood, I have been uncomfortable with being put into the typical female role. For me the Home Economics class at Ewha Girls' Middle School (7th grade) was a humiliating experience. Sixty girls were in the class. Everyone had to take the course since it was considered basic to a female's education. The Home Economics teacher was one of the most respected teachers at the school because of the importance of her subject and because she had the reputation for knowing it so well.

One of the main required projects was learning how to embroider a full-bibbed apron. It was more complicated and difficult than any project I had been assigned before, and I was embarrassed by not knowing how to do it. The girl next to me quietly let me see what she was doing, and I was able to complete my apron by copying her design. To this day, I do not like to do embroidery.

I remember another bit of indoctrination I got at Ewha, although I was too young at the time to identify it as such. Every morning at school all the girls had to line up for morning drill. Our principal, Mr. Cho, would always give us a speech on how Ewha girls were highly prized as daughter-in-law material. "Everyone wants to marry their sons to you," we were told. "You are such a prized commodity." That's what he always used to tell us. I was not influenced by his admonitions. I didn't really appreciate what they were talking about and I didn't like hearing that girls had to live for other people's approval. All this contradicted the early childhood education I had received from my own Grandfather who told me that I could be somebody good on my own without depending on the approval of others.

Women in Higher Education

Several studies have been conducted since 1982 about women involved in higher education in Korea. This is a key issue since it is in the Korean institutions of higher education that the battle to obtain sex equality for Korean women may be won or lost.

In 1982, noting a scarcity of published materials in English, I focussed my doctoral dissertation on discrimination against women in Korean higher education. My plan was to review existing materials and also to develop new information on this subject. I conducted a detailed survey of the attitudes and perceptions of faculty members in three Seoul institutions. The sample was composed of 170 men and 65 women.

The areas of study included the following:

(1) Faculty perceptions as to whether discrimination exists.
(2) Faculty perceptions of job performance ability of women in Korean higher education.
(3) Faculty perceptions of why women attend college.
(4) Faculty criticisms of women college students.

Subsequent studies have delved further into women's college education in Korea, how women students feel about academic success, and about the attitudes of successful Korean women professionals.

What my dissertation and the subsequent studies have overwhelmingly shown is the continued existence of many biases against women. Many Koreans in the field of higher education believe that women are in general less qualified than men to be valuable members of society. Often the women hold these stereotypes themselves.

1. Whether Discrimination Exists

When educators were asked whether there is sex discrimination in Korean schools, the usual answer was "No." Educators asserted that women are allowed to major in any fields they choose and that they are free to progress as much as men. Left unexplained by the educators was that women students in Korea seem to avoid certain "masculine" fields, and they are not as successful as men are in academia, business or the professions. The educators did not consciously recognize that Korea's system of lifelong social conditioning has had a detrimental effect on women.

2. Perceptions of Women's Job Performance Ability

Educators were asked their opinions on various points as to what was the *societal* attitude, and also what was their own *personal* attitude. The opinions of men respondents were compared with the opinions of the women respondents. According to the respondents generally, Korean society overall is strongly inclined toward the view that men are superior to women in many areas in the field of higher education. Specifically, the areas in which men are considered superior include chemistry, mathematics, engineering, business administration, law, medicine, political science and philosophy.[26] Korean society also considers men superior to women in such areas as personnel management, fund-raising, organizing ability, logical thinking, and

financial management.[27] Obviously, these jobs are quite important to any contemporary high technology society, particularly from the economic point of view.

When the personal attitudes of the respondents were compiled for men and women respondents separately, an interesting phenomenon was disclosed. Although men generally followed the societal view that men were superior in the above areas, most women educators saw no difference in the ability of men and women in most of these areas.[28]

3. Why Do Women Attend College?

In some respects, female faculty members were better able to understand realistically the motivations of female students than were male faculty members. This was revealed by comparing the answers of male and female faculty members to the multiple-choice question: "Why do female students in Korea go to college? Four response categories were available. (1) To improve marriage opportunities, (2) to improve career opportunities, (3) to increase knowledge, or (4) other."

Female and male faculty members have quite different ideas from each other as to the motivations of their female students. Male faculty members tended to believe that the female students were in college primarily to get married. By contrast, female faculty members were more inclined to think that their students were primarily interested in careers.

Results were as follows:

	Female Faculty	Male Faculty
Marriage	31%	54%
Career	42%	22%
Knowledge	18%	21%
Other	9%	4%

Assuming female faculty members had greater insight (since they had been female students themselves), male faculty members tended to stereotype women students as not being serious intellectual creatures, but as going to college just to get a husband. Female faculty members, on the other hand, tended to take women students more seriously, and were far more likely to see women attending college to improve career opportunities.

4. Faculty Criticism of Women Students

One interesting part of the survey was an open-ended question asked of both male and female educators as to what they thought was the single most important need at the time (1982) with regard to women in Korean higher education.

Responses of the female educators were quite revealing. They saw a need to eliminate discrimination and give better employment opportunities to women. They believed they should

use their education after graduation. To achieve these goals, women should be more serious, be more determined, think more logically, and have a clear purpose in college.

Responses of the male educators represented two viewpoints, one sympathetic to women and one antagonistic. Moreover, the antagonistic responses were twice as numerous.

The sympathetic responses agreed that women should go to college for knowledge, should not go to college for marriage, and that they should be more independent. The antagonistic responses endorsed the concepts that women should train for marriage, that they needed a "pragmatic" curriculum (doubtless home economics, etc.), and that women did not need education.

The overall conclusion is obvious, that there is a great deal of hostility to female students among many male educators. Their attitudes need to be corrected. More female educators with critical thinking ability are needed.

Attitudes of Women College Students

In deciding on her college major, a crucial consideration for a Korean woman student could be her desire for and ideas about marriage. Korean men are usually put off by women who appear too smart, and this is one of the reasons that some areas of study are not popular with Korean women.

To investigate this particular point, in 1985, students at Ewha Women's University were surveyed

to study the learning motivations of female students.[29] A free-answer format question was asked of 780 students on their thoughts about the future of a "gifted woman scientist" in Korea.

Some sixty-four percent of the students surveyed believed that it is possible for women scientists to succeed in their careers, but that they may have unhappy personal lives. Only one lone respondent thought that gifted women scientists could have both successful careers and happy personal lives. Most of the women thought, however, that gifted women scientists would have to make greater efforts than equally gifted male scientists to succeed.[30] Most women were not comfortable with the idea of having to sacrifice a happy family life to succeed at a profession. A few thought that a bright woman would have little attractiveness as a woman, and that her intelligence would work against her and would cause an unhappy marriage.

This study appears to illustrate that Korean women value intellectual ability and professional success, but that these will lead to unhappiness in marriage. Most Korean women would dismiss a brilliant woman's success as being unfortunate (*palja sedah*). This fear could certainly undercut the motivation of women to be intelligent or successful professionally.

The findings of the survey show a deep-rooted ambivalence among Korean women, especially educated women. This ambivalence is the result of continuing the long-standing pattern of socialization in Korea that convinces women that

they are not as good as men. Many of these women acknowledge advantage of receiving a modern education, yet they see that very same education as being the cause of an individual's unhappiness.

Among female students generally, the most popular choice of study is reported to be fine arts. The second choice is education. Following these, in order of popularity are languages, nursing, and pharmacology. Compared with men, very few women major in the social sciences, agriculture, or engineering.[31] Most women students at the university level study in the departments of the arts or home economics, the so-called womanly science. In some departments such as social science, economics, and business administration, only one percent of the students are female.[32]

Attitudes of Women Professionals

Although professional success for women is looked down upon by many men in Korea, occasionally the situation is the reverse. A few women have not only been successful in professional fields, but also have been encouraged by their husbands in their professional work. In 1982, under the sponsorship of Ewha University, twelve successful women were interviewed. Although intended just as a pilot study, with a small number of cases and no random selection involved, the amazing similarity of the individual cases to each other may suggest some of the main reasons that women who are successful get ahead. All the women included in

the study were engaged in professional and scientific fields ordinarily dominated by men, such as chemistry, physics, mathematics, education, political science, architecture, horticulture and others.

Six determinants appeared to be contributing to the successes of these women:

(1) All the women had whole-hearted support from their parents. The supportive attitude of their parents helped them build self-confidence.

(2) The husbands of all the women were very supportive, encouraging and understanding.

(3) Teachers and colleagues were not as essential as were parents and husbands.

(4) All the successful women all received little or no support or encouragement from their female colleagues.

(5) Five of the twelve women had attended women's colleges. This factor was thought by the author of the study to facilitate leadership training by which the women were able to hold leadership positions as students and to cultivate creativity. In a coeducational school setting,

opportunities to exercise leadership may be limited for women.

(6) For these women, it was not only possible for the women to engage successfully in both professional career and family, but the professional standing of the women was seen as mutually beneficial to the women and to their husbands.

Conclusion

Until very recently, because of the economic success Korea has enjoyed as a newly emerging country, it has not been easy to criticize discrimination against women in the Korean educational system, except on grounds of fundamental fairness. Now, however, the system is not turning out enough trained people to support continuation of the economic growth rate, especially in technical fields such as engineering. Instead, the system, in effect, trains women mainly to be housewives, nurses or teachers of home economics.

The relative success of an emerging high technology society in the immediate future may well depend upon the society's discovering a way to make maximum use of all its resources, both material and human. For a society to overlook the mental abilities of its women is tantamount to ignoring the talents of virtually half of its citizenry.

The overall problem of underutilizing women in Korean society is only part of a larger worldwide problem. That Korea may not be as far behind as a few other countries in achieving sex equality is no cause for complacency. There are also increasing numbers of modern countries in which women have begun to make important gains in virtually all occupational areas. In these countries, women are proving that they can perform as well as men, if not held back by society, and if not held back by themselves.

Educational policies should be made consistent with the spirit of the Korean constitution and the Education Act. Article 1 of the Education Act stipulates that the purpose of education is:

> **to enable every citizen to perfect his personality, to uphold the ideals of universal fraternity, to develop a capability for self-support in life, and to enable him to work for the development of a democratic state and for the common prosperity of all mankind.**

Underlying any real improvement in the status of women in Korean higher education are two key goals: To eliminate sex-discriminatory attitudes among university faculty and administrators, and to increase belief by women in their own value in the emerging Korean economy. Of these two, the improved self-concept among women generally is probably the more important.

Notes

1. *Ewha Photo Dairy* (Seoul: Ewha Women's University Press, 1982), p. 122.

2. Soon-Man Rhim, "The Status of Women in Traditional Korean Society," *Korean Women In A Struggle For Humanization*, ed. Harold Hakwon Sunoo and Dong-Soo Kim (Montclair, N. J.: The Korean Christian Scholars Publication, No. 3, Spring 1978), p. 22.

3. Except among a very few girls from elite families, girls in the day of Helen Kim's mother were not supposed to learn to read and write. Helen Kim, *Grace Sufficient* (Nashville, Tenn.: The Upper Room Press, 1964), p. 15.

4. Ibid.

5. Yung-Chung Kim, ed. and trans., *Women of Korea - A History from Ancient Times to 1945* (Seoul: Ewha Women's University Press, 1979), p. 213.

6. Ibid., p. 220.

7. Ibid., p. 218.

8. *Women and Saemaul Undong* (Seoul: Ministry of Health and Social Affairs Republic of Korea, 1980), p. 10.

9. Kim, *Women of Korea*, p. 218.

10. Edward B. Adams, *Korea Guide* (Seoul: Taewon Publishing Company, 1976), p. 33.

11. *Ewha Photo Diary*, p. 124.

12. Kim, *Women of Korea*, p. 216.

13. *Tongnip Sinmun (The Independent)*, 12 May 1896, cited in Kim, *Women of Korea*, p. 216. See also, Rhim, citing in "The Status of Women," *Korean Women*, p. 27.

14. *The Independent*, 5 September 1896, editorial, cited in Kim, *Women of Korea,* p. 215.

15. Kim, *Women of Korea*, p. 217.

16. Yong-Ock Park, "The Women's Modernization Movement in Korea," *Virtues in Conflict*, Sandra Mattielli, ed. (Seoul: The Samhwa Publishing Company, Ltd., 1977), p. 102.

17. Ibid., p. 103.

18. *Women and Population* (Seoul: Korean National Council of Women, circa 1975), pp. 5-6.

19. Kim, *Grace Sufficient*, p. 32.

20. Kim, *Women of Korea*, p. 259.

21. Dong-Wook Lee, "Korean Women's Education: Yesterday and Today" (Ed.D. Dissertation, University of Tulsa, Oklahoma), p. 53.

22. Kim, *Women of Korea*, p. 237.

23. Sei-Wha Chung, "Socialization of Women in Korea from the Perspective of the Family, School and Social Education," ed., *Challenges for Women: Women Studies in Korea* (Seoul: Ewha Women's University Press, 1986), p. 177.

24. Ibid., pp. 179-80.

25. Ibid., p. 181.

26. Ducksoon Yu-Tull (Diana Yu), "An Investigation of Attitudes and Perceptions of Educators in Korean Higher Education Toward Job Performance Ability of Women in Korean Higher Education" (Ed. D. Dissertation, The George Washington University, Washington D.C., 1983), pp. 243-44.

27. Ibid.

28. A Comparison of the Perceptions of Male and Female Educators about Personal Attitudes Toward Women's Job Performance Ability in Korean Higher Education. Ibid., Table 4.4, p. 183.

29. *Challenges for Women*, pp. 178-79.

30. Ibid.

31. The curriculum in women's colleges is narrower than in coeducational universities. In selecting her major field, a woman's training for married life is the principal consideration. Careful planning for her future career is seldom regarded as an important factor. Hyo-Chai Lee and Chu-Suk Kim, "The Status of Korean Women Today," *Virtues in Conflict*, ed. Sandra Mattielli (Seoul: The Samhwa Publishing Company, Ltd., 1977), p. 150.

32. Yu-Tull, pp. 248-49.

CHAPTER 6

Women and Politics

"When a hen crows like a rooster, it brings ruin to the home." Korean men use such an expression to silence assertive women and to undermine their self-confidence. Such sayings are calculated to intimidate females and to discourage them from attempting success in a "man's world," especially in politics.

Korea is a country in which men vote like male chauvinists. Surprisingly, however, and against their own interests, women vote that way as well. In spite of the influences of Christianity and Western ideas of individualism and freedom, Korea is still one of the most male-dominant societies in the world. The basic thinking of both men and women is often steeped in ideas of male superiority. Because of this, women often will choose to vote against other women who attempt to improve women's status.

History shows that the involvement of Korean women in politics has never been substantial. Under the Confucian ideology prevailing in the Yi Dynasty

women were never allowed to participate in politics.[1]
Even after the 1945 liberation from Japan, the status
of women has been so low that there has been little
participation by them in public matters. A few
women today try to be active in politics, but they are
generally quite timid about advocating true equality
between the sexes. While they favor "basic rights" for
women, they give a higher place to men. They go
along with the idea that women and men should not
walk "side by side," but women should walk "three
steps behind." Such women's advocates usually say
they favor both upholding Korean traditions and
advocating women's rights. Mostly, however, they
appear to be interested in not "rocking the boat."

Incidentally, many male politicians actually
view these timid women activists with contempt.
Much of the "cooperation" these women receive is
quite two-faced. In private the men are sometimes
friendly, but to publicly preserve their image as macho
males, the same men often show aloofness towards the
women to whom they promised cooperation.

Psychologically, most Korean women have
allowed themselves to be trapped by Confucian
traditions and have long considered themselves to be
second-class citizens. In spite of good examples by a
few truly excellent women, most women have
tolerated the kind of outdated thinking that has put
men at the top of the social order in Korea and women
at the bottom.

Perhaps the most important area for progress in
women's equality is for women themselves to become
aware of women's liberation as an issue. But most

women still take little note of the unjust social environment in which women's rights are minimized in a male-dominated political structure.

The most serious problem faced today by the women's rights movement in Korea is the desire among many women to go along with traditional ways. Women appear unwilling to organize pressure groups to enhance their status or to protect their own basic human rights.

Women, including educated women, will not be liberated until they free themselves from outmoded stereotypes about women. Women must accept the idea that brains and ability are more relevant than brute strength. Although the complete liberation of Korean women will undoubtedly one day be an historical fact, the rate of progress is probably up to Korean women themselves. Until they are willing to shake loose from traditions that only hurt them, Korean women in general will continue to be their own worst enemies. In discussing Women and Politics, we will look into the subject in the context of historical development in Korea.

Inception of Women's Movement

The seed that later grew into the Korean women's movement can be traced back to very early times. The first protests by Korean women against their traditional role in the Confucian social order appear to have been connected with the entry of Catholicism in Korea. Introduced from China in the

17th century, Catholicism was proliferating rapidly in Korea by the second half of the eighteenth century, attracting believers from both the upper and lower classes of women. The upper-class *yangban* women demonstrated strong support for their newly found religious beliefs. As the government began perceiving that the social content of Catholicism constituted a threat to the hierarchical Confucian order, the government began to take measures against western religion.

In traditional Korea, it had been unthinkable that a woman would ever put her religious beliefs ahead of duty towards her family. Nevertheless, some Catholic women began to do just that and refused any compromise. They rejected domestic life when it conflicted with the exercise of their religion. During the persecutions of 1801, Kang Wan-Suk, the wife of an upper-class official, was prosecuted by the King because she had left her family to go out and do missionary work. She was followed by women from the royal family and other *yangban* families.

For this type of activity Korean women were persecuted and even put to death. Their martyrdom marked the beginning of the change in Korean women's traditional status. Although these women were not specifically asking for sexual equality, one writer has called this period the symbolic beginning of the sexual equality movement.[2]

The Christian religion had a particular appeal to the long-secluded *yangban* women. For these women, belonging to an organization or to a church, or even taking part in group activities outside the

home, was a new experience. Especially being able to participate in church group activities provided them with organizational know-how.[3] Therefore, participation in Christianity was more than the practice of church rituals; rather it represented a liberation from rigid customs and traditions. Participation in Christianity helped individual Korean women to develop many useful social skills.

The early 1800s was a period of questioning the old traditional beliefs in Korea. Catholicism made particular inroads among both Korean men and women. The Confucianists fought back by actively persecuting Catholic converts, forcing many to recant, especially the men. Many women converts, however, gave up their lives rather than their new faith. About two-thirds of the Catholic martyrs of 1839 were women.[4]

In the 1880s, Korea was in a period of much social and political turmoil. The government was weak and indecisive and allowed the Chinese government to handle what small amount of international affairs it had. Because of the Chinese Confucian influence, the government was socially quite conservative. Rights of women were given no attention whatever, and western ideas were frowned upon.

Japan was quite different from Korea. Much modernization had been achieved following the Meiji Restoration, and western influences had brought about much prosperity. Among certain anti-government liberals in Korea, there was much admiration of Japanese-style reforms. The most prominent three,

Kim Ok-Kyun, Park Young-Ho, and So Chae-Pil (also known as Phillip Jaison), formed a party in opposition to the pro-Chinese conservatives in power.[5]

In 1884, with the aid of the Japanese legation in Seoul, Kim, Park, and So seized power through a *coup d'etat* and formed a pro-Japanese government. This government lasted only three days because the Chinese and the native armed forces took the side of the King and the conservatives. The three *coup* leaders went into exile in Japan. Four years later from Japan, in 1888, Park Young-Ho wrote a long petition to the King of Korea, demanding various liberal reforms such as had already been achieved in Japan. In this petition, Park spoke about the "modernization" of women -- the first time in Korean history that a public document had brought up the question of women's rights. Park suggested reforms such as prohibiting a husband from mistreating his wife, allowing a widow to remarry, an end to concubinage, and an equal opportunity for girls.[6]

The majority of Park Young-Ho's recommendations were not implemented immediately, but some were reflected in the Japanese-influenced *Kabo* reforms of 1894. For this reason, the women's liberation or "modernization" movement in Korea can be dated as beginning in 1894.[7]

The most influential of the *coup* leaders was So Chae-Pil. From exile in Japan, he went on to live and study in America for seven years.[8] As "Philip Jaisohn" he acquired an American wife, citizenship, and a medical degree from The George Washington University in Washington, D.C.[9] He was granted

American citizenship for his contribution to the Spanish-American War. During the late 1890s, Dr. So returned to Korea, bringing with him ideas from America. Challenges presented by Dr. So to Confucianism in the form of ideas he had collected from the West were a great aid in building the women's movement in Korea.[10]

Period of Japanese Influence (1898 - 1945)

Between 1898 and 1900, many women's groups were founded in Korea. However, a very limited amount of information about them exists.[11] At first, these groups were called Training Institutes (*Yang Sung Won*). The main purpose was to provide an educational training opportunity for women.[12]

In the early years, the leaders of local women's groups in Korea primarily consisted of ladies from upper-class *yangban* families. The early women's movement in Korea was not very well organized. There were many different groups, all with differing goals and memberships. In Seoul, one of the most important groups was the Chanyang Association (*Chanyang Hoe*) founded in 1898. This Association was formed to advocate equality between the sexes, and to provide additional educational opportunities for women. Membership, however, was restricted to women who were legal wives. Exclusion of the concubines and their daughters led to the formation of a competing group, the Yang Jung Women's Educational Association (*Yang Jung Yuja Kyo Yuk Hoe*).[13]

It is significant that, in excluding concubines and their daughters from membership, the women founders of the Chanyang Association did not perceive that lack of sexual equality was a common problem for all women. By restricting membership to first wives, however, the association was potentially excluding many women who would be progressive and for equality between the sexes. Nevertheless, keeping the membership of the association exclusive was more important in the early years than any ideas about solidarity among women.

Korean women's status, during the politically volatile period of the early 1900s, can only be discussed within the context of the Japanese annexation of Korea in 1910. An anti-Japanese movement had been started in 1895 by the Righteous Army of guerilla forces organized under the leadership of patriotic Confucian scholars. By 1905 the resistance had become violent, but the guerrillas were no match for the Japanese Army, and they were driven out of the country to Manchuria and Siberia. From then on, the resistance was by Korean intellectuals who had studied Western culture.[14]

Beginning in 1905, the Japanese stepped up their efforts to dominate Korea politically and economically. One of the ways in which the Japanese attempted to influence Koreans towards a pro-Japan position was by founding pro-Japanese Korean women's organizations such as the Hanil Women's Association (*Hanil Booin Hoe*) (1906), the *Daehan* Women's Association (*Daehan Booin Hoe*) (1907), the Jasen Women's Association (*Jasen Booin Hoe*) (1907),

the Dongyang Aaekook Women's Association (*Dongyang Aehkook Booin Hoe*) (1908), and the Jah Hoe Women's Association (*Jah Hoe Booin Hoe*) (1908). By the latter part of 1908, most members of these groups were pro-Japan.[15]

In spite of the success of the Japanese in organizing pro-Japanese women's groups, there were a significant number of western-educated women who were strongly opposed to the Japanese occupation and who became active in the Korean national liberation movement. Women formed secret patriotic organizations of their own apart from men, many of them in the form of church groups. The concepts of women's liberation and national liberation combined. These clandestine women's groups were devoted not only to the original purpose of transcending traditional stereotyped feminine roles, but also to the added purpose of liberating their country from oppressive foreign domination.[16]

Prominent Women in Liberation Movement

Four women stand out as being the most prominent figures in the early years of the women's liberation movement. These were: Yu Kwan-Soon, Kim Won-Ju, Park Soon-Chun, and Yim Young-Shin. However, in the struggle, first for national liberation, and later for women's liberation, many more women were active than these four. In fact, many Korean women in all age groups have suffered over the years for national and women's liberation, and in some cases have given up their lives for the cause.

Yu Kwan-Soon

The single most important day in the national liberation movement against Japan was March 1, 1919, the beginning of the famous March One Liberation Movement (*Sam-il Tongyip Woondong*). On that day, a public mass protest against the Japanese occupation took place in Pagoda Park in the middle of downtown Seoul. Men, women, and young students participated.[17] Among the participating female students participating was a 15-year-old, Yu Kwan-Soon, who was then a student at *Ewha Haktang*, now, the *Ewha* Girls' High School, an institution founded by Methodist missionaries. Against her principal's advice, Yu and six other politically active students joined the crowd at Pagoda Park in Seoul. A few days later, she participated in a similar student demonstration and was jailed for a short time.

Because of student unrest, the occupying Japanese government issued orders to close all the schools. Yu returned to her hometown where she, her brother, and several friends decided to hold another rally modeled on the one in Pagoda Park. Secretly they met with people in the surrounding area and arranged for a second March 1 demonstration that would take place on March 1 of the lunar calendar, the date usually coming one month after the same date according to the solar calendar.[18]

The Japanese military police were on hand with loaded guns. On that day Yu addressed the crowd assembled in the marketplace. There was waving of the national flag and shouts for independence,

"*Mansei! Mansei!*" (Let Korea live ten thousand years). The Japanese opened fire, and Yu's parents were among the first who were killed. Yu herself was then arrested, and after a long period of torture and suffering, she died in 1920 at the age of sixteen. The March 1, 1919 incident and later events marked the beginning of public participation in the independence movement by educated Christian women.[19]

The women of Korea in the fight for their country's independence succeeded in capturing international attention. India's Jawaharlal Nehru, in a letter written from his prison cell, described the situation to his sixteen-year-old daughter, Indira Ghandi:

> **For many years the struggle for (Korean) independence continued and there were many outbreaks, the most important one being in 1919. The people of Korea, and especially young men and women, struggled gallantly against tremendous odds. The suppression of the Koreans by the Japanese is a very sad and dark chapter in history. . . . (Y)oung Korean girls, many of them fresh from college, played a prominent part in the struggle.[20]**

Kim Won-Ju

One of the most noted and controversial intellectual women leaders in the women's liberation movement was a writer and editor, Kim Won-Ju. Even when Korea was at the height of its attempt to oust the Japanese, Kim was one of the few women

who were vocal about sexual equality. For this, she was criticized severely by the conservative public. Born in P'yongan Province in 1896, Kim had studied at *Ewha Haktang*. After *Ewha*, she was trained in nursing at *Tongdaemun* Women's Hospital. From there she went to Japan and studied English. Beginning in 1920 she was the chief editor of New Woman (*Sin Yoja*), the first women's literary magazine sponsored by *Ewha Haktang*. In 1920 she helped set up the literary magazine, *P'yeho* with a woman named Na Hye-Sock and ten men members.[21]

Kim Yung-Chung, who would later be director of the Women's Institute at *Ewha* Women's University, has written admiringly about Kim Won-Ju:

> **Her work also showed a woman's sensitivity of feeling and observation. She was excellent in the description of objects as well as in the pursuit of her theme. Her work generated a sincere and intellectual atmosphere. She was the first woman writer to treat ethical and ideological problems, but she never attempted to convey moral lessons.[22]**

As one of the foremost leaders of the Korean women's equality movement, Kim Won-ju was more concerned with the liberation of women than with her own success as a writer. Her writing often received severe criticism from the traditional male-oriented traditional Korean society. For example, in 1921, she published an article entitled "First, Break Through the Status Quo" (*Monjo Hyonsang ul T'ap'hara*). In the

article, Kim Won-Ju asserted the need for women's self-awakening, for their liberation from men, and for their acquisition of a proper social status. She advocated a similar view in "The Necessity of Women's Education" (*Yoja Kyo Yuk ui P'iryo*) and "Were I Born a Man" (*Sanhi ro T'aeyo Nassumyoin*), which were printed in the *Dong A-Ilbo*, a Korean language newspaper in 1920 and 1922. Her novel, *Awakening (Chagak)*, which was serialized in the *Dong-A-Ilbo* in 1926, also expressed her idea of women's self-awakening, liberation from men, and even liberation from their own children. These positions were considered as too radical for the conservative male-dominant Korean society. She was definitely ahead of her time for Korea.

Kim Won-ju practiced what she preached. After her first marriage ended in failure, she lived with several men for short periods. She finally immersed herself in Buddhism, became a Buddhist nun, and spent the rest of her life until her death in 1971 at Sudok-sa, a Temple in Choongchung Province. She left an autobiography, *After I Burned My Youth (Ch'oongch'ung ul Pulsarugo)*.[23]

Park Soon-Chun

Another famous woman leader in the women's liberation movement was Park Soon-Chun, who was born into a *yangban* family in the southern part of Korea in 1898 the only child of a country scholar. Although her parents were practicing Christians, they were traditional enough to feel that they would rather

have had a son. Consequently, Park was educated like a male, and the family expected her to fulfill a son's role.

When Park was twelve years old, and the Japanese were in the process of trying to eliminate Korea as a separate culture, her father told her, "If we are ever to get our country back, you must study hard." These words stayed with Park for life.

At age seventeen, her family wanted her to marry Byun Hi-Yong, the son of a local banker, but she turned down marriage so she could devote herself to Korea's liberation from the Japanese. Two years later, Park graduated from school and secured a teaching position at *Ui Shin* Women's School, located at Masan in the southern part of Korea. Her pay rate was set at fifty percent of what a Japanese teacher would have received.

In 1919, Park was arrested for participating in a demonstration against the Japanese that involved displaying the outlawed Korean flag. After being bailed out of jail, the police discovered a supply of the illegal flags hidden at her home, and wanted to rearrest her. Disguised as a *kisaeng*, however, Park fled from Korea to Japan. She entered a rural school as a student. The security system in Korea was so tight that it was actually easier for her to hide from the Japanese in Japan than in Korea. Back in Masan, the Japanese tried Park in absentia for possessing the flags and sentenced her to a year in jail.

Park's parents, as they had always done, sent money to her in Japan. The Japanese, however, found her by tracing the payments and threw her in jail. She

became something of a hero to a group of other dissident Korean students also in Japan. A contingent of them came to visit her, headed by the same Byun Hi-Yong whom she had turned down for marriage in Korea.

As a penalty for fleeing from arrest, Park was returned to Korea, and her jail sentence was increased to one year and four months. After getting out of jail, Park again returned to Japan to attend school. She continued to cause trouble from time to time by being involved in anti-Japanese activities.

In September of 1923, an enormous earthquake devastated many areas of Japan. Many Japanese died of polluted water after the earthquake. At the time, some 80,000 Koreans were living in Japan. There was much prejudice against them. Rumors circulated that Koreans had poisoned the wells, and some 5,000 Koreans were massacred.[24] Park returned immediately to Korea where a memorial service was being held for the murdered Koreans. At the service, she ran into Byun Hi-Yong again, and in another two years, on December 24, 1925, Park Soon-Chun and Byun Hi-Yong were married. Over the next twelve years, Park lived on the farm owned by Byun Hi-Yong's family, following the Korean custom which dictated that a wife must live with her in-laws.

During her entire life, Park was always socially and politically active, never living or acting like an elite *yangban* lady of leisure. In addition to her farm work, she founded a rice *geh*, (a capital development fund based on contributions of rice by the members), a kindergarten for farmers' children, and an evening

school for women to whom she taught *hangul* (Korean writing) and mathematics. After the villagers discovered how hard she worked, she became good friends with many of them.

In 1940, Park needed more scope for her talents than were required on the farm. She and her husband moved to Seoul where he taught school. Park had a succession of jobs and business activities that were to prepare her for her later successful career as Korea's most durable and well-known woman legislator and chairperson for one of the major opposition parties, the *Shin Min Dang*.

Yim Young-Shin

The fourth famous woman politician of the women's liberation movement was Yim Young-Shin, daughter of a wealthy and aristocratic family from Kumsan, the center of the ginseng-growing district in southwestern Korea. Yim was born in 1899, one of twelve children, with three older brothers and one older sister. Yim's father was progressive about Christianity, and he furnished financial support to an American missionary for building a church in Kumsan. He was a conservative, however, on women's issues. He thought that daughters needed little education and that they should marry as soon as possible.

When Yim Young-Shin was about seven years old, her father made a practice of inviting her older brothers into his *sarang* (men's quarters) and discussing politics and current events with them. One

day Yim accidentally sneezed while eavesdropping on their meeting and was discovered. Her father was angry that his daughter didn't know her proper place. He told her to go to the women's quarters where she belonged, and to help her mother and grandmother. This was the beginning of the realization by Yim that females were considered second-class. She immediately changed her attitude toward her male siblings. While she was good to her younger brothers, she would not let her older brothers get away with any unfair treatment towards her. She was ridiculed by everyone as a "tomboy" and as uncouth, but she was insistent on being treated equally with males. Whenever her older brothers treated her unfairly she squeezed an apology out of them.

Before Yim was ten years old, she had a personal experience with a Christian missionary that impressed her. Yim and her grandmother were in the shopping district in Kumsan and ran across a female western missionary with white skin and blue eyes. She was talking in a rather thick accent to the townspeople in Korean. Yim was fascinated and kept asking her grandmother what the missionary was saying, but her grandmother was just trying to quiet Yim down. People in the crowd told Yim that the missionary was saying that if she didn't keep quiet, God was going to punish her. The kind missionary, however, took Yim by the hand and spoke to her personally. "Christ died for our sins," the missionary told her. God loved young people like her, and also other poor and lonely people so much that he had given up his only son to be killed for their sake.

Three days later the son had come alive again. Yim was so much impressed by what the missionary had said that, from that time, she wanted to get an education and be able to talk as the missionary talked.

Soon after Yim was ten, she began attending the local elementary school. It was without her father's knowledge and against his wishes. At the time education for females was not usual, and it was even something of a social disgrace for her to attend the school. When whispers by neighbors of Yim's activities reached her father's ears, he beat his daughter, leaving black bruise marks in an effort to make her stop attending the school, and he forbade her to continue any more.

When Yim was twelve her family arranged for her to marry a local bachelor they had picked out for her. Yim had a mind of her own and refused. She argued with the matchmaker, saying, "If you had a daughter, would you insist on marrying her off at age twelve? Or wouldn't it be better to let her study and be able to amount to something someday?"

When Yim was fourteen, a missionary named Mrs. Gordon visited Kumsan and conducted a revival meeting. Yim attended each session. One day when no one else was around, Yim paid a visit to Mrs. Gordon. She told her, "Someday, I want to be an asset to Korea, but my parents not only block my ambition to study, but they also want to marry me off! So please, dear missionary, help me to study because I want to help my people and save my people's soul. I want to become their shepherd." Mrs. Gordon was much moved and promised to write to Yim's father.

Ten days later Mrs. Gordon wrote to Yim's father about how impressed she had been with his daughter. The missionary said that one day she thought that Yim Young-Shin would be a big asset to Korea, but that she first needed to go to school. After the letter arrived Yim sneaked into her father's quarters to read it. She begged her mother to intercede with the father. Yim's father was so enraged, when he found out about Yim stealing into his quarters to read the letter that he shouted he wanted to kill his daughter. Yim, who was also eavesdropping on this conversation, was frightened. Her response was to lock herself in her room and go on a hunger strike. Finally, after four days, Yim's grandmother interceded for her with her father. Yim's father always did what would please his mother. He apologized to his daughter and agreed to send her to Mrs. Gordon's school at Chonju.

Yim spent the next several years at Chonju finishing middle school where she excelled in mathematics and English. Staying on in a teaching position, her father wanted her to take some further courses at *Ewha Haktang* in Seoul, and then get married, but Yim still resisted the idea of marriage. About that same time, Yim was offered a job teaching in a rural school; she accepted. After several years' experience, Yim did go to *Ewha*, but as a teacher.

By 1923, when Yim was twenty-four, there was considerable anti-Japanese activity among Koreans. Yim wanted to go to China to join Koreans in exile there, but it was difficult at the time to go anywhere outside the country except Japan. Yim did

go to Japan and continued to be involved in anti-Japanese activities.

By this time, Yim's father was reconciled to having a politically active daughter. When she decided she wanted to study in America he agreed to pay her way. With the assistance of influential family friends in Japan, she was able to get a passport to America.

The boat trip from Pusan to San Francisco took nineteen days. On her voyage to America, Yim was able to further the cause of Korean liberation by smuggling out some proof of the Japanese atrocities in Korea. Concealed in a basket of fruit she carried with her were some revealing photographs and documents. Had she been caught by the Japanese she would have been executed. On her arrival in America, Yim delivered the materials personally to Syng-Man Rhee, who was at the time the leader of Koreans abroad who were opposed to the Japanese. This was the beginning of a relationship between Yim and Rhee that was to be important to both of them in the years following the end of World War II.

Yim did well in school in America. By 1932, when she was thirty-three years old, she had received both her bachelor's and master's degrees from the University of Southern California, after which she returned to Korea. Through much determination and hard work, at the end of the period of Japanese influence, Yim was well prepared to be influential in Korean politics.

During the early 1940s, Korea continued to be dominated by the Japanese. There was no such thing

yet as Korean politics, but there was secret plotting against the Japanese. There were also no Korean women in government and no Korean women's liberation movement as such. In 1945, however, the Japanese surrendered and fled from Korea. A few months later, it was Yim Young-Shin who organized the Women's National Party. In 1960, representing this party, she would run for the office of Vice President of Korea, albeit unsuccessfully.

Women's Movement
Since National Liberation (1945)

For three years after 1945, national elections were not held because Korea was divided at the 38th parallel by the United States and the Soviet Union into North and South Korea. During this period, the two areas were placed under separate military governments until national elections could be arranged.

Finally, in 1948, when the Soviet Union refused to allow United Nations supervision of an election in the North, the decision was made to go ahead with free elections in the South.[25] In this election, for the first time ever, Koreans could and did run for elective office. From this time on, Korea was governed by a series of mostly authoritarian governments, including very few women. Only in the most recent years, however, has the country made any real progress in achieving a lessening of the discrimination against women which had in fact persisted under all the governments since the inception of the Yi Dynasty.

Activities of Women Under
the First Republic
(1945 - 1960)

In preparation for the election of 1948, the most prominent of the women's organizations, the Daehan Women's Association, attempted to help women candidates who might try to run for a National Assembly seat. Although this organization encouraged women candidates to run and provided campaign assistance, the lack of unity among the members, caused the organization to withdraw support for specific candidates.[26]

For women candidates the election of 1948 was a total failure. Of the eighteen women who ran, not one was elected. The names of prominent women who ran again in later years included Yim Young-Shin, the founder of the Women's National Party, and Park Soon-Chun, the well-known heroine of the national liberation movement.

In a number of instances, beginning during 1948 in the administration of President Syng-Man Rhee, women have been appointed to high offices in the government. Because these women received their offices through appointment, and thus owed primary allegiance to the government and not to women generally, they were seldom active in crusading to expand the rights of Korean women. Indeed, such women appointees, with few exceptions, have usually been selected with the understanding that they would be "token females" in government. They could be counted on not to "rock the boat."

One of the most prominent women appointees in the administration of Syng-Man Rhee who did amount to something was Yim Young-Shin. In 1948 she had run unsuccessfully for the National Assembly. She was thereafter appointed to a substantial position in Rhee's administration. He made her his first Secretary of Commerce. Receiving the position by appointment, however, did not make the job itself easy.

The backwardness of the Korean males in Yim's new office was astonishing. Her first day on the job, no one from the department reported to work. As the new Secretary Yim instantly found out, the reason was refusal to work under a woman. Virtually all of the employees were men. A high-ranking employee actually said, "How could a person who urinates standing take orders from a person who urinates squatting down?" Therefore he refused to report to work.[27] Yim Young-Shin was not discouraged by such Korean male attitudes towards women and continued to work for gender equality in Korean society by remaining in the political arena.

Since the beginning of the Korean republic in 1948, a fair number of women have entered politics through appointment to the national congress by the various political parties. Few of the women in congress, however, have ever secured their offices through the election process. Electoral politics in Korea always has been considered men's domain. Some women politicians who have run for a National Assembly seat have experienced so much pain that many of the most highly qualified among them have

doubtless been convinced never to try for elected office again.

For example, Helen Kim, the former president of the Ewha Women's University, was a well-known educator with a doctoral degree in Education from Columbia University. She had a strong conviction to work towards enhancing the status of Korean women and to enter politics. Her case illustrates why a woman of sensitivity in Korea has always had a difficult time participating in the political arena.

In 1948 Dr. Kim's district was in Seoul, Sudaemoon Ku. One day she was making a campaign speech in her district. In the middle of her speech a man ran up to the podium without any warning, and slapped her in the face.[28] The probability that such incidents will occur has inhibited many women from running for political office.

The few women in Korea who have run for election to the national congress are models that should be studied, whether or not they were successful candidates. In the 1950 National Assembly elections, eleven women ran and only two were elected. It is possible that the women who lost elections were probably unsuccessful in large part because they had not received the full support of the Korean women's community.

One of the two successful candidates in the 1950 elections was Park Soon-Chun, the well-known heroine of the national liberation movement, who ran on an opposition party ticket. Although there was no women's movement at the time to support her, she was personally popular among both men and women

voters because of her previous activities on behalf of national liberation from the Japanese. Women did not vote in a block against her. Park continued her career in congress until her death at eighty-six from a urinary infection. Ironically, she suffered this illness because Korean government buildings at the time were built for the convenience of men, and few ladies' rooms were available.

The other successful candidate in 1950 was Yim Young-Shin. Her term in congress was interrupted by the outbreak of the Korean war in June of 1950, however, and she was not elected thereafter. In order to run for the congressional seat, Yim had stepped down from her position as Secretary of Commerce in the Syng-Man Rhee government. Although Yim was successful in her election bid, it was not because she received the backing of women's groups, but mainly because of the strong political support she received from Syng-Man Rhee's party.

During the period of the 1950s in the administration of Syng-Man Rhee, many of the Korean women's organizations became quite politicized. Women's issues tended to be forgotten, and most of the interest was in advancing the causes of association members who were also running for political office. Many of the organizations became mere public opinion tools of the government. For some women politicians, these organizations were a major source of political support.

In 1952, so the government could gain greater control over the various women's organizations, Syng-Man Rhee ordered the officers of organizations such

as the Women's National Association (*Kook Minh Hoe*), the Women's Sports Association (*Chey Yuk Hoe*), and the Daehan Women's Association (*Daehan Booin Hoe*) to join the government party.

Rhee's order caused much consternation, especially for the Daehan Women's Association whose president was Park Soon-Chun. Not only was Park Soon-Chun the association president, but she was also an elected member of congress, and a prominent leader of the major opposition party in congress. Her open and strong disapproval of Rhee's government made it impossible for her politically to join the government party, as Rhee's edict required.

Park Soon-Chun tried to dodge the issue by citing a provision of the association's bylaws which stated that the organization should not participate as a member of any political party until the Korean unification problem was solved. The government, however, continued to harass Park Soon-Chun. Her unwillingness to join the government party infuriated Syng-Man Rhee. On December 24, 1953, due to government pressure, Park's organization lost the right to meet at its association headquarters.[29]

The shock of losing the meeting place caused a shake-up in the leadership of the Daehan Women's Association. Park Soon-Chun was replaced in the presidency by another woman, Park Maria, then Vice President of Ewha Women's University. Park Maria was also the wife of Lee Ki-Boong, the speaker of the National Assembly and Syng-Man Rhee's right-hand man. The Daehan Women's Association fell under the complete control of the government.

The takeover of the Daehan Women's Association by Park Maria is a good example of how far many women's organizations leaders were from thinking about the welfare of women as a group. It was obvious to everyone, that what Park Maria cared about most was the political success of her husband. To achieve that goal, Park Maria, as the new president of the Daehan Women's Association, was quite willing to do all she could to influence members to vote for Syng-Man Rhee and his party. She had no loyalty to the goal of enhancing women's status.

The election of 1960 was to be the last election won by the Syng-Man Rhee regime. Rhee ran for president with Lee Ki-Boong, Park Maria's husband, as his vice-presidential running mate. After widespread outrage was demonstrated against fraud practiced in the election, the government was overthrown. Syng-Man Rhee was forced to flee to Hawaii. Also coming to a tragic end were lives of Lee Ki-Boong and his wife, Park Maria. The shame of the crooked regime and the fraudulent election caused their son, who was then a young man, to search out and kill his parents. After that the son shot and killed himself.

Activities of Women under the Second Republic (1960 - 1961)

Because the various women's organizations had all become overly involved in politics during the time of Syng-Man Rhee, the years immediately after 1960 reflected a turning away of most of the women's

organizations from politics. This has persisted ever since. The years immediately following Syng-Man Rhee's overthrow also marked a declining interest in women's rights, which set the women's movement back as well.

Following the disastrous ending of Syng-Man Rhee's regime, the next government was headed by Chang Myun of the major opposition party, the Democratic Republicans. Along with the ending of Syng-Man Rhee's regime, the influence of the Daehan Women's Association, and most other women's groups as well, was reduced. These groups all had a rather negative reputation of being too politicized and too closely associated with the Syng-Man Rhee government.

Only one small group, the Women's Rights Club headed by a long-time veteran women's leader Choe Un-Hi, tried to continue to engage in politics. This club offered suggestions for the names of women who might serve in the new government. The club recommended Park Soon-Chun for the post of Social Welfare Secretary. A rising woman lawyer, Lee Tae-Young, was recommended for the post of Assistant Secretary of Political Affairs. Lee had attended college at Southern Methodist University in Texas, and in 1949 had graduated from Seoul National Law School. Also recommendations were made to include women as county executive directors (*Koonsoo*). Chang's government accepted none of these recommendations. After about one year, the ineffective Chang Myun's government was toppled by a military *coup* under Park Chung-Hee.

Activities of Women Under Recent Governments (1961 - Present)

Following the end of the Second Republic, Korea was governed under a series of rather harsh military dictatorships. This type of government has continued in Korea down to the present day. The government of Park Chung-Hee lasted eighteen years from 1961 to his assassination in 1979 by the head of his own secret police. After several months of confusion, one of the *coup* leaders, General Chun Doo-Whan, assumed the Presidency for eight years, stepping down voluntarily in 1988 at the end of his second term in office. He was succeeded by his close friend and former general, Roh Tae-Woo, who is in office at this writing. Although Roh is a civilian, the power of the military in the background is still quite considerable. This regime is quite similar to the two prior military regimes.

Under Park Chung-Hee, the first of the military presidents who succeeded the weak civilian government of Chang Myun, Korea came to be regarded by the rest of the world as an "economic miracle." Political and civil rights were very much ignored but the economy developed very rapidly. Rights of women were also very much at a standstill until the mid-1970s. In 1975 and 1977, however, minimal improvements were made in family law to benefit women. However, no overall effort was made to carry out the express mandate in the Constitution which gave sexual equality to women and men.

Women's organizations were not a strong force during Park Chung-Hee's regime. In 1961, one of Park's first acts had been to order the dissolution of all existing civic and social organizations, including the women's organizations. For some time during Park's military regime, there were no women's organizations at all. In 1963, however, Yim Young-Shin founded a new national women's organization called the Hankook Women's Association (*Hankook Booin Hoe*). As a matter of policy from the beginning, the Hankook Women's Association has always tried to avoid getting involved directly in partisan politics. Instead, it has focussed on issues affecting women or the general public. One such area of concern is its consumer protection activities. The Association's policy to keep a proper distance from politics has allowed the organization to grow over the years without political interference. With a membership of 1.17 million in 1989, the Hankook Women's Association is one of the largest women's organizations in Korea today.

After Park's assassination in 1979, with the ascension of Chun Doo-Hwan to the presidency, there was continued emphasis on national security and economic development and little consideration was given to human rights or women's issues. However, dissatisfaction began to be expressed by some elements within the population. Workers became increasingly dissatisfied with low wages, long working hours, and the use of government police to suppress all union activities. Women's organizations also, although in a very non-violent fashion, began lobbying for

increasing the rights of women under the Family Law.

In 1984, pressured by women's organizations, President Chun Doo-Hwan promised sexual equality. The Women's Union for Family Law Revision prepared a comprehensive list of changes to be consideared by the National Assembly. The Women's Union was headed by Lee Tae-Young who was then seventy years old. She had become quite influential with Korean women' organizations, and was the first woman lawyer in Korea. Her organization had the formal support of a broad spectrum of some seventy women's organizations in Korea.

According to newspaper accounts, the proposed revision did not pass in 1984 because of the opposition by Confucianists and rural voters. A failure of women to unite behind the proposal also was alleged. In order for the proposal to have become a bill, the signatures of twenty members of the National Assembly were needed. Only seven signatures were obtained. Although eight members of the National Assembly were women, only one of them signed the proposal.

In a newspaper interview, Lee Tae-Young explained that women representatives had been hesitant to sign the measure because they had to be tactful about going against the wishes of their party.[30] She went on to express her opinion of the timid women legislators as follows:

> **These people who cannot even speak up for their constituents are not qualified to be National Assembly representatives, and should not be re-elected.**[31]

In 1989, the proposal to revise the Family Law was resubmitted to the National Assembly, this time under the regime of Roh Tae-Woo. It was passed relatively intact with comparatively few amendments.

In the 1988 elections for the National Assembly, fourteen women ran for office, but not a single one was successful. One can only speculate as to the reasons why. Obviously, women did not go out of their way to support women candidates. A newspaper article discussed the matter and suggested that some women had said that it was wrong for women incumbents to continue in office for more than one term. Many women thought that female incumbents should step down and give the men a turn.

In Korea, unfortunately, the job of National Assemblyman still appears to be seen both by men and by many women as a job best performed by a male. The few women legislators often vote on the issues like men. At least one woman legislator in the past has actually dressed in men's clothes, worn a masculine hairstyle, and acted as much like a male as possible so she would be "taken seriously." One of the main problems in Korea, however, may be that a type of woman legislator is needed who is able to see women's issues from a feminist point of view.

Conclusion

Modernization of women in Korea has made significant progress. There is an overall trend away from Confucianist ideas and toward greater democracy. Greater equality of the sexes is simply a

price that Korea has to pay in order to join the society of advanced countries of the world. To achieve greater equality between the sexes, more women need be included in the National Assembly by popular vote.

The truth is that women's organizations in Korea have on the whole been much more effective to date in securing improvements for women in the Family Law than have women politicians. Progress in the past would doubtless have come much faster, however, if women had been more aggressive in looking after their own interests.

If progress for women is to accelerate, Korean women must not regard politics as a job best done by men. The rough and tumble of politics may at times be unpleasant, but women need the courage to stand up and be counted. In fact, if women participate actively, they can do a far better job for themselves of protecting their own rights than men can do for them.

It is to be hoped that women in Korea will be able to meet this challenge. Their unique contribution after being elected to the National Assembly will be to think and act like the women they really are. They certainly do not have to dress like men to be taken seriously. Women should use their voting power to assume the influence in the National Assembly that is proportional to their numbers in the general population. Their talents and insights are too valuable to waste.

Notes

1. Pyong-Choon Hahm, *Korean Political Tradition and Law*, 2d ed. (Seoul: Royal Asiatic Society, 1979), p. 91.

2. Yong-Ock Park, "The Women's Modernization Movement in Korea," *Virtues in Conflict*, ed., Sandra Mattielli (Seoul: The Samhwa Publishing Company, Ltd., 1977), p. 99.

3. Yung-Chung Kim, *Women of Korea - A History from Ancient Times to 1945* (Seoul: Ewha Women's University Press, 1979), p. 249.

4. Park, "The Women's Modernization Movement in Korea," p. 99.

5. Bong-Youn Choy, *Koreans in America* (Chicago: Nelson-Hall, 1979), p. 26

6. Park, "Women's Modernization Movement in Korea," pp. 100-01.

7. Ibid., 101.

8. Ibid.

9. Fairbank, Reischauer, and Craig, *East Asia: Tradition, Transformation, and New Impression* (Boston: Houghton Mifflin Company, 1978), p. 617.

10. Park, "Women's Modernization Movement in Korea," p. 101.

11. Ibid., p. 102.

12. Included in the *Chanyang Hoe* were a small number of men and foreign women as well. *Women Studies* (Seoul: Ewha Women's University Press, 1985), pp. 212-15.

13. Ibid., p. 216.

14. Park, "Women's Modernization Movement in Korea," p. 104.

15. In addition to financial problems, the early Korean women's liberation movement also was held back by the large number of pro-Japanese women at leadership levels in the various Korean women's organizations. Japan had been quite successful in converting women in existing women's organizations to a pro-Japanese outlook, and even organized many new pro-Japanese women's fellowship groups. The Japanese saw the re-education of Korean women as one of the most effective means to achieve their objective to take control over Korea. *Women Studies*, pp. 214-15.

16. Kim, *Women of Korea*, pp. 259-66.

17. Ibid., pp. 260-61.

18. Ibid., p. 261.

19. Ibid.

20. Jawaharlal Nehru, *Glimpses of World History* (New York: The John Day Company, 1942), p. 465.

21. Kim, *Women of Korea*, p. 281.

22. Ibid., p. 282.

23. Ibid.

24. *Hankook Yusung Woondong Yaksa 1945-1963* (Hankook Buin Hoe Press, 1985), p. 68.

25. Young-Ho Lee, "The Politics of Democratic Experiment: 1948-1974," *Korean Politics in Transition*, ed., Edward Reynolds Wright (Seattle and London: University of Washington Press, 1975), p. 19.

26. *Hankook Yusung Woondong Yaksa*, p. 23.

27. Ibid., p. 103.

28. Interview with Kum-Soon Park, President of Hankook Women's Association, March 18, 1990.

29. *Hankook Yusung Woondong Yaksa*, p. 29.

30. *Korea Herald*, Seoul edition, November 6, 1984.

31. *Korea Herald*, Seoul edition, November 6, 1984.

Women in the Work Force

In the work place, all the discriminatory practices against women converge to assure the continued control by men over women. As indicated in previous chapters, the forces of religion, customs, law, education and politics all have supported the notion that men should be in control. The idea of male dominance has developed gradually over many centuries, and has become accepted in Korea as the social norm. Most women are not only accustomed to their subordinate position, but many even support it as being right and natural.

Working Women in the Past

From early times, it has been considered undesirable, even unthinkable, for upper-class *yangban* women to work outside the home, let alone take an active role in the work force.[1] The appropriate role for a *yangban* woman was to be a

wife and a mother. The social recognition accorded to a *yangban* woman was seldom determined on the basis of her personal merits. Rather, a woman was valued only as a wife to a prominent man or as a mother of a successful son.[2]

Women who worked outside the home for money were almost without exception from families of the lower socio-economic classes.[3] Much has been written about the position of three such categories of women that have existed for centuries: shamans, folk healers, and *kisaeng*. One characteristic these women have in common is that they all have been discriminated against by society.

Shamans

In ancient Korea female shamans were prominent. Nearly all shamans were women.[4] By the early Silla period they had already outnumbered the male shamans.[5] Up until the 7th century A.D., the word shaman, in Korean, was assumed to apply to a woman.

With the aid of spirits the shamans were believed to have knowledge and power superior to that of ordinary people. As shamans, women presided over national ceremonies, performed healings and exorcisms, and acted as prophetic sibyls.[6]

Wanne J. Joe, a cultural historian, speculates that Shamanism evolved from the animistic beliefs of the Mumun people. The Mumuns were makers of pottery without surface designs and presumably lived

in Korea during the Bronze Age.[7] Some historians date their origin back to the neolithic period, though without any specific archeological evidence.[8] Scholars agree that Shamanism is the oldest and was once the only religion of the Korean people. Practiced covertly in modern times, Shamanism still remains a major religious influence in the country.[9]

In the old days as well as in modern times, shamanistic practices persisted more among village women than those from the city.[10] Shamans occupied an important position in their own households as breadwinners. As one writer notes, the shamans are the pioneers of dual careers for women in Korea.[11] They were capable of keeping their jobs while taking care of their families.

In the status-conscious Korean society, the shamans from the lower class were not always tolerated and often were treated with contempt by the male-dominant government. Beginning with the Yi Dynasty in the fourteenth century, many attempts were made by the government to stamp out Shamanism. Shamans were ordered to stay away from the people and the city. Female shamans and prostitutes residing within the walls of the capital were sought out and penalized.[12] The idea was to isolate shamans from the people to protect them from shaman influence.

Although the official policy in the Yi Dynasty was to replace Shamanism with Confucianism, all such measures ended in failure. In the minds of many people there was no substitute for a shaman in healing the sick, telling fortunes, and dealing with

natural calamities.[13] The Yi Dynasty coped with its failure to eradicate Shamanism by giving it begrudging recognition as "a belief system suitable only for women and some men of ignorance."[14]

Recent Korean governments have mounted a renewed campaign to eradicate Shamanism in Korea. Police raids on shamanistic ceremonies have been a commonplace occurrence, with the government singling out the shaman as a target of ridicule and attack.[15] Shamanism, however, has continued to pervade Korean life.

Even today, in spite of the societal harassment, the fortune-telling services of shamans are valued especially by all classes of Koreans. Ms. Park, an ardent Catholic in Seoul who goes to church every Sunday, also goes to a famous shaman fortune-teller *(jum jang-i)* for regular consultation about upcoming events in her private life, such as buying a house or setting a good date for traveling to foreign countries, etc. Whenever an important event such as a marriage is to take place, Koreans expectedly confer with shaman fortune-tellers about the suitability of the prospective marriage partners. Quite often advice from a shaman fortune-teller plays an important part in making the final decision.

A 30-year-old college-educated woman, Mrs. Lee recalls,

> I was twenty-three and I had just finished college. I went to see a fortune-teller about whether to accept a marriage proposal I had gotten from the man who is now my husband. The fortune-teller asked me, "Is

**he the first man to propose to you?" Then
she said, "Don't let him leave, you must
marry the first man who proposes to you."
That's why I married my husband.**

This is how it works. One asks around
among friends or relatives for the name of a really
"good" fortune-teller. This means, one who has the
best reputation for being able to predict the way
things really will happen. Similarly to spending
money on medicine to cure illness, a caring Korean
mother or grandmother would see to it that proper
steps are taken to find out the family member's
fortune. Although the amount of the fortune-teller's
fee is negotiable, it is often expensive. This enables
fortune-tellers to make good working-class wages.

At one time before leaving Korea, my future
was also placed into the hands of a shaman fortune-
teller by my mother. Completing the necessary
procedures for coming to America took seven
months. Mother stated there was one more thing
which had to be done. This was to obtain the
counsel of her favorite shaman, the fortune-teller in
Taejun. Mother very much believed in consulting a
fortune-teller about her children's future whenever a
big decision had to be made.

One cold February day in Taejun, Mother and
I went to see the fortune-teller at her home. She sat
on a faded red and yellow silk cushion on her
bedroom floor which was decorated sparsely with
bright dust-covered paper flowers. As we closed the
door behind us, she murmured, "I knew you were
coming." The old pockmark-faced woman in her

mid-sixties motioned for us to sit on the floor of her small room where she had been waiting for her first customer of the day. At the fortune-teller's remark Mother and I looked at each other with surprise.

"I brought my daughter, she is my only daughter," Mother told the fortune-teller loudly, looking directly at the fortune-teller's face, since the old lady was a little deaf.

"Uh? replied the fortune-teller, moving her small body closer towards Mother.

"My daughter wants to go to study in America. She has completed all the necessary procedure." Mother continued, "She has her school picked out, got the passport, has a scholarship lined up and all. But I don't know whether or not to send her to such a faraway place," said Mother, lowering her voice.

"What's her sign?"

"Rat, born in *inshi*" (2 a.m.), first month of the year," said Mother, anxiously.

A long pause of silence followed while the fortune-teller mumbled, *"Inshi,* rat, the first month of the year," her left thumb touching the tips of her four fingers. "Rats are smart animals, born in *inshi* makes her doubly fortunate." Mother and I anxiously waited for the fortune-teller's prediction. "Hurry, send her! Your daughter will someday return to Korea with a big honor," said the fortune- teller, nodding her head up and down slowly as ifassuring herself about her prediction for my future. Mother was relieved and comforted about sending her only daughter far away to school in America. At

that time, I wasn't sure what all that meant but was glad to get that nurdle out of the way. What a relief!

Folk Healers

Korea's rigid social customs regarding interaction between men and women created the need for women healers for female patients as early as 1406. Often, rather than let a male physician look at her body for diagnosis, an upper-class woman would choose to die of illness. In recruiting women to be folk healers, since *yangban* women were not allowed to go outside their homes, the folk healers all came from the lower-class families.[16]

One problem, however, was that almost all the girls from peasant class families were illiterate. The government, therefore, decided that the girls selected to be folk healers should be taught the basic Chinese characters which were the language for medicine.[17] Even after a woman had completed this training, she was not allowed to act independently in treating an illness. Often the patients were reluctant to rely fully on a mere woman's diagnosis. There was a deep-rooted prejudice against recognizing the competency of a woman. Therefore these women had to be accompanied by male healers.[18]

Another clear sign of the condescending societal attitudes toward folk healers was that they were forced as a sideline to serve as entertainers for the guests at royal banquets.[19] During the reign of

Yangsan'gun (1494-1506), for example, they were called upon so often to entertain guests in the palace that they had little time left to concentrate on their profession.[20]

Yangsan'gun encouraged them to be better entertainers rather than competent healers. The King's view of women was that, even if they were well-versed in Chinese classics, they were of no use unless they had skills in music and dancing. Soon most women healers were drawn into professional entertaining and became *kisaeng*. In this case they were called the *yakpang-kisaeng* (pharmacy *kisaeng*), meaning medical entertainers.[21]

Kisaeng

The third group of lower socio-economic class women in the work force were the *kisaeng*. They appear to have originated with the female entertainers of ancient China, where they came into prominence during the Tang Dynasty. This group was considered the lowest social group.[22] The institution of *kisaeng* was later passed on to the Japanese who developed it into its best known form where the performers are called *geisha* or "accomplished persons."[23]

Since the early Yi Dynasty, there were demands for the abolition of the *kisaeng* system because it conflicted with the moralistic aspects of Confucian ethics. Serious efforts to eliminate *kisaeng* were not made. By the latter half of the Yi dynasty the women entertainers were still practicing

their profession and were divided into three levels or classes. The highest grade *kisaeng* were those who danced and sang at upper-class functions. Some of them were selected to entertain at state feasts. They were also allowed to receive private guests in their homes. They were the most privileged class among the *kisaeng,* but had to retire from their profession at age thirty. The next grade of *kisaeng* entertained at parties, while the lowest grade were simply prostitutes.

According to Osgood, the term *kisaeng* has no exact analogy in western cultures, the closest approximation probably being the *hetaerae* of ancient Greece.[24] Probably the *kisaeng* received a somewhat greater degree of respect in the beginning when they were not prostitutes.

Even today, *kisaeng* are severely stigmatized in Korean society. A *kisaeng*'s child is not accepted in a proper class of family; therefore, no one in Korea will willingly admit to being a *kisaeng* offspring. Some *kisaeng* are kept as mistresses or concubines by married men. They cannot marry into a proper family. To admit *kisaeng* lineage in Korean society would be humiliating, even today. Virtually no right-minded person will admit to such a family background.

Old *kisaeng* often end up being owners of restaurants and other service businesses. Their descendants might be able to move up socially by going to good schools and marrying discreetly, hiding their real family backgrounds. However, when the hidden lineage is discovered, the deceived

party might rightfully take the daughter or son away, even long after children have been born.

Modern-day equivalents to the *kisaeng* are the nightclub entertainers and the bar girls. Korea has developed a famous entertainment industry in which young and attractive females can earn much more money than they could as industrial or clerical workers. *Kisaeng* tourism is promoted by travel agencies which portray South Korea as a male paradise. Tour packages often include the price of a *kisaeng* as well as sightseeing and accommodations.

The *kisaeng* women themselves keep only one-sixth of their fee, which is split among guides, hotel owners, travel agents, and officials.[25] Most customers were Japanese males, numbering 400,000 a year from 1965 through 1978. They spent an annual amount equal to sixty percent of Korea's total circulatory currency at the time. Today's *kisaeng* usually are rural women who have migrated to the cities in search of employment, but have found no other options.[26]

Working Women in the Modern Day

Most working women in Korea today are not affluent. They are young and single, have no more than a high school education, and work out of economic need. While they are unmarried they generally work in low-paid occupations. Upon marriage they are generally expected to quit their jobs and become housewives and mothers. Few jobs are available to married women, even to those

without children or those whose children are grown.

Most affluent women never enter the work force at all. Employment would impair their social standing and, more importantly, the social standing of their husbands. There is a saying in Korea, "What kind of man is it who would send out his wife to work?" Although employment for a married woman may not be a disgrace to the husband, it is still defined by current Korean society as being somewhat demeaning to the husband's status.

Sex segregation in the work place contributes to the lower status of women. Certain categories of work that are dirty, tiresome, or physically difficult have been reserved almost exclusively as "women's work." In other occupations the duties have been divided in such a way that the less important jobs go to the women and the more important ones go to the men. Until recently, this type of occupational segregation has not been illegal.

Women's rights activists like to point out that average wages for women are forty percent of average wages for men.[27] Defenders of the status quo insist that this is largely because women are, on the average, young and unskilled.[28] Although the explanation has validity, the situation is unjust, and will not be remedied until the present degree of occupational segregation is reduced.

Women Household Domestic Workers

For hundreds of years a large number of Korean women have worked as domestic servants.

These jobs require no education. One result of hiring domestic household servants, of course, has been to relieve middle-class and upper-class women from having to do the housework themselves. Often, especially in modern days, Korean housewives with domestic servants have ended up doing little or no productive work. Women from *nouveau riche* families, especially, have gone out of their way to flaunt not having to work, and thus have added to their social respectability.

When visiting Seoul in May of 1989, I met a woman in her early sixties. She had three grown children, all married. Coming from a family in the publishing business and well-connected politically, was financially secure. She bragged that she was used to bringing along her kitchen maid when she visited her daughter in Los Angeles from time to time for a month or two. With increasingly high wages being paid for manufacturing jobs, however, even this wealthy woman had difficulty locating domestic help since many such workers have moved to employment in factories.

Household workers are among those most discriminated against in Korea. The Labor Standards Law, which protects workers in all other industries, excludes both those producing products at home or working as domestics. Household workers not only are not protected by various laws against discrimination in employment, but they also are not covered by regulations which provide equal benefits for retirement, medical care, or disability.

A practical problem for domestics with small children is not having money for child care. At times the problem can be severe. A recent tragedy regarding the children of a domestic worker alarmed residents of Seoul. A domestic wage earner had locked her two small children in her apartment during the entire time she was at work. To be sure that the children stayed in until she returned, she locked the place from outside. On her return, she found that the children had accidentally started a fire in the dwelling and had perished.

Women Agricultural and Industrial Workers

Women today are prominently represented in both the agricultural and industrial work force performing jobs that are tedious and physically demanding. Increasing mechanization has reduced the number of agricultural jobs, however, since the 1960s and 1970s. This was a result of a large population shift from rural to urban areas as Korea became more industrialized.[29]

Many of the migrants were young, single women. By the early 1970s, female workers were roughly one-third of the non-farm labor force.[30] In 1973, 82.8 percent of employed female workers were between eighteen and twenty-nine years of age.[31] In most cases it is still true that young Korean women only keep their jobs while waiting to be married off by their parents. Preferably, they leave their jobs early enough so as not to be regarded as unfortunate women and unmarriageable.[32]

The position of the young Korean women workers during the 1960s and 1970s was even more tenuous than that of young men. Desperation forced many of these women into prostitution. Slightly more fortunate women were able to secure sweatshop jobs at very low wages.[33] In recent times sexual harassment and intimidation of women working in factories is still prevalent.[34] The Korean criminal code, however, now makes sexual intercourse with an employee by force or threat of force a crime punishable by up to five years imprisonment.

A 1973 report by the Youth Association of Catholics in Korea states that working conditions for women workers were unusually severe at that time. Out of 300 women laborers in the Masan industrial export area, 35.8 percent of the women answered: "I am working now because I cannot kill myself;" 33.9 percent answered, "I am working to eat and live today." Their working environment caused various industrial diseases (for example, alimentary disorders, nervous prostration, skin diseases, eye diseases), and their cheap boarding caused malnutrition.[35] One woman worker wrote in her memorandum that she had to take sleeping pills one day and stimulants the next because of the daily change of shifts. The "five robbers" of Korea were said to be cabinet ministers, capitalists, members of Parliament, generals, and high government officials, all of whom had accumulated their wealth by exploiting the efforts of women workers.[36] Since 1973, however, wages in Korea have risen and sweatshop conditions have become less common.

The migration to the cities in the 1950s and 1960s gave Korea a large pool of potential industrial workers who were willing to work long hours for little pay. All the industrial jobs for women were low-pay and low-status. Until quite recently, labor unions have been strongly discouraged by employers and the government.

In today's society, both men and women industrial workers still work very long hours. According to a recent study conducted by the International Labor Organization, Korean women workers in manufacturing jobs work an average of 54.1 hours per week, compared to 54.0 hours per week for Korean men. These statistics are notable, not only because they show that Koreans work longer hours than workers from any other industrialized country, but also because Korean women work as long as, or even longer than, men.

Statistics from the International Labor Organization (I.L.O.) show a 41.0 hour average workweek for workers in the United States, but no breakdown of the average workweek by sex. However, unpublished statistics from the U.S. Department of Labor put the average workweek for U.S. manufacturing workers at 42.2 hours. Males work 43.6 hours and females work only 39.4 hours, or 90.4 percent of the male workweek.

The I.L.O. statistics for other countries, in which both male and female workweeks are reported, all show women working fewer hours than men. In Japan, the workweek for women is about 90 percent of the workweek for men. In Sweden, the

proportion is only about 85 percent of the male workweek. In Korea, however, women have the worst of both worlds. They work as long as the men do on the factory floor and still do most of the work at home.

Despite long workweeks, Korean females are not sufficiently appreciated in their society. As in many industrialized countries, while women increase their economic participation, they are left in the least developed sectors of the economy.[37]

A study by Boserup describes the way sex segregation in employment is used to discriminate against women in industrialized societies:

> In many cases, males were instructed in types of cultivation that guaranteed higher yields... Old horticultural techniques were often continued by women, along with their responsibility for providing dietary staples... Such development has the unavoidable effect of enhancing the prestige of men and lowering the status of women. It is the men who do the modern things. They handle industrial inputs, while women perform the degrading manual jobs... men ride the bicycle and drive the lorry, while women carry head loads as did their grandmothers.[38]

Women Office and Clerical Workers

Some degree of education is required to perform office and clerical jobs, but completion of

ninth grade or high school usually is adequate. Women with college educations also may be hired. College-educated or not, the main purpose of most office and clerical jobs in Korean businesses is to do the menial work required, and to add "atmosphere."

As a young woman recent college graduate rather cynically said, "If a girl is pretty, she can always find a job." Most women employed in office and clerical jobs are treated with little respect, and a part of most jobs for women is to wait on the men. A common requirement is to arrive early for work and prepare coffee for them. On occasion, men in positions of authority can be expected to ask for sexual favors. Other forms of sexual harassment are widespread.

Because of the degrading and humiliating treatment of women in offices, "decent" girls often are forbidden by their families to work in business offices for fear that it would harm the family's reputation and also that of their daughter. This was my own case.

At age eighteen, I had completed my first year at *Ewha* Women's University and had also decided to finish my degree in America. I had taken separate courses in English and typing, and wanted to find a job in which I could further improve my English skills. I considered myself quite fluent in English but wanted to improve it.

I found a job through one of my sisters-in-law who had worked before marriage. The job was with a Korean import and export company translating documents. I felt very good about the possibility of

improving my English while earning some money, too. I especially liked the idea of earning money to help my father who was always struggling financially, even though he was a congressman. He never had enough money to cover all his endless expenses, and often had to borrow tuition money for me and my two brothers.

When my older brother heard about the job I had gotten, he shouted from top of his lungs, "Under what bastard would my sister work! Never!" That was the end of my job-hunting venture in Korea. The truth was that my own brother would have been stigmatized if his sister had to work under just anyone.

Because pressures come both from the society in general and from one's home, many Korean women lose the opportunity to develop themselves and in some situations the only way out is to leave the stifling society. The male egocentric society seldom allows eager female minds to grow. In 1957, my experience with trying to do productive work in Korea made me want to leave the country even more. I felt that as long as I stayed in this fanatically status-conscious Confucian society, I would never be able to try my "wings."

I must admit that my family's motive had not been to stifle me, although that was the necessary effect as long as I remained in Korea. Sometimes, having one's sister or a daughter work outside one's home has serious social consequences. My brother's reasoning was that if his sister were to work for another man, he would automatically have to give

deference to the man who would be my boss. A working woman's status, even in a business office, is very low in Korea. No doubt, my brother only wanted to protect our family's reputation, and my own. My impression is that, even today, many Korean families have difficulty consenting to their daughters or sisters working outside the home.

The case of Eun-Jae Jung also shows that women who worked in offices in Korea during the 1960s underwent a risk of sexual harassment by Korean men. In Miss Jung's case, she relates the situation, as follows:

> I was able to speak English and type well, so this was my main means of making a livelihood. It was tough in Korea in the 1950s. I had an unforgettable experience while I was working in the Department of Commerce of the Korean government.
>
> My boss was a rather dignified and good-looking gentleman. He was married. One day, he said he wanted to take me and my girlfriend to a dinner party where other people from the office were invited. My girlfriend and I exchanged a glance and said, "Why not?" The night of the dinner party, we came with each other. Several men from the department came, too.
>
> The dinner party was at a fancy Japanese restaurant inside a hotel building in Pusan. My girlfriend and I sat on the floor at a low table after placing our high heel shoes at the right hand corner of the entrance hall. There were two Japanese *kisaeng* at our table. Of course, my boss was there without

his wife, and none of the other men had brought their wives. Not bringing wives along to employee parties is more the rule than the exception in Korea. My boss got really drunk, completely drunk. After that, he tried to make a pass at me.

My girlfriend and I started to put our shoes back on and ran out of the room. My boss saw us and followed us out. We ran and he chased us. We circled the hotel building three times. We were quite scared that he might catch us.

The area was dark. But we somehow managed to see a man working at the corner of the hotel inside. We stopped and told him the story. The man, without asking any questions, found us a spot -- a small room -- and hid us. My girlfriend and I spent the night and went to work from there the next morning. My boss reported to work the next day, too. He looked as distinguished as ever. We tried to look completely normal, as if nothing had happened.

Women Nurses

Not only high school, but four years of specialized training in college, as well, is necessary in order to work as a nurse. In Korea, nursing still is largely a female occupation, which makes it both low-pay and low-status. Much of the work is difficult, dirty, and tiring. Like office and clerical help, women workers in hospitals also may be called on to do sexual favors for the men they work for. This may include doctors and hospital administrators.

Mrs. Won-Oak Song was a 32-year-old administrator in a nursing school. She told me:

> **When I wanted to spend money, I had to go to the budget director for his approval. Even though our office was entitled to the money, the director was very rude to me for requesting funds. I would either have to grant him some favors, or at least bring him a lot of gifts on holidays. Sometimes, they expect even sexual favors to pay out funds which had already been allocated to my office.**

Technical and Managerial Women

The jobs which have been least attainable for college-educated women have been those at the technical and managerial level. This includes jobs in manufacturing industries, banking and insurance industries, large department stores, international trading companies, and the government. Only a small percentage of college-educated women are part of the work force in Korea.

In 1963, of women who were employed, only 2 percent worked in professional, administrative, and managerial occupations that required college educations and special training.[39] As recently as 1988, the percentage of women working in this category was still only 5.8 percent.[40]

Rationalizations are often offered as to why women in Korea are seldom hired in the higher level technical and managerial positions. The reasons given are all based on the general feeling that generally

women are less competent and less responsible than men. The stereotyped explanation is that young and single women usually are unable to handle *all* the duties on the job, and that women are not serious enough about business. Married women are even less dependable, since they would be inclined to put family duties ahead of the interests of the employer.

Often, discrimination against women on the executive and managerial level has been easy to rationalize because few women have had the necessary education in engineering, accounting, finance, or management science. Where executive and managerial jobs have been less technical, however, women have also been excluded from jobs on the ground that they would not fit in with the male-oriented style of business that is carried on in Korea.

For a woman, promotion from within is not as good an entre to a management job as it might be for a man. Mrs. Kim Jung-Soon, a middle-aged Korean woman, had been working at a bank for seven years and expected to be promoted with an increase in salary. After a long wait, the time of promotion had arrived, but contrary to her expectation, a young man who had been working at the bank for a much shorter time got the promotion. Mrs. Kim, in fact, moved lower.

Even after attaining promotions, a woman in a desirable position is confronted by jealousy from both male and female associates. For example, a 28-year-old female graphic artist working at a government agency found the job too emotionally trying and she no longer works there. She reported psychological

pressure from jealousy of male co-workers after her designs were accepted for an important project.[41] To cope with sex discriminatory situations, women turn to outside activities such as seminars on flower arranging or other educational subjects. Most women workers use their outside activities as an escape and an excuse to get together with friends.[42]

For women today, opportunities for technical and managerial jobs in Korea for women today may be more available within the Korean government itself than with other employers. The government is certainly capable of providing technical and managerial positions for women, if it chooses to do so. At present, however, the Korean government is not a large employer of women in middle management. And there are few women working for the government at levels other than clerical. The main reason for optimism is that the government can be influenced by political considerations in its hiring and its personnel policies. Korean women do vote!

Women in the Professions

The Korean society today still does not fully recognize the legitimate position of professional women. Therefore, even when an educated female desires to work, seldom is there much incentive for her to pursue most professions. While there is a high proportion of women in the field of education, there are few women scientific workers, specialists, and administrators.[43] At the present time, the

industrialization of Korean society has done much to break down many of the old traditions.

Three professions which now offer the best opportunities to Korean women are teaching, medicine and law.

Careers in Teaching. The most important and popular profession for Korean women, in terms of available positions, is teaching, both at the university level and below. Teaching jobs range from teaching in elementary and secondary schools to teaching in colleges and universities. In universities, the basic practices of sex segregation and occupational segregation need to be eliminated. Certain areas of the curriculum are thought to be more suitable for women teachers than for men. This has the effect of excluding women from certain occupational areas.[44]

Even as late as 1989, female teachers had problems of job security. An example is Miss Bae, a grammar school teacher, who was told that since student enrollment was shrinking, some teaching jobs would end. Because she was a woman, her boss started to pack her things up, and she had to resign.

Careers in Medicine. After teaching, the next most numerous profession for women in Korea is medicine. Many doctors in Korea are women, which may derive from the days of the folk healers.

Women physicians may have some natural advantage over male physicians, if they choose to pursue it, by building large clienteles of women patients. Depending on the confidence they are willing to place in women physicians, many women prefer a female doctor to a male doctor, provided

there is no doubt about professional competence.

Careers in Law. Women lawyers are only a small percentage of the total number of lawyers in Korea. The Korean society and women themselves view law as a profession reserved for men, and think that teaching of law is best performed by men.[45] The number of women practicing as trial lawyers is far fewer than the number of judges.

The number of female trial lawyers entering the practice of law in recent years: one in 1988; four in 1986; two in 1972; and one in 1965 -- a total of eight. By contrast, in 1988, the number of female judges was twenty-nine.[46]

The relative scarcity of women trial lawyers may be partly explained by comments of a high-ranking employee at the Korean Embassy in Washington D.C.: "Women just cannot perform trials. Korea doesn't have such women yet," he continued. "Women can, however, just sit at a bench and listen to trials," he said, as if he had convinced himself again.[47]

This same official's view is that a lawyer's role calls for more aggressive actions than that of a judge. Aggressive behavior by women lawyers against men lawyers, even during a trial, would be difficult to accept in the male-preferential Korean society.

The legal profession in Korea is quite different from the legal profession in the U.S. In Korea, lawyers mostly serve a very small segment of the population who need protection in the political area. In America, there are more services offered by lawyers for the general population, and the legal

profession has many areas of specialties. The embassy official was surprised that lawyers in America might specialize in an area such as "real estate law."

Beyond the fact that the law can be a lucrative profession for college-educated women, it is also a field which should have special relevance for women. First, the law is probably the instrument which will actually bring about most of the important changes in the rights of women. It is therefore appropriate that women should become experts in the law in their own behalf. Second, women lawyers may very well have special insights in issues that relate specifically to women, and they may be more able than men to understand the women's point of view.

Recent Trends in Employment for Women

More and more, it is becoming an acceptable idea for women to earn money outside their own homes. This may be due in large part to the growing pool of educated Korean women. For Korea to get ahead on the international scene, utilization of these women to the highest advantage might even help to put Korea ahead of its international competitors economically. Even at present, however, among educated females, a very small percent pursue careers after marriage. This is due to social stigma and the absence of incentives and scarcity of job opportunities. Things are changing, however. As the society experiences change, more women will desire employment outside the home. If college-educated women are willing to seize the initiative,

advancement may become possible for educated women in the work force.

There is much change among younger married women in Korea. Increasingly they desire jobs or opportunities for participation in voluntary organization activities.[48] The Korean woman is now facing a new problem. As she becomes middle-aged, her husband becomes busier with work and social activities, and her children become more preoccupied with school life. A woman may begin to question whether to continue her leisurely, monotonous life. Confined to the housekeeping role, she feels isolated and secluded from society. Drug abuse among the housewives in Korea might explain their lack of self-esteem.[49] As a result of the change in Korean women, it is likely that women's demands for increased participation in social affairs will become more vocal.

As has been discussed in Chapter 4 on Women and Law, considerable progress has been made in recent years in removing legal discrimination against women. Since a woman's most precious financial asset may be her ability to go out and earn a living, the new law in 1989 against sex discrimination in employment may prove to be very important to Korean women. Enforcement of the new law may be difficult, but the fact that the law has been enacted indicates a change in public attitudes for the better. Too often in the past improvements in the law have been ignored, and discriminatory practices continued.

If women take seriously the enforcement of laws in their favor, the situation for women may

improve dramatically. The first indictment under the
new law was brought in November, 1988, by the
Women's College Student Association for the Seoul
metropolitan area. Six large firms were charged with
discriminatory hiring practices in connection with
"help wanted" advertisements in Korean newspapers.

One of the advertisers, an insurance company,
had run an ad for a sales management position. The
group of people to be managed were all housewives,
ages twenty to forty. The company specified that only
males under age twenty-seven would qualify for the
job. In addition, applicants with military service were
given an additional five percent in bonus points on
their test score.[50] How this type of case is decided
will determine whether the law is effective, or just a
dead issue that has little or no application in actual
practice. If women allow this law to be ignored, they
have only themselves to blame. Also, women need to
take the lead in insisting on their own rights. They
cannot sit by and expect others to do their work for
them.

Strategies for Women to Get Ahead at Work

Much of the advancement for women must be
led by women with higher education who enter one of
the professions, or are qualified for technical and
managerial positions in big businesses or government.
Interestingly, government and other large
bureaucracies are among the easiest places for women
to get ahead. Books have been written on the subject
that deal expressly with how women can advance in

the U.S. work place. The advice given in these books
may have some use for women in Korea as well.
Some of the suggestions, however, indicate that to be
successful in the more responsible positions, Korean
women may have to adjust their thinking and
behavior.

A concrete recommendation is given by Daisy
Fields, an American management expert:

> **When you attend a staff meeting, or
> any other meeting within your organization, .
> . . and are the only woman present, don't
> volunteer to take notes or serve the coffee. If
> you weren't there, the men would manage to
> get their own coffee. If you are asked to take
> notes, graciously decline and suggest a
> secretary be called in, or say you are no more
> competent at note taking than the others
> present. Said with a smile, and in a gentle
> voice, you will win the respect of your male
> peers. You will never be put upon a second
> time. If you behave as a professional, you
> will be treated as one.[51]**

Fields also warns against bringing one's
personal or family problems to the job, and advises
never to use such problems as an excuse for failure to
accomplish the assigned tasks. One must be assertive
without being aggressive. Self-esteem is critical, and
women must believe in themselves. Success in
business or the professions for women is, most of all,
not going to come without of hard work, persistence,
and self-discipline. Women should not do this just for
themselves, but should also do it for the good of other

women. A feeling of camaraderie with other women is required for women to get ahead.

Conclusion

Much of the discrimination against women in the work place is entrenched in the Korean culture, and has been present for hundreds of years. Although women did not invent the present system which works so devastatingly against them in the work place, they are in large part guilty of putting up with its continuance.

With the economic boom in Korea beginning in the 1970s, a large service economy has grown up, with many well-paid jobs in business, government and the professions. College-educated women have filled few of these positions, however. Much of this discrimination, of course, is a consequence of the type of schooling which women have had.

It has been the practice in most universities to discourage female students from entering certain "men's" courses. Until females are equally encouraged to enter all college courses of study, there will necessarily be discrimination against college-educated women in business, government and the professions. Without the right educational background, women will not qualify for the best positions.

Let us face the fact that at least some women are satisfied with the present system. They go to college only to become a desirable marriage prospect. After marriage, they do not join the work force but choose instead to enjoy the benefits of the system as it

is. Only twenty percent of all women college graduates enter the job market.[52] However, until the time comes when the Korean women with higher education enter the work force, the status of women in Korean society will remain low.

Notes

1. Upper class women of Korea never saw sunshine or the open air in olden days. James S. Gale, *Korea in Transition* (New York: Education Department, Board of Foreign Missions of the Presbyterian Church in the U.S.A., 1909), p. 49. See also Yung-Chung Kim, *Women of Korea: A History from Ancient Times to 1945* (Seoul: The Samhwa Publishing Company, Ltd., 1977), p. 134.

2. Kim, *Women of Korea*, pp. 50-51.

3. Ibid., p. 134.

4. Young-Sook Kim Harvey, *Six Korean Women - The Socialization of Shamans* (New York: West Publishing Company, 1979), p. 5.

5. Kim, *Women of Korea*, P. 14.

6. Ibid.

7. Wanne J. Joe, *Traditional Korea: A Cultural History* (Seoul: Chungang University Press, 1972), p. 11, cited by Young-Sook Kim Harvey, *in Six Korean Women*, pp. 6-7.

8. Harvey, *Six Korean Women*, p. 6.

9. Ibid., pp. 11-14.

10. Kim, *Women of Korea*, p. 133.

11. Harvey, *Six Korean Women*, p. 4.

12. Kim, *Women of Korea*, p. 129.

13. Ibid., pp. 129-30.

14. Harvey, *Six Korean Women*, p. 3.

15. Ibid., p. 11.

16. Kim, *Women of Korea*, p. 134.

17. Ibid., p. 135.

18. Ibid., p. 137.

19. Ibid., p. 138.

20. Ibid.

21. Ibid.

22. Ibid., p. 139.

23. Cornelius Osgood, *The Koreans and Their Culture* (New York: The Ronald Press Company, 1951), p. 258.

24. Ibid., p. 259.

25. Robin Morgan, ed., *Sisterhood is Global*, ed. (New York: Doubleday Press, 1984), p. 401.

26. Ibid., pp. 401-02.

27. Interview with Kum-Soon Park, President of The Korean Women's Association, Seoul, Korea, September 8, 1988.

28. Ibid.

29. Nena Vreeland, et al., *Area Handbook for South Korea*, 2d ed. (Washington, D.C.: U.S. Government Printing Office, 1975), p. 54.

30. Ibid., p. 57.

31. Hyo-Chai Lee and Chu-Suk Kim, "The Status of Korean Women Today," *Virtues in Conflict*, ed. Sandra Mattielli (Seoul: The Samhwa Publishing Company, Ltd., 1977), p. 152.

32. Dug-Soo Son, "The Status of Korean Women from the Perspective of the Women's Emancipation Movement," *Korean Women in a Struggle for Humanization*, ed. Harold Hakwon Sunoo and Dong-Soo Kim (Montclair, N.J.: The Korean Christian Scholars Publication No. 3, Spring, 1978), p. 278.

33. Vreeland, *Area Handbook for South Korea*, p. 97.

34. Morgan, *Sisterhood is Global*, p. 401.

35. Son, "Emancipation Movement," p. 280.

36. Ibid.

37. Soon-Young S. Yoon, "The Role of Korean Women in National Development," *Virtues in Conflict*, ed., Sandra Mattielli (Seoul: The Samhwa Publishing Company, Ltd., 1977), p. 157.

38. Ester Boserup, *Women's Role in Economic Development* (New York: St. Martin's Press, 1970), p. 56.

39. Lee and Kim, "Status of Korean Women Today," p. 152.

40. According to *Han Kook Ilbo*, Washington, D.C. edition, June 2, 1988, the breakdown of women in the workforce by educational level was as follows:

Educational level	Totals	Pctg.
College-educated	384,000	5.8
High school graduates	1,792,000	27.1
Middle school graduates	1,387,000	21.0
Elem. or lower	3,054,000	46.1
Total women in work force	6,617,000	100.0

41. Barbara R. Mintz, "Interviews with Young Working Women in Seoul," *Virtues in Conflict*, ed., Sandra Mattielli (Seoul: The Samwha Publishing Company, Ltd., 1977), p. 188.

42. Women with a college education are treated very low in office situations. They are expected to run errands for cigarettes and pour tea for their male colleagues, for example. In order to overcome their extreme weariness and boredom, college educated women office workers often attend meetings or seminars after work in areas that interest them. *Korean Women and Work*

(Seoul: Ewha Women's University Press, 1985), p. 116.

43. *Women in Korea 1980* (Seoul: Ministry of Health and Social Affairs, Republic of Korea, 1980), p. 11.

44. According to a sampling of opinion of male and female faculty members in four Korean colleges and universities, Korean society overall is strongly inclined toward the view that men are superior to women in many areas in the field of higher education. This includes teaching ability in chemistry and physics, business administration, law, medicine, political science, philosophy, engineering, and mathematics. Women are also considered to be deficient in personnel management, fund-raising, organizing ability, logical thinking, and finance management. Obviously, these jobs are quite important to any modern day, high technology society from an economic point of view. Ducksoon Yu-Tull (Diana Yu), "An Investigation of Attitudes and Perceptions of Educators in Korean Higher Education Toward Job Performance Ability of Women in Korean Higher Education" (Ed. D. Dissertation, The George Washington University, Washington, D.C., 1983), p. 252.

45. Ibid.

46. Speech given at The George Washington University, Washington, D.C. on September 7, 1988, by Kum-Soon Park, President of The Korean Women's Association, Seoul, Korea.

47. Interview with General Counsel, Ban Ki-Moon, The Korean Embassy, Washington, D.C., September 7, 1989.

48. By tradition, married women are not supposed to work outside their homes for pay. Under this situation, most women simply do not choose to hold productive jobs. Some women with many leisurely hours on hand, work as volunteers for organizations. Lee and Kim, "Status of Korean Women Today," p. 149.

49. "Drug Problem Escalates in South Korea," *The Washington Times*, March 29, 1990.

50. *Dong A-Ilbo*, Washington, D.C. edition, October 26, 1989.

51. Daisy B. Fields, *A Woman's Guide to Moving Up in Business and Government* (New Jersey: Prentice-Hall, Inc., 1983), pp. 168-72.

52. Only twenty percent of Korean women with a college degree enter the job market with the result that women workers are mostly found in low-level jobs which do not require a high level of training. *Dong A-Ilbo*, Washington, D.C. edition, October 26, 1989.

PART TWO

CHAPTER 8

Koreans in America

Over the last 100 years, a great diversity of Koreans have immigrated to the United States for one reason or another. To them America has represented a place of refuge and safety, and sometimes the opportunity to start a new life. Many have come intending at first only to stay a short time, but they and their families have ended up making America their home. In many ways, they have become more American than Korean, and their children are very similar to other Americans.

Korean-Americans should never forget that America helped them when they needed it most, providing a place in which their future was not limited by the past. America is a country where hard work and intelligence usually has resulted in success.

Before the Korean-American friendship treaty in 1882, few Koreans had traveled to the United States, either to visit or to settle. In fact, very few had even travelled to China or Japan. Between the time of the 1882 treaty with the United States and the

1910 annexation of Korea by Japan, Korea was in political turmoil and economically dislocated. This was made all the worse by the stubborn refusal of the Yi Dynasty to accept any exposure to the modern world.

Meanwhile, at the same time that Korea was vainly attempting to keep itself isolated from contact with the Western world, several other countries had their eyes on her wealth of natural resources. Japan which had so few natural resources of its own, was especially interested. The Yi Dynasty tried to keep itself diplomatically under the protection of China to preserve the existing situation. Many internal political opponents of the Yi regime favored Japan because of the progress that Japan had made in opening up to Western influences. The United States government was also interested in Korea. Although the United States was not a geographic neighbor, business interests in the United States were eager to open up investment opportunities in mining and railroading.

During this period of political and economic unrest, some Koreans came to the United States, first for political and later for economic reasons.

Political Refugees and Students

During the late 1800's and early 1900's, some refugees fled Korea for political reasons, and a few students travelled abroad to become familiar with civilization in the west. Many of these immigrants travelled no farther than Japan, but some refugees and students went to the United States.

Three major political opposition leaders fleeing from Korea to America were So Chae-Pil, Park Yong-Ho and So Kwang-Pum.[1] They had escaped from Korea following their unsuccessful *coup* against King Kojong in 1884. Their activities have been previously described in Chapter 6 on Women and Politics.

Of the first Korean students coming to America, most were men. One of the early women students, however, was Ha Nan-sa, also known as Nancy. She was the first Korean woman student to study in the U.S. without scholarship assistance from America.[2] She was married to a wealthy man in Korea who financed her studies, first at *Ewha Haktang*, and later in America. In 1896 she went to Wesleyan Women's College in Ohio to study English literature, and received her B.A. in 1900.

Another early Korean student coming to America was Ahn Chang-Ho, who came to San Francisco's Korean community in 1899 to study Western civilization. By that time there were a number of Korean immigrants living in the Bay Area. Although Ahn did not run for political office, he became one of the best-known Korean community leaders in America.

One day while still a student, Ahn enacountered two native-clothed Korean men having a fist fight while a crowd of Americans were watching. Ahn was humiliated by the thought that the Americans might conclude that Koreans were uncivilized and unable to control themselves, so he stepped in personally between the two men and got them to stop fighting.

Questioning the men, he found that they were competing ginseng merchants in San Francisco's Chinatown section, and that one had accused the other of invading his territory and stealing his customers. Ahn could see that the Korean community lacked leadership so he took on the job personally. Ahn's friends supported him and provided his living expenses while he was serving the general welfare.

Ahn's first concrete step was to visit all Koreans in the Bay Area. He found their living quarters often had no curtains and that the windows were dirty. The houses had no plants or flowers, were dirty, and smelled bad. Some of the Koreans were so loud and obnoxious that they had driven away their neighbors.

Ahn began his community service by furnishing a free house cleaning service. He cleaned windows, rooms, and front and back yards. At first some Koreans suspected his motives and refused the services. But as time went by they began to understand his motives and cooperated with him. Within a few months the Korean community had changed its lifestyle dramatically. Flowers and trees had been planted in every yard. In addition, the Koreans became more courteous and respectful to each other. In this way Ahn won the respect of his fellow countrymen and became their friend and advisor.

Ahn also worked effectively to integrate Koreans into the broader American community by organizing a Korean employment agency. He introduced American employers to qualified Koreans looking for work. This helped Koreans in the Bay

Area to find good jobs at reasonable wages and become integrated into the American community.

Ahn worked diligently behind the scenes for the Korean community. One American landlord who rented his house to a Korean said to his tenant: "I think that the Korean people must have gotten a wonderful leader recently . . . because your lifestyle has changed drastically, and it must have come about due to a new leadership." The tenant told the landlord about Ahn. The landlord wanted to meet him in person. He was surprised to find out that this new leader in the Korean community was only twenty-two years of age.[3]

To show appreciation to Ahn, the landlord gave the tenant one month free rent and also made available a rent-free meeting place for the Korean people in San Francisco. This was the first Korean mass meeting place in San Francisco. Under Ahn's leadership, the first Korean social organization, the Friendship Society (*Chin Mok Hoe*), was organized in 1903. Two years later, under the leadership of Ahn, the first Korean political organization, the Mutual Assistance Association (*Kongnip Hyop Hoe*) was formed. The major activity of this organization was to locate employment for the Korean immigrants.[4]

Korean Laborers in Hawaii

Between 1903 and 1905, over 7,000 Korean workers immigrated to Hawaii to work on Hawaiian sugar plantations. They had been preceded first by Chinese and later by Japanese workers. Since about

1850, the Hawaiian sugar industry had expanded to such an extent that the plantation owners had to bring in farm laborers from outside the islands to work in the cane fields. The first group that came to the islands were Chinese workers from Hong Kong. They were employed on a three-year contract. The contract was renewable at the end of the term for another three years. At the end of the term, however, the Chinese laborers would go to cities in Hawaii and successfully look for better jobs. Since the Chinese offered to work for much less than the natives would, they generated hostility from the established residents whose jobs they took.

In 1882, Hawaii wanted to become a U. S. territory. The U.S. Congress passed the Chinese Exclusion Act, stopping all Chinese from immigrating to the U.S. or its possessions. Wanting to follow a policy consistent with the U.S., the planters began to hire laborers from Japan. Unlike the Chinese before them, however, the Japanese workers often refused to endure what they considered ill treatment. When their grievances were not heard they would band together and strike. In just five years, 1900 to 1905, the Japanese workers struck thirty-four times. Many simply quit working for the sugar plantations. The planters began to look elsewhere for their labor supply.

By 1900, there were more Japanese than Chinese working on the sugar plantations. Like the Chinese, at the end of their contracts, the Japanese went to town and looked for jobs. The Japanese were viewed by the native Hawaiians as a worse threat than

the Chinese had been because there were more of them. Over seventy-five percent of the labor force in the Hawaiian Islands was Japanese at that time. The natives feared that the Japanese might one day take over Hawaii.

On one hand, the planters wanted Oriental workers because they were cheap labor, but the native Hawaiians didn't like seeing the "yellow race" taking over the islands. By 1896, under public pressure, the Hawaiian government passed a law requiring that ten percent of the laborers brought in to work in the fields be other than Chinese or Japanese.[5] Koreans were not specifically mentioned in the law, doubtless because no Koreans were then present in Hawaii.

The most important names in discussing the later mass Korean labor emigration to Hawaii are Horace Allen and his business associate, David Deschler. Allen had started in Korea as the personal physician to King Kojong. He became the King's closest trusted personal advisor, particularly in the field of foreign affairs. When Allen's political influence with the King was recognized by the U.S. government, Allen was persuaded to take a position with the U.S. State Department at the embassy in Korea. Allen later became the American Ambassador to Korea. He was not only valuable for his contacts with King Kojong but also with other members of the Korean ruling class and with the American missionaries in Korea.

Guided by the opinions of his missionary friends, Horace Allen became convinced that it would be a good idea for several thousand economically

disadvantaged Korean farmers to emigrate to Hawaii to work on the sugar plantations. He discussed the idea with the King and received permission to go ahead with the plan.[6] This pleased the plantation owners who needed the cheap labor. It pleased the missionaries who saw the Koreans as potential converts to Christianity. King Kojong also was especially pleased that Chinese workers were being replaced by Koreans.[7]

After the plans to bring the Korean laborers were approved, there was still the matter of their transportation to Hawaii. The Hawaiian Sugar Planters Associates sent a representative to make transportation plans for the Korean laborers to go to Hawaii. An American ship owner named David Deschler arranged the transportation. An old acquaintance of Allen's, Deschler was paid $55 for every Korean sent to Hawaii on his ships.

Although all the authorizations finally were in place, the Korean workers still had to be convinced. They were reluctant to leave their homeland because they would be travelling so far from the grave sites of their ancestors. They had worked in Japan and Russia before but those countries were close to Korea. The Koreans had always been able to return home for memorial services. Hawaii however was, a long way across the Pacific Ocean. For many of those who decided to go, Hawaii appeared to be a tropical paradise in comparison to Korea where there was not enough food and clothes.

By January 13, 1903, the first Korean workers, 121 in all, left Korea and arrived in Hawaii. Korean

immigration over the next three years brought 7,347 Koreans on sixty-five ships to the Hawaiian islands. From 1903 to 1905, 7,026 Korean workers came to Hawaii under three-year labor contracts. When the contracts ended, all but about 2,000 of the 7,026 remained in Hawaii. The annual totals were 1,133 in 1903; 3,434 in 1904; and 2,659 in 1905.

Among the immigrants, ten percent were females, ninety-three percent were adults and seven percent were minors. Only thirty-five percent were able to read and write. The remaining sixty-five percent were illiterate. Only forty percent claimed to be Christians and the rest were members of Buddhist and other Korean indigenous religious groups.[8]

Most of the Korean sugar plantation laborers were originally from North Korea. There were several reasons for this. Contrasted with the abundance of farm land and the temperate climate in South Korea, life in North Korea's rugged mountains was harsh. The people in North Korea also were closer to the action in both the Sino-Japanese War and the Russo-Japanese War. They experienced the economic dislocations caused by the fighting.

Many had lived in barracks near Inchon, a port city west of Seoul. Most of these immigrants were from poor families without education and social connections. Horace Allen wrote to the Governor of Hawaii:

> Koreans are too poor to finance their own emigration. The government (Korean), is not only unable to loan money to these emigrants, but when they return, the

**government might take money away from
them by force.**[9]

A final reason that these North Koreans desired
to leave Korea was that they had suffered considerable
political and social discrimination. The higher
government officials of Yi Dynasty were from
southern *yangban* families. Many of the immigrants
simply longed for a better life, so when they saw the
opportunity, they jumped at it. Most however, looked
forward to saving up a nest egg and returning to their
ancestral lands.[10]

After arriving in Hawaii, most of the
immigrants were quite disappointed. Far from living
in a tropical paradise, plantation labor was harsh
beyond their expectations. Daily humiliation from
unsympathetic bosses was at times too much to bear.
A typical day was described by a worker in a
newspaper:

> I got up at 4:30 in the morning and went to
> work at 5. We started working at 5:30
> A.M. and ended at 4:30. We only took 30
> minutes for lunch. Once we started working,
> the foreman forced us to have our shoulders
> stooped and did not allow us to straighten
> up. We were treated like animals - working
> horses and oxen. The foreman, usually
> German or French, often slapped us across
> our faces. But for fear of dismissal, we
> didn't fight back. We were simply numbers.
> We had identification cards with numbers
> and the foremen used the numbers instead of
> our names.[11]

It was common for the foremen to whip the workers with a leather belt when he felt they were getting out of line.[12] The Korean workers launched a covert operation against the ruthless treatment by the foremen. One of the tricks played was putting urine into the foreman's coffee barrel.[13]

The lives of Koreans on the plantations were difficult. Lacking language facility compounded their difficulties. One of the plantation workers, Mr. Lee, remembered an incident illustrating the difficulty experienced by Koreans unable to speak English. Soon after arriving at the sugar plantation, Mr. Lee and a friend, Mr. Choi, went on an egg-buying visit to a local market. Attempting to communicate, Mr. Choi covered his balled-up fist with a handkerchief from his back pocket. He put the balled-up hand behind his buttocks and made the sound of a hen that has laid an egg. The shopkeeper, with a smile of understanding, sold the two men a dozen eggs.[14]

Still another incident shows the mental state of the Koreans when they arrived in Hawaii. Homesick for Korea, some laborers kept wearing Korean traditional white garments of loose trousers and a top jacket with a bow in the front. Some even wore their hair long and tied on top of their heads. As a symbol of being *yangban*, some men would wear black top hats made of horse hair. One day, when a man dressed in Korean attire with a top hat was riding a motor trailer, the wind blew off his hat. "*Ai-goo!*" he lamented. He was scared about losing his only hat. He tried to catch it with the help of several riders. This created such a commotion that the non-Korean

driver threatened to sue the man who lost the hat. All
the Koreans on the motor trailer got together and
apologized to the driver and promised never to repeat
the incident. After this no one wore a Korean
garment and hat to work.[15]

Korean immigrant women in Hawaii did not
have an easy life. They had to work as hard as the
men. Kim Tai-Hyun, at age eighty-six, quietly
reflected on her life in Hawaii:

> I came to Hawaii at age seventeen, and my
> husband and I were already married. The
> sun was hot and we had to make our home at
> the barracks provided by the plantation. I
> worried and didn't know how to make a
> home in that little barracks. My first job
> was keeping a boarding house for the single,
> unmarried Korean men. I cooked and
> washed for twenty-one of them. I charged
> seven dollars for one month. That seven
> dollars a month included three meals a day
> and washing their clothes. Seven dollars
> wasn't enough to cover my expenses even in
> those days, but the workers weren't making
> much money and they were sending some
> back home. To economize, I planted corn to
> stretch rice, cabbage and red pepper for
> kimchee. To make soup, I went to the
> butcher shop and bought the internal organs
> of cows and pigs. For laundry, I went to the
> river and hung our clothes up to dry. I had
> to get up at 3:30 every morning.[16]

The export of Korean laborers to Hawaii lasted
only three years and was finally stopped in 1905 after

Japan won its war with Russia and declared Korea a protectorate. Japan had her own reasons for wanting an end to the migration of cheap Korean labor to Hawaii. She used her influence to bring about this result, but the actual order banning the practice came from the Korean King. From the beginning, many Korean officials had objected to what they believed was selling Koreans into slavery abroad. In January of 1905, a particular case of abuse came up involving Korean workers who had been sent off to Mexico and mistreated. The Korean emperor complained to Allen's U.S. Foreign Office. The same day the King stopped all future migrations of laborers to Hawaii and Mexico.[17]

Picture Brides

Some stories about the Korean laborers in Hawaii are interesting, especially those describing the use of the "picture bride" system to induce women from Korea to join them in Hawaii. About eighty percent of the 7,000 Koreans in the labor camps were unmarried. Most of the men were of marriageable age in their early thirties and some had even passed the desirable marriage age. To amuse themselves, after ten hours of work every day, the men got together, drank, gambled, gossiped, and got into fistfights.[18]

Sexually starved, the laborer's lives were dull and boring, and they longed for female companionship. Interracial marriages were unthinkable by the conservative Korean men. The workers felt that having Korean women as wives was

a "necessary commodity in preserving the ethnic identity of the Korean community."

To make the Korean laborers feel more settled and to relieve the sexual tensions, both the U.S. immigration authorities and the plantation owners were glad to put the "picture bride" system into operation so Korean wives could be found for the workers. A similar system had been used by the Chinese and Japanese in prior years when they had been faced with the same problem.

In theory the system was simple and straightforward. Through a marriage-broker as intermediary a couple would exchange pictures and information about each other. If a woman liked what she saw she would communicate that fact to the marriage-broker. Then the man would forward $100 to the prospective bride for travelling expenses. Upon arrival on the dock the couples would be married, so the brides would be entering the U.S. legally.

There was room for deception in the picture bride system, however, and sometimes the results were amusing. Ideally, a man would want to send an attractive picture of himself dressed in a dark business suit. Prospective picture brides would typically be quite impressed with the idea of marrying a man who had travelled in the West and who looked successful.

Many of the Korean laborers were past the ideal marriage age and were also too poor to own a business suit. To solve these problems, a group of men would rent a suit in common and go to the photographer's together. The men sometimes simply sent the best picture to the marriage broker.

Love at first sight was not going to happen for most of these couples. When the brides landed at the dock, they looked for the young man wearing the dark suit that they remembered from the picture. It turned out, many men sent deceivingly young pictures of themselves.[19] Little did the women know that the men had shared one suit to pose for the picture. In some cases, the prospective brides had their hearts set on marrying a different man from the one waiting on the dock.

Picture brides often came from relatively well-to-do families. Based on the pictures and other information they had been given, these women expected prosperous-looking gentlemen to be waiting for them on the dock. They also knew that Hawaii was a part of America and America was a rich country where, they thought, roads were paved with gold. To most Koreans at the time, America was like heaven. When they first saw their men at the dock, however, many were shocked.

The men usually looked much older than they had appeared in the pictures. Their faces were dark and leathery from daily labor in the sun. The average age of the men was forty-two and the average age of the women was twenty-seven. The men were not as rich as these women had been led to believe by the matchmakers. Also, their hands were rough from menial labor.

"Ai-goo!" (Oh! no! God help me!) Some of the women fainted with disappointment at the looks of the men standing at the dock. Some refused to land and some went right back home.[20]

Many young Korean women saw marriage through the picture bride system as an opportunity to get what they thought would be a rich husband and a chance to liberate themselves from restrictive customs. Any relief from the Korean custom of confining women inside the home appealed to the young women. One 85-year-old grandmother in California recalls:

> **Marriage, that was the second consideration, I just couldn't wait to get away from the prison, my father's home. I couldn't go out of the wall of our house for over two years. My teacher was brought into my house so I didn't have to go out to school. I didn't care who I married. I just wanted to get away.**

Yet another woman, Mrs. Nam, had a different reason for agreeing to be a picture bride.

> **When my friend showed me a photograph of a man in Hawaii, I decided to marry him right away. Because my parents had ten children and I grew up in Kyungsang Province, in the southern part of Korea, we never had enough money to buy clothes for all of us. Honestly speaking, I was more interested in his money than in his looks.**

Between 1910 when the first picture brides came to Hawaii from Korea and 1924 when the Oriental Exclusion Act was passed, over 800 picture brides settled in Hawaii. They also went to various other mainland cities such as San Francisco, Los

Angeles, Sacramento, and Portland, Oregon. Because of the Oriental Exclusion Act, the next migration of Koreans to America was not to come until the end of the Korean War in 1952.

War Brides

The first Korean migration following the end of the Korean War was overwhelmingly female. Later male and female Korean students came to America to study. The first large wave of Korean immigration consisted of the wives of American servicemen or other personnel who had been stationed with the various United States government agencies in Korea. Many American men were stationed in Korea and became intimately acquainted with Korean women who worked on or near the bases and other U.S. related offices. By the time of the cease-fire in 1953, many American men had married Korean women and brought them to the United States. They are often called "War Brides" because the union with their husbands was related to the Korean War.

According to figures compiled by the United States Immigration and Naturalization Service, between the years 1950 and 1964, of the 14,027 Koreans who migrated to the United States 6,423 were Korean wives of U.S. servicemen - the largest group of Korean immigrants to the U.S.[21]

Although frequently overlooked, some of the women in this group should be regarded as the principal founders of the Korean American community as we know it today. This is because many of the

later immigrants were relatives whom the "war brides" sponsored. These women deserve to be thanked for the safe settlement of their many family members.

College Students

An important group of immigrants were the Korean college students who first started coming to the United States around the 1950s. Although numerically a small group compared to the war brides, the student immigrants were quite significant because many of them remained in the country and became the core of the initial leadership in the Korean American community.

Most of the students who came were male, mainly because very few families were willing to make the financial commitment to send a female to America. One of the few women students remembers, "I was the only female when I took the exam from the Ministry of Education and from the Ministry of Foreign Affairs. I used to not talk to any one too much because they were all men."

Before coming to the United States, most of these students had initially entered Korean colleges and universities. At the time, however, many felt that obtaining an American college degree and American experience was much more desirable than remaining in a Korean school. There was a craze to attend school in America.

Sometimes students would forego attending highly rated Korean educational institutions for smaller and less highly rated schools in America. An example

is Jin-Shi Park, who had passed the rigorous entrance examination for the School of Engineering at the Seoul National University, one of the most prestigious universities in Korea. But before attending one full semester, Jin-Shi transferred to a small Methodist-sponsored college located in a mountain village in West Virginia.

In 1950s, qualifying oneself to enroll in a foreign school was quite difficult. Before coming to the United States, students had to pass the rigorous academic examinations required by various Departments of the Korean government such as the Ministry of Education and the Ministry of Foreign Affairs. They also had to pass the written exam required by the United States Embassy to get a visa. These students, however, were the "cream of the crop" of students in Korea. Going to the United States was considered advantageous during the 1950s when Korea was in a devastated condition after the Korean War. Hyun-Sook Chung, a female student, recalls:

> **We didn't even have decent paper to write on, and I went to Ewha Women's University, the most prestigious women's school. I just wanted to come to America. I studied English every day, although my major was in Fine Arts.**

Some of the students had missionary connections, and some even had family members already in America. For most, however, coming to America reflected a pure determination to break away

from the poverty and political corruption in Korea, and from what appeared at the time to be a limited future.

For many students, the information about coming to the United States to study was obtained from a small but popular guidebook printed on cheap brown paper, entitled, *Oegook Yuhak* (*Study Abroad*). This book was available in some of the few sparsely stocked book stores in Seoul. The book listed the schools in the United States with details as to name, location, size of student body, affiliation (whether private or public), number of foreign students, how to apply for admission, tuition, and type of scholarships available, etc. I was one of the beneficiaries of this small guidebook. The cost of the book, about fifty cents, was well worth the price.

At that time, most Korean students were unaware of the size of the United States and often talked with friends about getting together in America someday when they too would be coming to study in the United States. Whenever two friends ran into each other in Seoul, they would ask, "*Unjae kahni?*" (When are you leaving?), which meant, "When are you leaving for the U.S.?" Coming to America to study in the 1950s was a popular venture envied by one's contemporaries.

Most of the early students were sons and daughters of middle and upper class parents, and had a basic knowledge of the English language. One motivation for coming to the United States to study was the widespread belief that in America college students could support themselves either by working at

a job or by receiving a scholarship. During the 1950s, such options as students working, going to college, and also being able to receive scholarships were not considered available in Korea.

At first, most of the students planned to get a degree from a U.S. institution of higher learning and then return home for a high position and almost certain financial and social success. Later, as it turned out, many of these student immigrants would decide to stay in America. Chong-Soo Kim is a good example. Mr. Kim had a tuition scholarship from a college in Birmingham, Alabama. Each summer he got a job at a local shoe store and make almost enough money to cover his room and board expense. In addition, he was able to send some money back to his parents in Korea. This was a good deal for a young student from war-torn Korea in the 1950s. For females, coming to America meant liberation from the age-old tradition of women's discrimination. Young-Sook Kim reveals,

> My mother wanted me to have better life than the one she had in Korea. My *komoh* (father's sister) objected to my coming to America, "Why bother? She is just a daughter." My mother had fought back, "I want my daughter to have the chance I couldn't have." Mother thought going to America meant freedom and sex equality. Actually, studying in college was not the main purpose of my coming to the U.S.

Adopted Children

Another numerically significant group of Korean immigrants who came about the same time as the War brides and the college students, were the Korean children adopted by American families. Between 1950 and 1964, the official number of such children who emigrated was 5,348. The number of Korean children adopted between 1953 and 1975 is listed as 35,000. The largest adoption agency, the Holt Adoption Program, reports that it had placed over 2,000 Korean children each year in America and other countries between 1972 and 1977.[22]

In this group, however, girls far outnumbered boys. The most likely explanation is that the strong Korean boy-preference tradition created a larger pool of girls for adoption by foreign families. It is difficult to believe the alternative explanation that the large number of girls indicates that American families have a strong preference for girls over boys.

Post-1965 Immigrants

In 1965, the U.S. Congress radically altered the rules for immigration, and laid the base for the largest Korean migration to America. The new rules introduced a provision giving priority to persons with special training deemed to be of use to the U.S. In addition, however, and fortunately for the families of the war brides, the new rules also permitted immigration for the purpose of reuniting family members. This latter provision of the new law made

it possible for war brides, and for other Koreans once they became American citizens, to invite members of their families to America.

The flood of Korean immigrants to the United States after 1965 was composed principally, at least at first, of the brothers, sisters, parents and other relatives of the immigrants who had been students or war brides. Later, after attaining U.S. citizenship, the post-1965 immigrants began sponsoring immigrants on their own.

In number, the post-1965 group of immigrants has been the largest group of Korean immigrants ever to have come to America. According to the U. S. Immigration and Naturalization Service, between the years of 1965 and 1980, 299,000 Koreans immigrated into the United States. An additional 200,000 arrived between 1980 and 1986, averaging 33,000 per year.

Korean immigrants have spread throughout the United States. However, most settled in states already having large Oriental populations such as California and New York. Many have gone to large cities such as Los Angeles, San Francisco, New York and Washington, D.C. In 1987, the main states in which Korean immigrants settled were California (41%), New York (16%), Illinois (8%), New Jersey, Pennsylvania, Texas and Maryland (6% each), and Virginia (5%).[23]

Current Korean-American Community

In 1990, the total Korean community in the United States is probably approaching one million

persons. In arriving at an accurate understanding of the Korean community in America today, it is helpful to distinguish between four clearly identifiable generational groups, since they are so different in their social and psychological characteristics.

The first group is the *ilse* (eel-say) generation. These are first generation immigrants to America, namely, the ones who were born in Korea. Second is the *ese* (ee-say) generation. These are second generation Koreans, the first generation born in America. The third group is the *samse* (sahm-say) generation, also born in America. These are the sons and daughters of the *ese* generation. The fourth group is the so-called *iljum ose* (eel-jum oh-say), or "1.5" generation. This latter group is sometimes called the "knee-high" generation. These individuals were born in Korea, but arrived in America when they were very young.

The *ilse* generation are the least Americanized of all four groups. This group now is an important asset for the Korean community, but also represents one of its more serious problems. These people are assets because they try to pull the Korean American community together and instill respect for Korean traditions into the younger generation. Yet they can cause problems by leading the younger generations to focus too much on Korean traditions and Korean language. There is a need to accommodate to American culture and to learn the English language. In this way, *ilse* Koreans have sometimes had an overall negative influence by holding back assimilation of Korean immigrants into the American mainstream.

A very large and growing portion of the Korean American community consists of the *ese* and *samse* generations. They were born in this country, and are, therefore, not included in the official immigration statistics. In examining the characteristics of the present day Korean community, however, it is helpful to look at the immigration statistics to see the probable number of *ilse* and 1.5 generation Koreans in the population today. More and more they are becoming outnumbered by the *ese* and *samse* generations who were born in the U.S., and also by what is known as "half and half" children, the children of Korean-mixed parentage.

Notes

1. Bong-Youn Choy, *Koreans in America* (Chicago: Nelson-Hall, 1979), pp. 71-72.

2. Young-Chung Kim, *Women of Korea - A History from Ancient Times to 1945* (Seoul: The Samhwa Publishing Company, Ltd., 1977), pp. 229-30.

3. Choy, *Koreans in America*, pp. 80-81.

4. Ibid.

5. Wayne Patterson and Hung-Chan Kim, *The Koreans in America* (Minneapolis, Minn.: Lerner Publications Company, 1977), pp. 17-20.

6. Ibid.

7. King Kojong was rather pleased that the Korean laborers were appraised as diligent and obedient workers and invited by the Hawaiian plantation workers, while the Chinese workers were being thrown out. *Dong A-Ilbo*, Washington, D.C. edition, May 31, 1989.

8. Choy, *Koreans in America*, p. 77, citing Won-Yong Kim, *Chaemi Hanin Osipnyon-sa* (Fifty-year history of the Koreans in America) (Reedley, Ca.: Charles Kim Ho, 1959,), pp. 6-7.

9. *Dong A-Ilbo*, Washington, D.C. edition, June 29, 1989.

10. Dong A-Ilbo, Washington, D.C. edition, June 17, 1989.

11. *Dong A-Ilbo*, Washington, D.C. edition, June 26, 1989.

12. *Dong A-Ilbo*, Washington, D.C. edition, June 13, 1989.

13. *Dong A-Ilbo*, Washington, D.C. edition, June 9, 1989.

14. Choy, *Koreans in America*, p. 295.

15. Ibid., p. 294.

16. *Dong A-Ilbo*, Washington, D.C. edition, June 22, 1989.

17. Patterson and Kim, *The Koreans in America*, pp. 26-27.

18. Choy, *Koreans in America*, p. 88.

19. Ibid., p. 89.

20. *Ibid.*, pp. 88-89.

21. Eui-Young Yu, "Korean-American Women: Demographic Profiles and Family Roles," *Korean Women in Transition At Home and Abroad*, ed. Eui-Young Yu and Earl H. Phillips (Los Angeles: Center for Korean-American and Korean Studies, California State University, 1987), p. 185.

22. Dong-Soo Kim, *Children Today*, vol 6, 2 March-April 1977, p. 2.

23. U.S. Immigrants Admitted by Selected States of Residence and Country of Birth, 1989, *Statistical Abstract of the U.S.* (Washington, D.C., U.S. Department of Commerce, 1989)

CHAPTER 9

Life in a New Land:
Post Korean War Immigrants

Immigrants coming to America following the Korean War differed from each other in their expectations of America. The differences were associated with their identity as war brides, students, post-1965 immigrants, men or women. At first the existing Korean community in America was so small and dispersed that the main problem of the immigrants was loneliness for other Koreans. Especially for war brides and students, the assimilation to American ways was emotionally quite difficult. Their immersion in American society and simultaneous isolation from things Korean was total and unrelieved. On the other hand, this type of assimilation was also quite effective and perhaps eventually less painful.

After 1965 the U.S. immigration rules were relaxed for relatives of U.S. citizens to permit family reunification. By this time, Korean communities had grown large enough in many of the larger U.S. cities,

so that in Koreatown, Los Angeles, for example, it was difficult to believe that one had left Korea. Although living within these protected communities was initially easier, it was more difficult for these latter immigrants to assimilate into the new society.

Emotional strain for many Korean immigrants has also increased because of changes in American society brought about by the American women's liberation movement. Many American men and women embrace the idea that preferring one sex over the other is morally wrong. Although some Korean women have begun to favor the idea of sex equality, many Korean men prefer that things remain as they remembered them in Korea.

War Brides

The war brides came to the U.S. by the thousands, beginning in the early 1950s. Most of them were married to men who either remained in the armed services,or went on to jobs in the civilian economy. Usually the war brides were not particularly bothered by economic problems. Also, most war brides were fairly proficient in English. Those who wanted to find employment could do so. The most serious problem the war brides experienced was purely psychological -- loneliness for the company of other Koreans.

In 1964, Mrs. Flowers met and married a U.S. Defense Department employee stationed in Seoul. In 1967, with their two year old daughter, Mr. and Mrs. Flowers moved from Korea to Alexandria, Virginia.

After a short time, feeling depressed, Mrs. Flowers "awakened to the reality that she had ruined her life by marrying a foreigner." She wanted to return to Korea but that was difficult to do.

Mrs. Flowers further confessed to me:

> I would lock myself in our bedroom with my child and wouldn't let my husband in. I asked him to send me back to Korea. He was understanding and didn't fight me, but I didn't end up leaving. When I had my second child, I finally decided to calm down, and told myself that I better get settled down for the children's sake. I started immigration procedures in 1967 to bring my family as soon as I could. My husband knew how important it was to me, and he was really supportive.
>
> My parents came three years after I arrived. My brother and two younger sisters followed in 1973. We have had to work hard. My 36-year-old brother has had to do menial work as a carpenter, but I am feeling very much at home in America now. Now my youngest sister is eighteen years old and goes to college. There is always a lot going on in my household. My husband is very supportive of all that's happening with my family. My parents think there is no one as generous and understanding as he is.

Ironically, many war brides, who had persuaded their husbands to bring their brothers, sisters and parents to the U.S. for a better life, have frequently been unable to get along with the relatives they tried to help.

Mrs. Carver brought her mother, brother and the sister-in-law to America, but was ultimately rejected by them.

> They lived with me and my husband for almost six months when they first came to this country. I had a hard time pleasing everybody -- my husband, my mother, my brother. I often cooked two types of food -- American food for my husband and Korean food for my mother, brother and sister-in-law. I had to drive them everywhere until my brother got his driver's license. It was a lot of work. I loaned my brother money to start a laundry business with his wife. Now they do OK and don't need my help.
>
> From talking with other Koreans, I know that my brother and mother are telling everyone that he came as a student and not by my invitation. Now they have nothing more to do with me. I don't feel good about all this. Looking back, it would have been better if I had left them in Korea. Instead of having these resentments we would at least miss each other.

It is no secret that many people in the Korean community are quite hostile to war brides and use derogatory labels to refer to them.[1] From the specifics of some of the derogatory remarks, there is at least a suggestion that the community disapproves of interracial marriage. Many Koreans, both men and women, appear to resent the possibility that the war brides have rejected Korean culture so they could have more individual freedom.

In the San Francisco Korean community, both the male President and the male Chairman of the Board of the Korean Association (*Hanin Hoe*) recently referred publicly to certain war brides as *yang kongjoo,* (Western Princesses), a term implying western prostitutes. Although the women made enough protest that the Chairman of the Board retired from his post with a public apology, the President continued in office.[2]

The rejection of Korean women with interracial marriages is not limited to those who came to America as war brides. Carol Kim Johnson, a Ph.D. who came to America in 1957 as a college student, and who now is a community leader in Philadelphia, says:

> **I was shocked by a long distance call to Los Angeles to a Korean-born friend I had known for over thirty years. She had been raised in America since age thirteen and had received her college education in America. We had become close friends over the years, or so I thought. But she no longer regarded me as a Korean woman because I had been "married twice, both times to an American." After the phone call I decided never to call her again. It hurts me so much whenever I think about it.**

In the mid-1950s after the Korean War, there was still considerable racial tension in the United States between whites and blacks. Surprisingly, however, the American in-laws of the war brides usually did not look upon interracial marriages between whites and Orientals as particularly

objectionable. Outward prejudice by whites against Asians was rare. Most of the Korean war brides had married Caucasians, although a very few married Black Americans.

Realization that certain white families were not racially prejudiced against Korean daughters-in-law, did not mean that Koreans themselves were accepting of other racial groups. On the contrary, many Koreans are quite prejudiced against both Blacks and Whites. This intolerance by Koreans against other racial groups infuriates Mrs. Davidson who is a war bride.

When Koreans talk among themselves their language is full of all sorts of racial slurs. Koreans sometimes contemptuously refer to Blacks as "*ggum-doongi*" (darkies) and Whites as "*hin-doongi*" (whitey), or "*mi-gook nohm*"(low class Americans).

Interracially married Korean women are painfully aware of racial slurs because such remarks are often made in their presence. If Koreans continue to be so insensitive to their feelings, many women may decide to have little more to do with the Korean-American community. This can be a great loss of valuable talent that the Korean-American community needs.

An example is Mrs. Schmidt, a full time employee of a large insurance agency in Washington D.C. area. She has been married for many years to a recently retired official with the U.S. State

Department. After fifteen years of living in Africa and Southeast Asia on foreign service duty, the Schmidt family moved back permanently to the Washington, D.C. area. Eager to meet other Koreans, Mrs. Schmidt initially did considerable volunteer work for a major Korean civic organization. Her experience, however, turned her strongly against such involvement.

> **I was glad to help the Korean community through my English ability, but I just couldn't take all the insensitive and insulting remarks that Korean men intentionally made in my presence about American men. For that reason, I not only have resigned my office, but I have since discouraged other Korean women married to Americans from even getting involved in the Korean community.**

In contrast to other Korean women emigres, the war brides appear to be less stifled by traditional Korean notions which limit the activities of Korean women. By noncompliance with the taboo against interracial marriages, war brides have found it easier to disregard the transported Korean customs that impose unnecessary sex segregation and sex discrimination upon women.

In one respect the war brides differ, not only from the rest of the Korean community, but also from their American husbands. Quite often the war brides are more ambitious economically than their husbands. A major reason for the higher degree of economic ambition usually is to be able to finance expensive

college educations for their children. It is also in keeping with the typical Korean desire in life that everything should be *ilyu* (first rate). Therefore they want to send their children to the private ivy league schools. In fact, in their obsession with "top schools," the war brides along with other Koreans sometimes overlook the benefits of many excellent U.S. public institutions of higher education.

Like other Korean mothers, most war bride mothers find it quite natural to feel a sense of personal achievement through the success of their children. Usually, Koreans consider that education is an inseparable part of one's well-being in society. The war bride mother feels more strongly about the issue of the children's education than does her American husband.

Now fifty years old, Mrs. O'Neill tells her side:

> I assessed the situation when my first daughter, Kelly, was born. I wanted everything for her. I wanted her to be famous and successful. I thought I would do anything to provide a good education for her. I hoped she would become an opera singer -- a dream I let go for myself when I married Joe and quit music.
>
> My husband didn't concern himself much about our daughter's education. In fact, he often remarked, "Let her husband do the job of educating her." But I didn't want to leave Kelly's education to chance. I started back to college myself to finish my degree that was interrupted when Kelly was

born. I thought if I completed my degree, I
would help my daughter, both as a role
model and also financially, as I would be able
to teach in public schools and earn a salary.
In fact, I did teach in American public
schools for about ten years when Kelly was
growing up and we needed extra money to
save for her college. My daughter, Kelly, is
now being accepted at a law school.

　　　She didn't become the most famous
singer, as I had hoped, but I am still very
proud of her. She has had to take out loans
and apply for scholarships but she will make
it.

In many instances, the Korean wife wants her
children to attend expensive private schools which may
be difficult to afford. But the U.S. is full of
opportunities where hard work, including work by
mothers, brings in extra money to afford the best
education possible.

　　Mrs. Snow proudly points out,

　　　I made my three children go to the
top schools. With my Korean brain, I fought
the American brain, and won. My husband,
like many Americans, said, "Let them go to
State schools and work themselves through!"
I told him, "Hush, my children will not go to
State schools." Yes, I worked fourteen hours,
some days, at my unisex barbershop to send
the kids to the best schools. They all did
well. My oldest daughter is getting her Ph.D.
from Stanford in Engineering, and my
younger daughter is going to go to Harvard
for her Masters. I don't care how much

**money I have now. I don't need much, but I
am happy that all my children are going to
the top schools.**

Some Korean women want more money than
could be earned in a normal salaried job. One
example is Mrs. Woody who opened a barbershop so
she could make money and pay the extra expenses
involved in participating heavily in the Korean
community. Another example is Mrs. Zimmerman
who wanted to make money to be able to give her
children everything they wanted, including college
educations. She made her money with a successful
beauty shop.

In spite of a few financial disasters, many war
brides have been diligent and hard-working in
business. They have been successful in adapting to
the American scene. Having broken the taboo of
marrying a non-Korean, they have also been willing to
assimilate to the culture of a new country. Soo Young
Whitaker, the former president of the Korean
American Women's Society for Greater Washington
carefully noted:

**Interracially married Korean women
are in general brave and courageous. They
are a special and exceptionally smart group
of people. In most cases, they have adapted
to American ways faster and better than
Korean women in America who have married
Korean men.[3]**

College Student Immigrants

The second large immigrant group of Koreans to come to America immediately following the Korean War was the flood of students. As might have been expected, over ninety-five percent of post Korean War college student immigrants were males.[4] According to the male-preferring Korean society only the male offspring were considered worthy enough to receive an American education. Daughters were seldom considered worth the investment. In Korea, once daughters are married they are outsiders (*chool gah oein*) and belong to their husband's families. One of the few female student immigrants recalls:

> **When I was taking the exam required by the Ministry of Education to study abroad, I was the only female out of over fifty individuals. I didn't have anyone to talk to during the short recesses. I would just sharpen my pencils over and over, trying not to appear too left out.**

Most Korean students had relatively few economic problems since most were single and only had to take care of themselves. Some had enough funds from their families, while others overcame financial difficulties by taking jobs while attending school. The most valuable advantage these students had was their good language facility which they had acquired to prepare for the "Study Abroad" exams. Passing these exams was required before a visa would be issued. First was the rigorous exam given by the

Ministry of Education on English, Korean History, and the major area in which the student intended to specialize in America. Next was the Ministry of Foreign Affairs exam on English ability, mostly of essay-type questions. Finally, there was the American Embassy exam on English knowledge, a multiple-choice exam. After arriving in America, the college student immigrants benefitted by their training in American schools where a democratic atmosphere prevailed. This opportunity also was responsible for advancing these college student immigrants beyond other immigrants who came later.

Following their graduation from American colleges these students found themselves in a favorable position in the Korean immigrant community, but they faced a serious moral problem. If they chose, they could return to their families back home and to Korea's development, or they could choose to stay in America and enjoy the fruits of their training. Many returned to Korea, and some became influential and important people in the Korean modernization process. Most of the students who chose to remain in the United States became U.S. citizens and encouraged their family members still in Korea to join them in the United States. Following the end of the Korean War, living conditions in the United States were much better than in Korea. Thus, many relatives accepted the invitations.

Many of the student immigrants who chose to remain in the United States have done well for themselves. In some cases, however, they consider themselves superior to the working class newcomers,

and are sometimes criticized by the Korean American community for their aloofness and isolation from other Koreans. This is a rather unfortunate situation because the knowledge and experience of these successful people could be of much benefit to the rest of the Korean immigrant community.

These former student immigrants are typically found working with American professionals. They often socialize mostly with non-Koreans and even sometimes deny their Korean origins. Compared to the other Korean immigrant groups, they are capable of understanding American society and some even can grasp Korean community problems, but many have chosen not to have much to do with the immigrant community.[5]

Criticism of the student immigrants as a class, however, is not always justified. Some of these students have tried to work in the community but have experienced difficulty. "They (the new comers) are so noisy and they care only about making money. They do not care to learn about America. Why should I waste my time?" complained one frustrated former college student immigrant.

A few people from the student immigrant group have tried to help with problems in the Korean community and have wielded influence. However, their primary concern is to help their own children succeed in school and secure a good economic future for them. This narrow focus overlooks that without a good deal of work by the parents, the children will not have an ethnic Korean-American community with which to identify with pride.

Post-1965 Immigrants

In 1965, the U.S. discriminatory immigration quota system based on race and national origin was expanded for Asians. This change brought into the U.S. many working class Koreans, contrasting with the prior immigrants, largely war brides and college students. Between 1965 and 1980, 299,000 Koreans emigrated into the U.S., making Koreans the largest group of Asians after the Filipinos. Most of this post-1965 group of Koreans were relatives of the college student immigrants and the war brides who had already settled in America. This third wave of Korean immigration was the largest group of Koreans ever to come to the U.S.[6]

Koreans in Business

Rather than working for others as manual laborers, many Koreans chose to become entrepreneurs, opening small independent businesses in Korean communities to serve a predominantly Korean clientele. Attracted by high profits, some businesses were opened in various ghetto areas with a concentration of Blacks. A few Koreans opened or bought businesses in locations with a diversified American population.

Specifically, Korean-owned businesses included such basic service enterprises as automobile service stations, shoe repair shops, dry cleaners, beauty parlors, manicure salons, barber shops, dressmakers

shops, grocery stores and restaurants. A few ventured into more sophisticated enterprises such as travel, insurance, and real estate agencies.

Businesses set up by Koreans in America have often been of the "Mom and Pop" variety, typically operated by a husband and wife. These businesses have been labor intensive and have not required fluency in English. Koreans who have set up businesses in America are considered a cut above typical "Mom and Pop" business owners in Korea.

One of the biggest weaknesses of Korean businesses in the United States is that too many are focussed only on the Korean community. The resulting competition for a limited number of Korean customers often is ruthless. Many businesses have been squeezed out. A moderately large Korean grocery store in Maryland was nearly destroyed economically by competition between a large Korean grocery store and a third Korean grocery store which was forced out of business. The first store was caught in the crossfire. The owner complained that the price competition had forced her to put all her goods on sale at a discount, as well. The owner grumbles:

> They (the new stores) sell everything on reduced price. We cannot compete. When I sell all goods at cost, I lose money. I am worried so much I lose sleep over it. Some Koreans just don't have heart. It doesn't help anybody. We are really worried.

In addition to problems of business competition, running a business has many other disadvantages. The typical fourteen to sixteen hour workday deprives the owner and his wife of much opportunity for social life. Thus, there is less chance to improve English language speaking ability and develop social skills. The wives have to help out with the family business and also have to meet other family responsibilities which can result in a pattern of broken marriages.

Mr. and Mrs. Jung, who were both from upper middle class families in Korea, came to Los Angeles in 1980. They were in their early thirties and had degrees from Korean colleges. Their marriage had been arranged by the parents through proper matchmaking. Two little boys were born to them in the U.S. The family's first economic venture was a driving school targeted to the Korean community. Their lack of business experience led to a failed venture. Next they opened a supermarket, which ended with economic disaster. "Life in America is tough!" Mrs. Jung confided in me. Sadly, the marriage ended in divorce. The two little boys were taken to Korea by their paternal grandmother.

Two years later, Mrs. Jung met a Korean Baptist minister in San Jose, California. They married after a one-year courtship. This was the second marriage for both of them. Rev. Chu worked part-time as a carpenter and did other odd jobs until they could save enough money to start their own business. Moving to Salinas, California, the Chus opened a small grocery store.

Mrs. Chu, whose major in college had been music, started the grocery business. She also had to care for her small child. It did not help an already stressful situation that Mrs. Chu was required by custom to live with and accommodate her widowed mother-in-law. One morning, Rev. Chu woke up to find his wife gone. Two days later she reappeared. She demanded and received a separation agreement which would allow her to have nothing further to do with her husband. In exchange she signed over custody of their four year old son to her husband. In the immigrant community where discrimination against women is prevalent, twice-divorced women are made to feel censured and humiliated. To save face she quietly moved from California to the East Coast.

Obstacles to earning a livelihood in a new country are not encountered exclusively by people inexperienced in business as were the Chus. Sometimes the problem can be quite jolting even for veteran business owners. Because of a shortage of capital and the unavailability of space in desirable locations due to race discrimination, many Korean businesses are located in low-income neighborhoods throughout the U.S. As a major participant in "Mom and Pop" businesses, Korean immigrant women spend the greater portion of each day, (twelve to sixteen hours,) often in rundown, unsafe neighborhoods.

Mrs. Sung and her husband have been the owners of a grocery store for fifteen years in Northeast Washington, D.C. This is a predominantly lower income Black neighborhood which often makes headline news for violence related to the drug traffic.

The doors and windows of the store are protected by iron grill work. When I visited the store, several Black men were sitting around the outside. Some obviously were under the influence of drugs. But inside the store, everything was neat and well displayed. The store was stocked with regular American general merchandise. Hard work and many hours of good management were readily evident. However, the store was not free of the problems that are common to many Korean-run business in big cities.

Mrs. Sung describes the problems she has:

> Almost every day, they come in to steal, and sometimes they have guns. I understand how they feel that we immigrants are taking over, and they don't like it. It hurts me a lot when I see those people, but what can I do? We didn't have any choice. We didn't have any plan to buy this particular store. The store was there when I was looking for a business and, somehow, we stumbled into it.
>
> Between my husband and me, we have thirty-one members of our families. This business helps to feed them. But they (Black trouble-makers) come in almost every day and try to give us problems. The most common trouble is at the cash register. When one of them needs money to buy drugs, for example, they will buy some fifty-cent item and give us a one dollar bill. When the cashier gives fifty cents back, the person claims to have given a $20 bill and wants more money in change. When the cashier

**tries to explain, sometimes physical violence
and shouting starts.**

Poor Blacks in these communities often have
ended up hating the successful Korean merchants who
are making profits, but have little concern about the
welfare of the community. It is mostly in black
neighborhoods that incidents have occurred in which
Korean business owners have been held up and killed.
In 1988 alone, in Washington, D.C., mostly in black
neighborhoods, there were more than thirteen
bombings and killings involving Korean businesses.[7]
Out of fear and shame, the tendency of the Koreans is
to be quiet about the crimes committed against them,
which makes it even more difficult to track down the
perpetrators.

Engaging in businesses that target the American
mainstream market may offer the best long range
potential for Koreans in America. However, such
endeavors often have required careful planning which
includes systematically learning good English language
ability and social skills. Now many Korean
immigrants are not willing or able to make such
efforts.

Another big problem facing the Korean
community is that many of them go into business
without an adequate appreciation of the risk factors
and hidden expenses of that business. Inexperienced
new arrivals, who have come directly from Korea,
often place too much trust in the middle man (or
woman), a fellow Korean, who talks the new
immigrants into buying the business. It does not

occur to them there is much risk. Instead, they only think about the profits the business will bring in, which often results in economic tragedy.

Pressure on *Ilse* Women

In the Korean community, the persons with least freedom are the *ilse* women, Korean women married to Korean men. These women tend to associate mostly with traditional members of the Korean community. In the intimate social networks of that community, there is consistent reinforcement of traditional Korean family roles, resulting in restrictions on the freedom of the *ilse* wives.

Having to be a double duty wife is a pressure on *ilse* women. They work very hard. Their jobs often are in the family business, where they may be unpaid employees of their husbands. Virtually all of these women who can work, do in fact work full time outside the home. However, many of the *ilse* women, although educated in Korean colleges, are part of the blue collar workforce. Quite a few of them are working in "secret businesses," doing domestic work for non-Korean families. For fear of gossip, most of these women avoid working for another Korean family. To cover up the humiliation, various nonmonetary reasons are sometimes given for taking on such domestic work. A 50-year-old domestic worker, Mrs. Park confided in me:

At my age I cannot learn to speak English. If I want to learn English I would

> have to pay money. In this way, I get to see
> what real American homes are like. But I
> have to think about my husband's feelings,
> so I am very discreet about my job.

After working many long hours at their regular jobs, these women return to fulfill all the womanly duties and assume the low-status role of a traditional Korean wife. This means doing all the cooking, cleaning and other household chores at home. Mrs. Kim, a food carry-out business owner, talks about her husband's attitude towards the family's business:

> I leave my house at 4 a.m., and
> sometimes I work until 9 p.m. I am tied
> down to the business so much I get too tired,
> but my husband only shows up to work at the
> business for three to four hours. It costs too
> much to hire a manager. He says he is too
> ashamed to show up at my store. He thinks
> the business is beneath him. At home he
> orders people around, "Bring me glass of
> water. Turn the T.V. on." He just plays
> around and does not work. Most Korean
> women work so hard. They struggle for their
> family. The husbands waste time. They
> think they are too good to do anything.

The typical Korean husband's involvement in household tasks is usually less than five percent of the household chores. If the husbands do help, their help is limited to such tasks as taking heavy garbage cans out to the street.[8] They conveniently assign the "women's work" to the women of the house.[9] Because of having to work outside the home and also

having to do virtually all the house work, the *ilse* women are worse off than Korean women living in America who have married Americans. They are even treated worse than Korean women who never left Korea. One of the main reasons they are mistreated is that, too often, the *ilse* wives who have been traditionally socialized in the Korean immigrant community do not expect any different treatment.[10]

In addition to being a hard-working wife and mother, the *ilse* woman must also be a perfect daughter-in-law. She must take care of her mother-in-law who expects deferential treatment from the daughter-in-law for herself and for her son. Catering to a Korean mother-in-law can be quite difficult. A recent case in the Los Angeles Korean community is a good example of how strained relations can be between a Korean mother and her daughter-in-law. Frequently Korean mothers-in-law will treat their daughters-in-law tyrannically, but will be solicitous to their sons-in-law in similar situations.

In this case, when the mother visits her son she usually has a chip on her shoulder for the daughter-in-law and always causes trouble. One day she saw her son trying to help his wife in the kitchen and voiced her disapproval. She chased the son out of the kitchen saying, "Housework is the women's job." Then she scolded him for two hours about how a man should not come into the kitchen, but must train his wife right. Otherwise the wife will develop wrong habits!

Back-home family pressure can also be a heavy burden on Korean women living in America. Because of Confucian tradition women are expected to

meet extended family obligations to help financially or in other areas, whether they want to or not.

According to the Korean custom, a woman married to the oldest son bears the heaviest burden of all married women. Because it is a primary duty of the oldest son's wife to take care of her husband's parents, she often has to acquiesce in sending money back home to support them. Without making some financial contributions, the son's whole family would have to live with guilt, especially the daughter-in-law.

> **My husband is the oldest son. We have been sending money to his parents for about twenty-eight years. Now that his mother is ill, I feel guilty that we are not there to take care of her. Since I am not there, the wife of my husband's younger brother has to take care of my mother-in-law. I feel my in-laws are talking about me behind my back, since my husband is the oldest son. But I don't know what else to do. We have two young children to educate and I have to work.**

Back-home pressure also comes to support relatives other than parents. Mrs. Koh was married to an American and living in America. While working on her Ph.D., she was notified by the family in Korea that her teenage nephew, her brother's son, was coming to America to attend high school. Since she was a woman family member, Mrs. Koh was required to meet all the young man's needs for two months until he would start school in America.

Mrs. Koh talks about how difficult and thankless her situation had been:

> There I was, working on my Ph.D., and the family back home felt free to send me more responsibility, just because I was a woman. Of course, I had raised three children of my own without any help from the family. My children were all teenagers. Now, in the midst of my Ph.D. course work, the family was expecting me to drop everything and look after this boy, still fresh from Korea.
>
> I don't need to tell you how much of a disturbance this was for me when I needed to prepare a paper to present to the class of doctoral candidates and to the professors. I bet you that they would not have expected the same thing if I had been a male. Ignoring my needs, my three brothers and their wives, who each have living-in maids, simply decided that I had to raise another child. Because I never asked them for help they must have concluded that I needed extra responsibility, or they must not have thought that what I do is important. I resented that strongly.

Domestic violence, which is on the rise in the Korean-American community, is another pressure on many Korean *ilse* women. Wife beating is considered a major crime in American society. The same act, however, is sometimes looked upon as "love beating" by Korean husbands. "I beat her because I love her. I have to teach her right."

In the 1980s, the Korean divorce rate rose, perhaps influenced by the increasing number of Korean women going out of the home to earn wages, thereby gaining economic independence. The situation is also aggravated when husbands are either unemployed or underemployed. Many times, this is due to language difficulties. In such cases, the men may feel that their authority as head of the family is diminished. If wives complain domestic violence can easily result.[11]

One way in which such family squabbles come about is explained by Steven Han:

> **When the wife brings home more money, the husband's family headship is threatened. Quite often, the working wife doesn't drive a car. When the Korean wife gets a ride to work by another man, sometimes their eyes meet and troubles slip into the fragile family. Finally, family violence flares.[12]**

Domestic violence has become a severe problem among Koreans in southern California, as shown by statistics from the Center for the Pacific Asian Family in Los Angeles between 1978 and 1985. About a third of the clients are Koreans. From 1982 to 1985, ninety percent of the resident clients were battered women and their children; the remaining ten percent were victims of rape or child sexual assault.[13]

In a recent two-year period, the residential caseload at the center averaged about 400 women and

children annually. Of this number, about 120 were Korean, with about half being adult Korean women. This means that, among Koreans, more than one woman each week was so severely abused by her husband that she sought the safety of shelter outside of her home.[14]

According to the Korean Family Legal Service Center in the Washington metropolitan area, the major causes of the rising divorce rate among Koreans are: incompatibility, assault and battery, adultery, problems with mothers-in-law, heavy drinking by husbands, gambling, problems with youngsters, and money handling.[15]

Reverse Immigration

Korean men with a strong mental orientation towards Korean life and customs have had the most difficult time adjusting to immigrant life in America. Many of these men decided to return to Korea. Some, however, could not convince their wives and children to accompany them and have returned alone.

Most Korean men brought male-chauvinistic attitudes with them from Korea. For these men, life in a strange land, with a language and culture gap, has been too much to bear, so they often seek to return to Korea. Three reasons have emerged as the most common for wishing to return to the Korean homeland:

1. In general life in America is too difficult,

2. Korea, by contrast no longer is
 no longer so strongly perceived
 as a place of political danger,
 and

3. A job promotion may have been
 offered to selected professionals
 willing to bring their skills
 back to Korea.

Pertinent to the first reason, although the difficulties of immigrant life have fallen on both men and women, in one special way life in America has been easier on Korean women than on Korean men. For some Korean women, life in America has actually given them a degree of freedom that they did not have in the male-dominant society of Korea. Men on the other hand, sometimes like the idea of returning to a society in which men have more authority.

Improvement in South Korea's political situation in recent years is the second factor that has encouraged reverse immigration to Korea. The political threat from the North Korean communists in the years following the Korean War had made many Koreans think that Korea was not a safe place. In recent years, however, with America's recognition of the People's Republic of China and the development of an even closer relationship between the U.S. and the Soviet Union, the chance of war between the two Koreas has diminished.

The third reason for the increasing tendency towards reverse immigration, in at least certain

professions, is that opportunities for success and advancement may have become greater in Korea lately than in the United States. Many Korean scientists and engineers working in mid-level positions in American companies have been offered top positions back in Korea. For this reason, especially, reverse immigration has been occurring at a more rapid rate.

An article in the *Wall Street Journal* tells about a Korean engineer accepting an offer to become director of research for a well-known Korean electronic company. In the new position, he would supervise sixty people instead of four people with his former U.S. employer. Out of 12,000 American trained scientists, some 6,000 have been brought back to Korea from the United States since 1968, most of them since 1982. The American scientific community is concerned with this reverse brain.[16] Reverse immigration has brought about many broken families in the Korean-American community.

Disagreements among family members whether to go back to Korea or to remain in America have also caused difficult situations. Usually the children, who have become accustomed to American life and language, want to stay. It is the father who wants to go back. One answer is for the spouses to separate -- the husband returning to Korea, and the wife remaining with the children in America.

Typically, Koreans who remain in the United States undergo five stages of attitude change-about regarding life in America:

1. Believing that everything in America is wonderful. This unrealistic expectation eventually is tempered somewhat by experience.

2. Awakening to the harsh reality of immigrant life. The language and cultural barrier seem too much to cope with.

3. Contemplating returning to Korea. A decision whether or not to stay.

4. Confronting the reality of the situation. Moving back to Korea isn't easy either.

5. Deciding to stay. Make whatever adaptation is necessary.

These five steps often take fifteen to twenty years before the Koreans feel more comfortable in the U.S. than in Korea.

In conclusion, most of the Korean immigrants to the United States have been moderately successful, especially war brides and students. Mostly, both of these groups were able to make the transition from one society to another. Today many of them are fairly well assimilated into the American mainstream. Not all immigrants, however, have been successful. Immigrants who were old and set in their ways, who came to America after the liberalization of the immigration laws in 1965 had problems adapting. Less familiar with the English language, these

immigrants were often trapped in low-wage and low-status jobs within the Korean-American community, usually working for other Koreans and unable to get ahead. For many of the less successful in adapting to American life, the solution has been to retreat within the Korean-speaking community and imagine that they had never left Korea.

Notes

1. Interview with Mary Sung-Il Kopf, President (1989-90) of Korean American Women's Society for the Greater Washington Area, in Alexandria, Virginia, March 20, 1989.

2. "Chairman Byun Kwang-Soo, Chairman of the Board Yu Jin-Sung Resign," *Sae Gae Ilbo*, Washington, D.C. edition, June 29, 1989.

3. Interview with Soo-Young Lim Whitaker, Annandale, Virginia, February 10, 1989.

4. Interview with Sung-Ho Kum, Education Attache at the Korean Embassy, Washington, D.C. on December 11, 1989.

5. A young Korean student from Seoul observed that the so-called elite of the Korean-American community, such as the old-time student immigrants who have become professionals and are able to access problems of both sides of the community, usually choose to shun the Korean immigrant society. *Dong A-Ilbo*, Washington, D.C. edition, September 9 and 12, 1989.

6. Over 90% of Koreans came to the U.S. following the 1965 U.S. immigration law revision, Won-Moo Hurh, "The Korean Community in America: Future Prospects and Issues," *Koreans in North America*, eds. S.H. Lee and T. Kwak (Seoul: Kyungnam University Press, 1988), p. 51; "Tenfold Increase," *New York Times*, September 24, 1989, section 4, p. 4.

7. Interview with Henry Shin, President, The Korean-American Chamber of Commerce of Washington D.C. Metropolitan Area, March 19, 1989.

8. Kwang-Chung Kim and Won-Moo Hurh, "Employment of Korean Immigrant Wives and the Division of Household Tasks," *Korean Women in Transition: At Home and Abroad*, ed. Eui-Young Yu and Earl H. Phillips (Los Angeles: Center for Korean-American and Korean Studies, California State University, 1987), p. 212.

9. Ibid.

10. Korean women in America work doubly hard due to their tendency to adhere to traditional values and their husbands' unwillingness to alter life patterns and aid their wives at home. Proportionally more Korean immigrant wives are employed outside the home than white and black married women in the U.S. Yu and Phillips, *Korean Women in Transition*, pp. 212-15.

11. Domestic violence tends to occur most frequently when the husband insists on observing Korean traditional family mores under which he is the authority figure over his wife. Domestic violence flares when the wife wishes to adapt a more egalitarian, American type of relationship with her husband. *Dong A-Ilbo*, Washington, D.C. edition, April 12, 1990. Because

physical abuse of Korean-American women can be the root cause of many other problems, there is an urgent need for setting up some type of structure such as an organization or agency to provide assistance to battered women. However, the Korean American community does not appear to recognize the seriousness of the problem. *Sae Gae Ilbo*, Washington, D.C. edition, July 8, 1989.

12. Interview with Steven Han, President, Korean Association of Maryland, March 17, 1989.

13. Nilda Rimonte, "Domestic Violence Among Pacific Asians," *Making Waves*, ed. Asian Women United of California (Boston: Beacon Press, 1989), pp. 327-28.

14. Domestic violence has been one of the major problems of the Korean immigrant community. The male superiority concept which Korean immigrants brought with them tends to encourage physical violence by husbands towards wives. In the more egalitarian American society, however, the wives come to expect better treatment. Nevertheless, since divorce is considered a severe stigma for a Korean woman, she will often choose to continue the marriage and endure the physical abuse. *Dong A-Ilbo*, Washington, D.C. edition, April 12, 1990. See also Rimonte, *Making Waves*, pp. 327-28.

15. Interview with Soon-Young Lee, Founder and 1st President, Korean Women's Legal Service Center of Washington D.C. Metropolitan Area, November 2, 1989.

16. *Wall Street Journal*, April 18, 1989.

CHAPTER 10

Korean Children
in America

Children in the Korean-American community often have much less difficulty in assimilating to mainstream American society than their parents. The children have less to "unlearn." The biggest problem from their point of view is in accommodating to what they may consider unreasonable parental demands.

It is interesting to compare the reactions of Korean children reared under three separate circumstances: those with both parents Korean, adopted children reared by American parents, and the potentially most numerous group, children with one Korean and one American parent.

Children with
Both Parents Korean

The relationship between Korean parents and their offspring is complex. Often the main reason

the parents had come to America in the first place was so their children would be better off. There is almost no limit to the sacrifice that Korean parents make to benefit their children. The parents, however, expect the children to be disciplined members of the family, particularly the daughters, and to perform excellently in school. It is interesting to talk to these children after they have grown up and have had a chance to develop a mature understanding of their experiences.

One of the young women interviewed, a recent college graduate in Northern Virginia, remembers:

> **My parents had a hard time with me when I was in high school. They often shouted at me if I was a little late from school, "Korean girls should come home early and help out around home! Where have you been all afternoon?" they shout in Korean when they get angry. They are a little better about that now.**

Many Korean parents set up strict rules. Most children wish to please their parents, but are more concerned about their own assimilation into the new culture. They desire to be like the other children they know at school and in their neighborhood.

One, an *iljum-ose* (born in Korea, reared in America), protests the strictness of her upbringing:

> **Many of my friends are torn between two cultures. We are just doing**

**what our parents want us to do ... to be
good students and to become Americans.
They came here for us to be more like
Americans, didn't they?**

The most difficult problems facing the
younger generation of Koreans are handling the
generation and culture gaps between themselves and
their parents. Unlike many of the parents, the
members of the younger generation view themselves
as Americans, or as Korean-Americans, instead of as
Koreans. Few, if any, Korean-American children
ever think about moving to Korea.

Since Korean parents typically are quite
economically motivated, a conflict is beginning to
appear among some Korean parents and their
offspring. The children often are less compulsive
about getting ahead economically than their parents,
and are less obsessed with choosing a remunerative
occupation.

Korean parents typically expect their children
to:

1. Be interested in learning the
 Korean language and preserving
 Korean culture.

2. Look forward to maintaining
 close family ties and supporting
 the parents in their old age.

3. Get college educations, in ivy
 league colleges if possible, and
 become professionals, such as

doctors or lawyers.

4. Marry spouses of their parents' choosing, or at least someone of whom the parents approve, and most important, that the spouse should be Korean.

When both parents are Korean, it is a rare child who meets every expectation. Of all the above expectations, however, the one most likely to cause conflict is the last, outmarriage. Outmarriages are becoming a growing phenomenon in the Korean-American community, particularly among the daughters.[1]

Rev. Nahm, a Korean minister in Long Beach, California, with two young daughters, says he always reminded the daughters that they must marry someone who was both Christian and Korean. He and his wife repeated this for fifteen years every night before the children went to bed. Laughingly, the minister revealed that both of the daughters had married Americans.

According to a 1979 study, a large proportion of Korean women in Los Angeles County, 79.6 percent, married out of their own ethnic group. Also Korean females outmarry at a higher rate than males and the rates are increasing, whereas the rate and trend for the Korean males are in the opposite direction.[2] According to another survey, twelve percent of college-graduated Korean women expressed a desire to marry a non-Korean. Thirteen percent also expressed their preference for marrying a Caucasian

male.[3] Korean male children are more likely than female children to please their parents by marrying within the Korean community, because the culture favors them.

The son in a Korean-American family likes the idea of marrying the relatively submissive Korean girl his parents have picked out for him. After all, he would be the master in his family and would have all the privileges traditionally accorded to a Korean husband. A daughter, by contrast, may very well prefer marrying an American, because she is not willing to tolerate the dominating ways of Korean men. One Korean female college student in Los Angeles with a Caucasian boyfriend said:

> **If you are outspoken, they (the Korean males) don't like you. I once had a Korean boyfriend, and he was ultra Korean. He wanted me to wear a skirt all the time. I didn't like his trying to order me around. Our ideas often clashed.**

The younger generation of Koreans in the United States who were born in America, the *ese* (second generation), have assimilated to American ways. So, too, have the younger generation who were born in Korea, but arrived in America as children, the so-called *iljum-ose*, or "knee-high" generation. The most effective way for a Korean woman to assimilate has been to marry outside the Korean community. This has been one way of expressing dissatisfaction with the traditional woman's role.[4]

Recently, many Korean parents have come to think that American society is a bad influence on their children, particularly on their daughters. In the context of marriageability to a Korean male, they consider this a serious problem. To de-Americanize their daughters, concerned parents sometimes send their daughters back to Korea. An *ilse* woman beautician confessed:

> When my daughter was a junior in an American high school in Maryland, she would run around with shorts and leather shoes without socks. She was too unfeminine, so I sent her back to Korea. She protested at first. I was told that she cried every day when she first got there, but she has improved. Finally, after two years, she pays attention to what she wears and goes to a college in Korea. Now I can relax.

Adopted Children with American Parents

The biggest victims of the Korean War, if one just looks at the immediate results, might easily have been the thousands of Korean war orphans. One of the major characteristics of Americans, however, is their generosity toward other people in need. This is illustrated by the many American families who have adopted Korean children and given them a high degree of love. These children have assimilated quite well.

Soon after the war in 1950-53, the streets of Seoul were inundated with beggars. Most of these were orphans who had lost parents in the war. In

some cases, the parents were alive, but too poor to be able to feed and clothe their children. In other cases, the children were the unacknowledged offspring of Korean women and American servicemen.

These children usually ran around in packs of four or five. On getting close to them, one could not help noticing their mucous-smeared faces, often not washed for months. Often, the little beggars would gather at bus stops to intercept passengers getting off buses. I remember one incident:

"Give me change," said a small boy of about seven years of age, reaching out his dirty cupped right hand and cornering a young woman wearing a freshly pressed summer dress.

"I don't have any," she refused. As she pulled away, the boy grabbed the lower part of her white cotton dress, leaving a big abstract mark.

Once the Korean government got the situation better organized, the orphans were herded into shelters and off the streets. Many generous American families adopted these children.

Studies show that most of the Korean children who were adopted by American families have adjusted well to American society. In fact, in one study, Korean adoptees were found to be better adapted in their new homes than white American orphans in general.[5]

> **In spite of the fact that the Korean physical features and heritage were devalued, the adjustments of these transracial adoptees have been superior to their white adoptees."** [6]

The successful adaptation by these Korean children may show that the Korean children saw immigration to the U.S. as a very desirable goal, a view held by most Koreans around the time of the immigration in the 1950s through the 1970s. With their total immersion into the American way of life, the adopted children maintained little Korean identity. Even when a Korean child was not adopted until adolescence, the child would say, "I am an American" or "I am a Korean-American."

A 1977 study sheds further light on the ages and racial backgrounds of the Korean children adopted by Americans and raised in America. The average age of the children in the group was fourteen years and one month. Two-thirds were full Koreans and the rest were Korean-Whites. Only a few were Korean-Blacks.[7] Based on the study, most of the adoptees did well in school and aspired to attend college and have professional careers.

Typically, the Korean children in this study were adopted by middle-class, white, Protestant families living in rural areas or in small cities. The adoptive parents had strong marital bonds, and most had one or two children of their own. Some adoptions were out of pity, but most simply wanted a child to love.

Adoption was prevalent in the 1950s and continues today. The many success stories are heartening. Mrs. Johnson, the adoptive mother of a Korean teenage girl and the wife of an executive in Scottsdale, Arizona said:

> Susie is great. She made our lives worthwhile. We wanted to give Sam a big sister and have a daughter too. Susie is twelve. She has been loved very much by her Korean maternal grandmother and her own natural mother. Although her Korean family was too poor to keep her, she was loved very much, and they continued to stay in touch with her. That made it easier for us to raise her than if we had gotten a child who had been shuffled around from foster home to foster home, as many children would be in similar circumstances in America.

Another success story concerns a four-year-old Korean girl, Debbie Greenberg. Debbie was just eight months old when the Greenbergs adopted her.

"She is just brilliant. She definitely is her father's girl," says an obviously satisfied Mrs. Greenberg, the 39-year-old wife of a college professor in Greensboro, North Carolina. "We are Jewish, and the Korean children and Jews will get along well. We both have determination to make it in this world. We were childless for a long time. We feel complete now. Before she grows too old, we want to give her a brother. We want to adopt a Korean boy."

Adoption of Korean children is not confined to married couples. American soldiers have gone abroad and many fell in love with the young children. Sometimes the soldiers were single men who simply wanted to have a family. Through a friend's introduction, I met Stan O'Neill, a retired U.S. Air Force officer with three adopted Korean children. One balmy summer afternoon, I had arrived at the

O'Neill home in Annandale, Virginia.

One of Mr. O'Neill's adopted children was now married, but the younger two still lived at home with him and were preparing to start the new school term. Kyung-Woo, the son, was 17 and a senior in high school. The daughter, Kyung-Hi, was 16 and entering 11th grade. Mr. O'Neill's story about the way his married daughter, Kyung-Sook, became a part of this single parent family was quite intriguing:

> The oldest one, Kyung-Sook was the latest addition. When I took the children to visit Korea, the director of the orphanage where I got my first two, begged me to take her. I didn't want her because I felt I had just settled with my children. It took me two years. She was 14 and she was a handful, at first. I just had to sit on her sometimes. She has already finished high school and has now gotten married. She comes to see us with her little baby boy and husband.

How did you get to adopt children?

> I have always been a family-oriented person. But being in the Air Force, I could never settle down long enough to start a family. I wanted to have two children, a boy that would be the oldest, and a younger sister for my son. Kyung-Woo, my son was 3 years old when I first adopted him. We fell in love on our first meeting. When he saw me in the room, he walked towards me and rubbed his face on my shoulder. We played together on the first day. I would visit him

every week after that. My daughter Kyung-
Hi was just 9 months old when I adopted her.
She is doing well in school. She wants to
become a teacher.
My children have adjusted rather
well at school and at home. The children eat
Korean food for snacks, and once a month
we go to a Korean restaurant and "pig out."
They view themselves as whites, though.

Looking at the situations of the Korean
children in America, especially those like the O'Neill
family, adopted and living in a home with no adult
Koreans, the children have all adapted rather
successfully to American customs and the American
way of life.

Children With One Korean
and One American Parent

During my research into bi-racial Korean
daughters, I became aware of the absence of published
information about these women. This led me to
conduct a number of first-hand exploratory interviews
with the daughters I could locate.

The sources for obtaining the names of these
"half-and-half" children, as they are sometimes called,
were Korean wives of American men. In 1990, some
thirty-seven years after the end of the Korean War,
many of these marriages are still intact. It is revealing
to talk to the half-and-half females, now grown up,
who were the children of these marriages.

By a process of networking, I was able to locate twelve of such mixed-marriage children to interview. The youngest of these "children" was now twenty-two and the oldest was thirty-six, born just after the 1950 Korean War. To respect their privacy, pseudonyms are used, and locations have sometimes been substituted. The major purposes of this survey were to assess the self-concepts of interracial children and to rate their assimilation into the Korean-American community.

Although one has to be cautious in drawing conclusions from a small, select group, individuals like these could be a rich source of information about the success of interracial marriages in the Korean-American community. This information might be regarded as the findings of a pilot study for future study.

During the interviews I conducted with female children of interracial Korean-American couples, I asked all the children the following four open-ended questions: **(1)** *What are some of the negative aspects of having mixed Korean and American parentage?* **(2)** *What are the positive aspects?* **(3)** *Do you feel that you are a member of Korean community in America?* **(4)** *Have you considered marrying a Korean man?*

In addition, the women were also encouraged to volunteer any other general information from their experience that might be of some relevance in understanding their situation. Many of them volunteered that they had been especially affected by their mothers as role models, and some discussed the amount of contact they had had with Korean relatives.

In talking to these women, I was impressed with how uniformly "upbeat" they were about themselves. A 29-year-old law student definitely had a positive attitude:

> **The advantage of being half-and-half is that you appreciate more than one culture. And I am in the forefront of what the world is going to be. In time, the world will be more like me, all the intercultural marriages and all. Being born as a Korean-American child, my social awareness is broader by having had to alternate from Korean to American. I see this as an asset to be half-and-half, a Korean-American child. I can deal with a lot more in life than I otherwise could have.**

All the twelve women interviewed had achieved an education and become professionals. Their mothers, even the ones without higher education themselves, encouraged their daughters to get college educations. It was heartwarming to learn how much influence their mothers had on most of them. Now a mother herself with two small children, Norma shared a keen appreciation of her mother:

> **Marrying a GI with no money, coming to a new country, she knew she would be rejected. She worked very hard all the time. She sold Avon cosmetic products, worked as a florist and also as a hairdresser. She did all this so we could go to college. She was determined, and made it. My sister and I both have graduated from college.**

**Mom is a great role model. You tend to
follow in your mother's footsteps.**

In summary, the interviews produced answers
to four broad questions intended to probe the degree to
which the women identified with the Korean-American
community and how they felt about themselves:

1. *What are the negatives of being a mixed
race child?*

Most of the women, as children, had
experienced "name calling" from other children when
they were growing up. Two said they didn't feel
accepted 100% by either the Korean or the American
community. Two were aware that in Korea there is
much discrimination against biracial Koreans. As
adults, two objected to being stereotyped by
Americans as subservient Korean females.

2. *What are the positive aspects of being a
mixed-race child?*

All the women were quite positive and upbeat
about their being biracial. Many saw advantages to
being mixed. For most, a specific advantage was that
they had become more open to and tolerant of other
cultures as a result of their having been exposed to
two cultures.

3. *Do you feel that you are part of the Korean-American Community?*

Only two women really felt part of the Korean-American community. The rest generally did not feel part of the Korean-American community because they were all involved instead in the American community. Several expressed doubts that they would be welcomed into the Korean community, or would have much in common with people in it.

4. *Would you marry a Korean man?*

Only one interviewee seemed at all affirmative about marrying a Korean man, and gave as her reason only that her mother would like it if she made this choice. One expressed the opinion that Korean men often treat women in a violent and sexist manner, but said that a Korean-American man might be O.K. All the rest either flatly rejected Korean men as too sexist, or else rejected sexist attitudes in men in general.

Although their attitudes about certain aspects of Korean-American society differed somewhat, all the women were quite positive and upbeat about their bi-cultural heritage. The Korean-American community will gain much by making special efforts and welcoming them to the community. Bicultural persons could play an important role by forming bridges from the Korean-American community to mainstream American society. For specific questions asked and answers given in the twelve interviews, see the Appendix.

The Future

Overall, Korean-American children of all three categories appear to have had an easier time assimilating to American ways than did their parents. Their most important advantage, of course, has been the chance to learn English as a native language. In addition, they have often been under pressure from their Korean parents to do well in school. Having a Korean parent in one's background, especially a Korean mother, does not seem to have been a hindrance.

Perhaps the children with two Korean parents have been under the greatest pressure to succeed in school. This pressure may have been higher on the children born in Korea but raised in America than any of the other children. The children born in the United States have been more influenced by peer pressure from mainstream American children, and therefore are not as motivated to excel.

The second category of children discussed were the adopted children. In virtually all cases the adoptive parents were Caucasian-Americans. Mostly the parents have treated the children with special care and love. The adoptive parents have tried to expose the children as best they could to a part of their Korean heritage. Concerning pressure to do well in school, however, there is probably no substitute for having at least one Korean parent!

In some ways, the children with one Korean and one non-Korean parent have been the most significant group in terms of future impact. Because

of the increasing number of outmarriages, this group ultimately will become the largest of the three. It is probably the wave of the future. The mixed-marriage children in this group have done rather well for themselves. They have good self-concepts. If they do not always identify strongly with the Korean-American community, it is probably because the community itself does not, at present, strongly identify with them. In the future the Korean-American community could benefit greatly by being more inclusive.

Notes

1. An Asian sociologist, Harry Kitano, found out in his extensive study, that Korean women marry out of their race at a higher rate than the Japanese or the Chinese women do. Janice Mall, "Asian Outmarriages is Subject of Study," *Los Angeles Times*, August 18, 1985, Part VI., p. 5.

2. Harry H. L. Kitano and Lynn Kyung Chai, "Korean Interracial Marriage," *Intermarriage in the United States*, eds., Gary A. Cretser and Joseph J. Leon (New York: The Haworth Press, Inc., 1984), pp. 78-79.

3. Sucheta Mazumdar, "General Introduction: A Woman-Centered Perspective on Asian American History," *Making Waves*, ed., Asian Women United of California (Boston: Beacon Press, 1989), p. 16.

4. Ibid.

5. William Fergelman and Arnold R. Silverman, *Social Service Review*, December 1984, Vol. 58, Number 4, pp. 598-99.

6. Ibid.

7. Dong-Soo Kim, "How They Fared In American Homes: A Follow-up Study of Adopted Korean Children," *Children Today*, Vol. 6, Number 2, March-April 1977, p. 4.

CHAPTER 11

Role of Women in
Community Organizations

The main attraction of many Korean-American organizations in the past has often been to give newly-arrived immigrants a feeling of a "home away from home." Such organizations have provided enjoyable social opportunities to meet other Koreans, to converse in the Korean language, and to share Korean food together. Yesterday's advantage, however, may turn out to be today's biggest problem.

Failure to assimilate into the American mainstream is quite serious and quite common. A recent study shows that Koreans are still among the least assimilated of all the ethnic groups in America. Some Korean-American organizations are very helpful in aiding members to assimilate into the American culture. In some situations the reverse is true. Los Angeles is an example.[1] If a community organization ends up serving as too much of a protective shield, insulating its members completely from mainstream

American society, there is a good chance that participation in the organization will end up distracting the members from their main goal, which is making a success in the new country.

In most Korean-American organizations today, both the leaders and the members still have their minds focussed too much on Korea. Although the leadership may truly care for the members and want the best result for them, the members are hurt if they are misled into thinking that the American scene is irrelevant.

In shaping the attitudes and perceptions of newly-arrived Koreans, Korean television and Korean language newspapers both have an important role to play if only they would do so. It would be very helpful to the Korean-American community if more coverage were given to American oriented activities. This is not being anti-Korean, but there needs to be more focus on informing Korean-Americans about making a success in U.S. society, and perhaps somewhat less attention to the situation back home in Korea.

Another major problem within the Korean-American community is that too much sex segregation exists in Korean-American clubs and organizations. To many Koreans, democracy is not yet a familiar concept, and Koreans often feel more at home with Confucian-style authoritarianism. One of the very worst examples of authoritarianism in Korean-American society, so far as Korean-American women are concerned, is the continued practice of outmoded Korean ideas of male-superiority and sex segregation.

Most of my experience with Korean-American clubs and organizations stems from the Washington D.C. area which is representative of other Korean communities in the United States. The Washington, D.C. area has long been held in high esteem by Koreans. Among the reasons, the climate resembles that of Seoul, and, like Seoul, Washington is the political center of the country.

In analyzing the importance of the various kinds of Korean-American organizations in community affairs, one needs a list of all such organizations in the community. The list could include: political organizations, churches and other religious organizations, civic organizations, businessmen's associations, and women's organizations. "Outreach" organizations in which Koreans participate and build bridges to the mainstream American community also should be included.

In many large cities, one can find a published list of local area Korean businesses and organizations that provide an accurate idea of the diversity of Korean organizations in a given community. An example is the Greater Washington Area Korean Directory, updated annually.[2]

Political Groups

In the Washington D.C. area, there are at least four political groups, perhaps more accurately referred to as political cliques than as political organizations, which have actively supported a political party back in Korea. One group has been in sympathy with the

Korean military government, and the other three groups have been aligned with each of the three other major opposition political parties.

At the end of 1989, the three major opposition parties in Korea were: the Unification Democratic Party headed by Kim Young-Sam; the Republican Party headed by Kim Jong-Pil; and the Peace and Democracy Party headed by Kim Dae-Jung. In early 1990, the ruling government party, (called the Justice Party) merged with the first two opposition parties, leaving the party of Kim Dae-Jung very much isolated.

The major activity of the Washington D.C. groups, has been to organize receptions whenever a representative from any of the Korean parties visits the D.C. area. Local support for the respective parties is shown by raising campaign funds for them and by holding rallies. Another activity in which all of these groups have engaged has been to sabotage each other when representatives from the other political parties come into town.

The reason for talking about these groups at all in this book is to note with regret the relatively high importance that they have in the Korean-American community. In reality, back-home Korean politics occupies a large part of the attention of the Korean-American community. Looking just at the best interests of Korean-Americans, however, these groups are almost completely irrelevant. They do nothing to improve the lives of Koreans in America. Instead, they only serve to fix the attention of Korean-Americans on politics back in Korea, and to distract

them from the serious business of integrating into the mainstream American community.

During the 1988 U.S. presidential election I was dismayed to learn that one of the Korean Association chairmen was not aware that November 4 was election day for the U.S. President and other national officials.

"I must man the polls next Tuesday. I won't be able to meet with you that day," I had told the chairman.

"No?" he answered, with a blank look. Seeing the puzzled expression on his face, I realized that he didn't understand anything about the coming U.S. election day. So long as Koreans fail to participate at all in American democracy, they are likely to be short-changed from its benefits.

While Korean organizations certainly are needed, participation in mainstream American activities also is quite essential to the welfare of the Korean-American community. Distracted from political involvement in the American community, minority rights of Korean-Americans will not be protected as much as they should be.

Churches

The most truly important organizations in the Korean-American community are the Korean churches. About eighty percent of the Korean immigrant population are churchgoers.[3] The number of churches in the overall Korean-American community is reportedly over 2,000, and still growing.[4]

In the New York metropolitan area alone, there are more than 350 Korean congregations.[5] Mostly these are Christian churches. Many are small and not well financed, with congregations of between twenty and fifty.[6] There are also many larger congregations of 500 or more, that often are well endowed.[7] Korean churches in America fill a vital social as well as religious function, and often are the main source to relieve some of the homesickness felt by immigrants.

In the past, Korean churches also have been centers of political action, with emphasis on supporting or attacking the government back in Korea.[8] This is no longer the case, and the churches now are more or less de-politicized. One minister sees Korean churches as going through a gradual process of Americanization.[9]

Research shows that most Korean churches are conservative and slow at acculturation. As a rule, the churches now are run mostly by *ilse* males (born in Korea) for the *ilse* generation.[10] Church policies usually are made by men; women are seldom given positions requiring the making of important decisions. Most churches are focusing a good deal of attention on fulfilling the needs of new immigrants. A problem that many churches now have, however, is accommodating the needs of both the 1.5 generation (*iljum-ose* - Born in Korea but raised in America) and second generation (*ese)* Koreans.[11]

As time goes by, the Korean-American church has become an institution in evolution. Some tradition-bound churches probably will disappear as the older *ilse* members pass on, but churches with a

younger membership will flourish and grow even stronger. By about the year 2000, the forecast is for an expansion of the present churches into an Americanized Korean ethnic church that will distinctively address the needs of the 1.5 generation (*iljum-ose* and the second and third generation (*ese* and *samse)* Koreans. The liturgy in the new churches probably will be conducted largely in English.[12]

Since published research is somewhat skimpy on how Korean-American churches are run, additional general information about them has been gathered for this book through personally interviewing the ministers of three Korean churches of different denominations in the Washington D.C. area.

The main problem in all the churches, according to the opinion of all three ministers, is the generation gap and culture gap between the *ilse* and the younger generations. In all three churches, the Korean language was used for most church services, but two of the churches conducted at least part of their services in English.[13] All three of the churches conducted church school classes in English since the *ese* children speak only English.

Recognizing that most of the children knew little or no Korean language, one of the churches conducted a 50-minute Korean language lesson each week just before the main service. The other two churches are conducting Korean language schools on Saturdays to try to teach the children at least some appreciation for the language of their ancestors. Often this is an uphill battle, since the children are not particularly interested in learning Korean.[14]

At this writing, about seventy-nine Korean language schools are in the Washington D.C. area alone, and forty-eight of these schools are members of the National Organization for Korean Schools. Most of these are connected with Korean churches. As with other parts of the church organization, most of the personnel at the decision-making level in member schools, such as principals, are men. Most of the actual teaching, however, is done by women.[15]

Many *ilse* generation Koreans speak poor English or no English at all. Lack of English ability is the single most difficult problem Korean immigrants have to face. Some churches do not recognize this, because they see their purpose solely to provide a comfortable place for new immigrants where English does not need to be spoken. None of the four churches were offering adult language classes in which *ilse* generation adults could learn to speak English.[16]

In addition to providing a place for worship and a tool for youth to socialize Korean churches do provide opportunities for Koreans to get together socially. All four of the churches surveyed for this writing put on informal church suppers, picnics, and formal annual church dinners. Not unlike churches of many other ethnic or mainstream communities, the expected role of Korean women turned out to be one of supporting rather than one of leadership. The women's auxiliary (*booin hoe*) of the churches usually was the organization responsible for all the practical arrangements, the food preparation, and especially cleaning up afterwards.[17]

Discrimination against women in most Korean churches still is the norm with regard to holding important church offices, although the situation is changing slowly. Many American Protestant denominations, with which some Korean churches are affiliated, have gender discriminatory charters and bylaws.[18] These formally exclude women from governing positions in the church. Perhaps this has made affiliation with certain denominations more attractive to tradition-bound members. Out of the four Korean churches surveyed, two churches were in fact prevented by their charters from electing women to their governing bodies. In these churches, however, discrimination against women reportedly was not seen by women as an issue.

The fourth Korean church surveyed belonged to a denomination with no provisions in the charter for discriminating against women,[19] and in that church there was less discrimination against women. A male was the minister, as were most other church officials. A qualified woman, however, was being sought to serve as assistant minister, and the chair of the church's governing board was a woman.[20] This church was consciously planning for the development of strong lay leadership and saw the "second generation issue" as its top priority. The 1.5 generation members were the backbone of this church, and this may well be a picture of the Korean-American church that will survive into the future.

Churches and their pastors obviously have the potential for doing much valuable social work in the Korean community. Churches can serve as

community centers. They can help to educate the children of the community in the Korean language. Ministers can help mediate the marital problems that Korean couples might have, and they can also offer personal counseling in other emergencies.

It may be, as a Korean author suggests, that some churches have become too involved with petty doctrinal problems.[21] Looking at the real interests of Korean women, however, the worst defect of Korean churches is that, too often, they perpetuate the tradition that women are inferior to men. Church women now mostly participate through preparing and serving food, and washing pots and pans, the same menial work in which they specialize at home. Women, themselves, do not complain which is the problem. Churches could do much to cure this.

Civic Organizations

In American cities with a large Korean population, the major Korean civic group will usually be the Korean Association (*Hanin Hoe*). Until recently, the Metropolitan Washington D.C., Korean Association included members from the Maryland suburbs and from Northern Virginia. The story of its break-up in 1986 is revealing. It illustrates the tendency of Korean-American organizations to generate political in-fighting among various factions.

Although Koreans in America pay very little attention to American politics, they are often caught up in the periodic elections of officers in their local Korean Association. The 1986 election for

chairmanship of the Korean Association for Metropolitan Washington is a good example of a bitter factional controversy. The battle was between a slate of candidates headed by Shin Pil-Young, a Baltimore business owner living in Columbia, Maryland, and an opposing slate of candidates headed by Michael Lee, a realtor from Northern Virginia.

As usual, this election received top coverage for months in all the local Korean newspapers. Much money was spent by each candidate personally on advertising, dinner meetings, and various types of entertaining. In the Korean community, spending money lavishly is extremely important for any candidates who want to win. Members of the organizations rarely pay dues, but successful candidates pay out of their own pockets for running the organizations.

There was a large voter turnout. The voting took place on a Sunday, October 6, at local schools when no students were present. It looked as though everybody in the Korean-American community was participating. My husband and I were there, too, to cast our ballots. As the voting ended, Shin Pil-Young's side was insisting that the election result should be set aside for fraud, obviously believing that he had lost. Michael Lee's group, believing that he had won, wanted the results to be honored. When the ballots were actually counted, however, to everyone's surprise, it was Lee's slate of candidates that had lost.

Charges of election fraud then flew thick and fast from both sides, the opposing groups taking the matter to the Washington D.C. District Court for a

ruling on the validity of the election results. One specific controversy brought to the court for consideration was whether the votes for Shin's group from the Koreans in Columbia and Baltimore, Maryland, were invalid because of having originated outside the geographical limits of the D.C. metropolitan area. The D.C. District Court found no proof to back up the charges of election fraud and dismissed the complaint about the Columbia, Maryland, votes by saying that for a voluntary organization, the appropriate geographical boundaries were a question to be determined by the association itself.

The election ended up producing hard feelings on all sides. Begrudgingly, Lee's group broke away from the Metropolitan D.C. Korean Association to form a separate Korean Association for Northern Virginia. A second group broke away to form a Korean Association of Maryland. This very much lessened the power of the Metropolitan Washington Korean Association, which, without the groups from Maryland and Northern Virginia, became a much smaller and less influential organization.

Factional infighting in this case did not produce only negative results, however. Many Koreans in the D.C. area said that the divided organizations turned out to be able to serve the needs of the Korean community better, now that they had smaller jurisdictions that did not cross state lines.

As Sam Shin said, who became the president of the Virginia Association, remarked, "We don't care what they say. We work closely with the Fairfax

County government and get a lot done for our people. The county provided us a school building and a vehicle for our community use. We have many more plans and we will get to all of them very soon." When administered effectively, *Hanin Hoe* could be valuable to the immigrant community. They could lend a hand in difficult times. In 1990 the New York city *Hanin Hoe*, along with other Korean organizations, provided much needed help during a six-month period when Blacks were conducting an economic boycott of Korean stores.[22]

Like other Korean organizations, as a rule, the Korean Association typically is dominated by men. Only a small percentage of the members have been women, and it is not likely that a woman will gain a position of leadership any time soon. A few exceptions exist, but these just prove the rule.

Hopefully, community service is one of the main reasons for an organization's existence. The exclusion of women from positions of leadership, however, makes Korean Association meetings look more like a "night out with the boys" than a serious attempt to make contributions to the community. The absence of women at the policy-making level in Korean civic organizations also renders the organizations less able to understand and serve all the needs of the Korean community. Barring women from participation at the decision-making level of the Korean Association reinforces outdated Confucian traditions of discriminating against women and is inconsistent with the direction of mainstream American society.

inconsistent with the direction of mainstream American society.

Even when a woman occasionally is allowed to hold a leadership role, sex discrimination exists and becomes a difficult burden to carry. Some Korean women in Los Angeles have complained about women there receiving only ornamental positions in civic associations,[23] and that the function of women in their association is to create a pleasant atmosphere. Sonia Suk, the nine-year veteran Korean American Citizens Council president in Los Angeles said, "If I cared about sex discrimination, I would be mortified." She continued, "They sometimes listen if I really insist that they pay attention." Still she continued, "I demand respect from them, but sometimes I still get angry."

I am only aware of two major exceptions to the exclusion of women from important offices in the Korean Associations located in the D.C. area. The first exception is Soo-Young Whitaker, who was once elected Secretary General of the Metropolitan Washington, D.C. Korean Association. In a Korean organization, the post of Secretary General is somewhat higher than the Secretary in an American organization. It is less important than the *kohmoon*, the president, and the two vice presidents, but more important than the secretary or the treasurer.

The Secretary General presides at most meetings and handles most of the details of running the organization. Mrs. Whitaker was successful in this post for several reasons. First, she was willing and able to do the large amount of work involved. In

Finally, men didn't mind working with her, since she was doing most of the work, and they probably viewed it that she was working for them. The ego of a Korean man is very sensitive.

I am the second exception, having been appointed by the president of the Korean Association of Maryland to the office of *kohmoon*. Reasons for being appointed include having been a close associate to the president, Steven Han; having had experience as president of another Korean organization in the past, the Korean-American Citizens Council of Maryland, when Steven Han was the Secretary General; having earned a doctorate degree, having fluency in the English language, and having useful connections in local American community politics. While being grateful for the opportunity to serve, I believe that organizations will have maximum effectiveness when as many as half of the officers, and sometimes the president, are women.

Business Associations

There are many small businesses in America owned and operated by Koreans. This has given rise to the founding of many Korean-American business associations. In the Washington D.C. area, the main one is the Korean-American Chamber of Commerce, founded in 1973. All meetings are conducted in Korean.[24]

Most current members of the Chamber are male business owners. Although many Korean businesses are husband and wife partnerships, the

wives rarely attend meetings. Henry Shin, the president, expressed little concern about this issue. "We have the door open to women but there appears to be no interest from the women's community." He paused, "To tell you frankly, we never thought about the problem much."

Of course, not thinking about it is the problem. Of 1,800 members in 1989, less than one percent of the membership was female.[25] An effort could be made to get Korean businesswomen in the organization who could be valuable in policy-making positions.

Although the Korean-American Chamber of Commerce now primarily serves as a social club for Korean male business owners, it has helped to solve serious community problems such as vandalism and crime being perpetrated against Koreans doing business in the Black community. For the last seven years, the organization in Washington D.C. has promoted better community relations by giving Christmas dinners to the homeless.[26] Scholarships have gone to deserving Black students. Golf and soccer outings have been arranged between Korean business owners and the predominantly Black D.C. police force. The Washington D.C. Korean Chamber of Commerce deserves praise for these wise efforts at accommodation.

Korean-American Women's Organizations

Women's organizations, by their very existence, like virtually every other instance of sex segregation, in one sense help to support the

philosophy of male superiority. Nevertheless, these organizations have made some contributions toward establishing a better place for women in society. Although Korean-American women have had virtually no leadership positions in the churches or in any of the other male-dominated organizations of Korean-American society, the various women's organizations have given them something of a base to work together for their mutual benefit, and women have remained in full control of their own all-woman organizations.

One of the first major Korean-American women's organizations appeared at a very early date. In 1919 in Dinuba, California, the Korean Women's Patriotic League (*Daehan Yoja Aekook Dan*) was founded to support the movement for Korea to be independent from the Japanese. The organization advocated the boycott of Japanese goods, and following World War II, promoted educational and relief work for needy Koreans in America and in Korea. In 1946 alone, the League sent out one thousand tons of relief goods to South Korea.[27]

Korean women's organizations are located throughout the U.S., mostly in the larger cities. Three associations in Washington D.C. may be somewhat representative. These groups differ from each other in their aims, their membership and their program activities, but they have in common a general desire to benefit their communities.

The first large group to form in the Washington D.C. area was the Korean-American Wives Club (*Hanmi Buin Hoe*), now the **Organization of Korean-American Women, Inc.** (*Hanmi Yusung*

Jaedan). It was founded in 1963 for the benefit of Korean wives of U.S. servicemen in the area. This group is distinctive because all the members have interracial marriages, and because the organization has always focused on the needs of Koreans in unfortunate circumstances. The first President was Chon S. Edwards, who had married an economist with the American Embassy in Seoul. This club has been very helpful to many Korean wives in the Washington D.C. area throughout its history.

The club has about 200 members. It sponsors many activities which are of interest to its members and are of general benefit to the Korean-American community. Monthly meetings are held featuring speakers on topics of interest and benefit to the membership. The Wives Club typically chooses a Korean restaurant in the Washington D.C. area and each member pays for her own luncheon.

Usually, the club meeting starts with a business meeting, a review of the past meeting, and a reading of the treasurer's report. After introduction of guests, there usually is a special speaker on a selected topic of practical usefulness. Except for an English-speaking speaker from time to time, most club meetings have been conducted totally in Korean, although all the members are from English-speaking households. Some of the subjects have been, "How to conduct a successful small business," and "How to claim insurance benefits."

Along with the regular monthly meetings, each year the organization sponsors a Christmas party. Various other club events are held with the proceeds

going to various community causes. In 1986, $500 was donated to the Korean Art Fund of the Smithsonian Institution.

Over the years, the club has sponsored many projects of community benefit from welfare to politics. The club has bought a home that furnishes temporary shelter for battered women in the community, and is considered by officials at the Korean Embassy the main source of help for battered women.[28] Notwithstanding the club's focus on helping Korean-Americans, this shelter is open to all women whether or not they are Korean-American.

Members of the club also conduct regular visits to dying Korean patients at Walter Reed Army Hospital, giving them Korean food and conversation during their last days. Mrs. June Dawson says, "We visit all Koreans in the hospital. We bring Korean food like Korean pickles (*kimchi*) and casserole (*jjeegeh*). I know they won't get such food in the hospital. Our members work very hard."[29]

The club has also interested itself in financial support to Amerasian families who were being mistreated in Korea. In 1986, the club brought some forty-five Amerasians to live in America, they are now living in Bethesda, Maryland.

In the area of politics, the club has furnished active financial support to Joe Vasapoli, a local lawyer-politician with a Korean mother, who ran for election to the Virginia State Senate in 1986. Though this candidate did not win, the women in the Korean-American Wives Club proved their commitment to the Korean-American community.

In spite of the good works, this organization struggles with its image in the Korean-American community because the members have interracial marriages. "No matter how much we give and work for the Korean community, they discriminate against us. I can feel it, even when I go to Korean Embassy events," states an ex-president of the club. "I feel the cold air all around. Their reception is not good toward us. Only when they need us, they come knocking on our door."[30]

A second Korean women's organization is known as the **Korean Women's Association** (*Daehan Booin Hoe.*) This was started in 1981, mostly for the benefit of the older people in the Korean community. To date, there have been no wives of non-Koreans as members. The club has been most popular with older persons. Many of the members have little interest in assimilation into American society. The first President was Jong Ki Moon, who is now about 75 years old.

The purposes of the organization are indicated by its stated list of objectives:

1. Let's be loving wives and wise mothers for our Motherland.
2. Let's help Korean-American women in the areas of Korean etiquette and proper Korean language usage.
3. Let's promote world peace and good will among nations.[31]

According to the founder, Mrs. Moon, dues-paying membership is over 500, but Mrs. Chu, the 1989 president of the organization reveals that only thirty people show up at monthly meetings. "Too many Koreans don't feel the obligation to help out in our community. They are too busy making money. It's hard to just rely on the volunteers. But we do what we can."[32]

The most important function is the fellowship opportunity for these people after stressful work as baby sitters for grandchildren, working as hospital custodians, and helping in family-owned laundry and grocery stores. This is time to relax and greet each other, and compare notes of the past week. The ages of the members range from about forty-five to perhaps seventy-five. All programs are in Korean.[33]

For their monthly meetings, the club meets at one of the Korean restaurants in the Washington area. The subjects discussed often include the importance of passing down and instilling Korean etiquette in children. The membership appears to have little or no interest in becoming more Americanized.

Charitable activities by the Korean Women's Association have included providing financial support to an old age home in Korea. The organization also participates in an annual Washington D.C. July 4th parade, and it sponsors the annual Lunar New Year celebration for the area's Koreans.[34]

The third Korean woman's organization in the Washington D.C. area, is the **Korean-American Women's Society for Greater Washington** (*Washington Yusung Hoe*), formed in 1982. Soo-

Young Whitaker was the first president of the organization. The membership in 1989 was about 100, and the club has an active program. Monthly meetings are held with an average attendance of about forty persons. The average age of members is thirty-five to forty. A few members are wives of Koreans, although most members are wives of Caucasian Americans. Most meetings are conducted in the Korean language, but there is nevertheless much emphasis on helping members to assimilate into the American community.

The club provides charitable, cultural, and educational activities for its members and for the Korean community. In 1989, the club collected money for blind people in Korea and sponsored a local exhibit of Korean art. In the past, the club has brought in speakers who lectured on ways the members could participate in the American political process. Programs have been given on subjects of general interest such as, "Korean Television in America," and "Starting Successful Businesses."

The club holds annual Christmas parties, and in September 1988, the organization held a successful dinner banquet where Ms. Kum-Soon Park, the president of one of the principal women's organizations in Korea, the Hankook Women's Association (*Hankook Booin Hoe*), spoke on the need for a study that would address the issue of Korean women's equality. Ms. Park, physically small, but a hard-working woman for women's causes, had travelled from the organization's headquarters in Seoul to address this function.

I know Ms. Park very well. A long-time veteran of the women's equality movement, Ms. Park was handpicked as the president of the Hankook Women's Association in 1974 by the late Yim Young-Shin (see Chapter 6), the founder of the organization. Ms. Park has served the organization as the president continuously since her first appointment in 1974.

The foregoing three Korean-American women's organizations in the Washington D.C. area have all been important sources of personal self-fulfillment for their members. Through these groups, club members have shown a real ability to organize, work hard, and make important contributions to the Korean-American community in the Washington D.C. area. Unfortunately, the atmosphere among the three Korean women's organizations has not always been one of mutual harmony and respect. In the future it would be very helpful if at least the leaders of community organizations were more considerate in their remarks about other clubs.[35]

Women's organizations in the Korean-American community are only beginning to work towards increasing the status of Korean-American women. Without special consciousness-raising activities by such organizations, however, very little will be done to achieve this goal.

In many cases of discrimination, unfortunately, women themselves are responsible. They fail to take certain steps that would recognize and cure the problems. It is difficult to find instances in which Korean-American women's organizations have started programs designed to combat the general belief in

Confucianist doctrines of male superiority. Only a tiny minority of women is beginning to take some interest in promoting women's liberation issues in the Korean-American community. Most Korean-American women, however, still are ignorant or distrustful of women's liberation, and are inclined to follow past traditions rather blindly.

With strong backing from Korean-American women's organizations, research could be sponsored on women's issues cross-culturally, and grants could be requested from local, state and federal governments for job training of Korean-American women. Women's assertiveness training workshops and seminars could be conducted, and would be very helpful. Referral service to various professionals such as family counselors, medical doctors, or legal services personnel could be provided. Work could be done towards forming coalitions with other American women's organizations for building a political power base for Korean-American women.

It may take a long time to bring about, these changes in direction even if some Korean women leaders work continuously towards meeting the goal. Because Korean-American women have seldom vocalized their concerns with a single voice, a multiplicity of uncoordinated organizations have arisen. The various women's organizations too often have worked at cross purposes from each other.

There is an urgent need for an organization that would not only unite all Korean women in America, but would also be the ombudsman for Korean-American women. Such an organization should

receive the active participation of all Korean-American women, whether their husbands are Korean or non-Korean.

Outreach Organizations: Personal Experience

Most of the broadly based Korean community organizations, including the women's organizations, have focused almost exclusively on giving transplanted Koreans a "home away from home" in America. By concentrating so intently on Korea, however, something of a ghetto mentality sometimes has resulted that has hindered integration into the American community.

Nevertheless, a few organizations in the Washington D.C. area are of the "outreach" type. These organizations are not turned inward toward the Korean community. Instead, they are dedicated to setting up links with the mainstream American community.

I have personally participated in three such organizations, and my experience reveals much about how such organizations could help the Korean-American community.

Korean-American Federation of the Republican Party

The first Korean-American outreach organization in which I personally participated, was the Korean-American Federation of the Republican

Party. This is a national organization with active chapters in twenty-four states. The program of the organization was simply to make contact with and support Republican Party candidates who had favorable attitudes towards the Korean-American Community. The organization engages in fundraising and political education, and holds a national conference once a year.

I first read about the organization in one of the local Korean newspapers in a story about a conference to be held shortly in May of 1986 in Arlington, Virginia. There was to be an essay contest on how Koreans could become involved in Republican politics in the upcoming midterm election. Conversing with the then President of the organization, John Yoon, I mentioned that I was conducting an eight-session seminar on U. S. foreign policy for the American Foreign Policy Association in Bethesda, Maryland. He asked if I would be willing to conduct a seminar for the May 1986 meeting on the subject of getting involved in U.S. politics. I accepted.

The convention was held at the Hyatt Regency Hotel in Crystal City, Arlington, Virginia. My seminar was, "How To Get Involved In The Upcoming Midterm Election." Most of what I included was what I had learned during the 1960s and 1970s when I was personally active in grass-roots American presidential campaigns. I considered leading the seminar as my long-time overdue contribution to the Korean community.

It was at this seminar that I first met Dr. Kyo Jhin. At the time, Dr. Jhin was rising in American

politics, and was also an employee of the D.C. school system. He was one of the nineteen attendees, and was one of the few Korean-Americans who had attained a position as high as Secretary of the Maryland Republican party. The rest of the audience, as I found out during the seminar, was mostly made up of Korean men who had had rather disappointing experiences with American politics.

One Korean businessman from Houston told the group, "When I go door-to-door campaigning, people would just slam the door at me saying, 'What's this Chinaman doing here?' Another man from Los Angeles expressed his gripe, "We campaign and give a lot of money, but at the end, all we have is an empty suitcase." We listed the major strategies on getting involved in American politics on a flip chart and reported to the general meeting on the same afternoon. Overall, it was a good seminar I felt was appreciated by the audience.

Korean-American Citizens Council

After the seminar, I was contacted by Dr. Jhin who had been impressed with how well the session had gone. Dr. Jhin interested me in becoming involved in yet another Korean-American outreach organization, the Korean-American Citizens Council of Maryland, then looking for a president to lead it. "They need someone who can speak English," he pleaded with me. The purpose of the Council was to protect minority rights and encourage good U.S. citizenship.

The Korean-American Citizens Council had been founded in 1976 by a small group of concerned Koreans in Northern Virginia. Chapters of the Citizens Council had been formed in both Virginia and Maryland. The Virginia chapter was established first, and the Maryland chapter was started in 1982.

Dr. Jhin assured me that the Citizens Council would be a perfect opportunity for me to help the Korean-American community get involved in the American mainstream. Up to this point, I had in fact had very little to do with the Korean-American community. I had lived in locations where there were very few Koreans. Now that I was living in the Washington D.C. area, I thought it was time I made a contribution.

After I prepared a resume of my background, Dr. Jhin and I went to a meeting of the Citizens Council on May 30, 1986 which was held in an Arlington Korean restaurant. Dr. Jhin brought along another Korean woman, Sunny Lee, who worked in the Montgomery County, Maryland school system, and who would later be very helpful to me.

The first part of the meeting was devoted to Dr. Harry Kim, an obstetrician, the current president of the organization, who was submitting his resignation. It was six months after the end of his elected term; no successor had been found, but he was quitting anyway.

After Dr. Kim sat down, Dr. Jhin stood up and introduced me to the group as a "godsend," and suggested that I had the perfect background for the job as president. Everyone liked that I had achieved a

doctorate, and that I had done frequent volunteer work in various mainstream American organizations. The resume was passed around among the twelve or fifteen people present. There was no other candidate, and the organization was about ready to fold. No actual vote was taken, but no one voiced any objections. This was how I came into the presidency of the Citizens Council. I served as president of this organization from May 1986 to June 1987. It was the first time a woman had held this post. I didn't realize at the time that I had been given the position when the organization was at a low point and no qualified men had been interested in serving.

After the meeting, I spoke with my predecessor, Dr. Kim and told him, "I would appreciate your support and help with the organization." He told me, rather curtly, "It's all yours. If I could help you and had time for it, I would have stayed on myself." Sunny Lee, the other female attending, however, said she would be glad to help. One other person who promised to help was Dr. Bill Lee, a distinguished gentleman and medical doctor in his early sixties, who had for many years been an important person in the Korean community. No date was set for the next meeting.

After the meeting, I began to realize I didn't actually know much about my new organization. A week later, I ran into my predecessor Dr. Kim, at a meeting at Kyo Jhin's house. At the time, Kyo was running for the Republican nomination to the Maryland House of Delegates. I asked Dr. Kim about the membership list, and he replied that the

organization had never had a formal list. I asked about the funds on hand in the treasury. He shook his head and told me there was nothing.

I also saw Ki Lee at the same meeting. He had just been elected president of the League of Korean-Americans (LOKA), an organization that had been founded by Dr. Bill Lee along with a few other concerned men in 1978 to further the interest of Korean-Americans. Ki said he was interested in working with me since we were both newly elected chairs. He also had a worker for me, Mrs. Myung Goodsell, who would be important in my organization.

I complained to Ki that it looked as though I had been elected president of an organization without members or a treasury, and told him I had just about decided to resign. I had been active in various American organizations as a volunteer. I had held various officer level positions, as executive member of the board of directors, but never had to start like this. Ki wanted me to stay on so he could work with me. I also felt that by resigning so soon, I would become a laughingstock, having accepted the job of chair one moment, and then relinquishing it the next. I could see myself disgracing my ancestors back home if I resigned. Since this was the first time for this organization that a woman had been president, I also felt some duty to all Korean women.

Word of my election rapidly spread throughout the Korean community. One night, soon after my election, when my husband and I were working late in our business office in Rockville, Maryland, I received an anonymous phone call. It was a young-sounding

male voice, and his message didn't show much maturity, either.

"Are you Dr. Yu?" the person asked, with an unusually thick accent.

"Yes!" I answered, then asked, "May I ask with whom I am speaking?"

"I am Mr. Lee," said the voice. "I got a master's degree from Columbia University. Are you the president of the Citizens Council?"

"Yes!"

"Do you think," he demanded, "that you can lead the Koreans in Maryland? Do you think you have the ability? You are a woman. What makes you think you can do this kind of job?" His voice got louder and louder. Obviously, this man was having some problem with the thought of having a woman as a chair for the Citizens Council.

"Maybe, you can lend a hand," I said, "Let's work together for the Korean-American community." At that, all I got was silence. The caller quietly faded away into the night.

I called my first planning meeting July 7, and invited Dr. Harry Kim, my predecessor, Dr. Bill Lee, Sunny Lee, and Myung Goodsell to attend. Sunny Lee agreed to serve as Secretary Treasurer, and Myung Goodsell, who liked to make food, agreed to be Social Chair. Neither Dr. Kim nor Dr. Lee wanted to hold specific offices. I was destined to have a very difficult time getting men to serve as an officer in my new organization. Part of the reason was that few people, and especially Korean men, really like the idea of working for a woman. I was seriously troubled by

the aloofness of Korean men. I had been rather accustomed to more egalitarian mainstream organizations until now. I actually missed working in situations where gender role had not been so specific. In Korean-American community organizations, I had to learn new skills to work with a group of men from a male dominant society, a Korean society so frequently described as a male paradise. (See Chapter 7) Many Korean men love big titles and honor. Like the anonymous phone caller of the week before, most Korean men simply did not think a woman could be competent to do the job.

There was another fact I later discovered. In the Korean-American community, the position one holds in a civic organization can have a real effect on one's social status. Once a person has been president of an organization, the only official capacity in which that person wants to serve is in the office of *kohmoon*, that is, adviser to the president. In the Korean way of thinking, this position is higher in importance than the president. If one saw himself as *kohmoon* material someday, one wouldn't want to be working in a lesser position, and particularly not under a woman chair.

At our kick-off event, we decided to hold a "Meet the Candidate" night for some local politicians, all of whom happened to be Republicans. The Citizens Council itself was a nonpartisan group. The star attraction was to be U.S. Senatorial Candidate, Linda Chavez. We also were going to have Bill Skinner who was running for the Montgomery County Council, and Bill's 21-year old son, who was running for a Maryland State Senate seat.

To save money, instead of holding a dinner at a restaurant, it was decided to do a potluck supper at my home. This avoided having to commit to a restaurant for a guaranteed number of people. We really were not sure how many would come. The list of invitees was quite diversified, with only about a dozen Koreans including several members of the Korean press invited. On the list were many Chinese, some Japanese and Vietnamese, as well as a sampling of our American friends, neighbors, and acquaintances.

When the "Meet the Candidates" affair with Linda Chavez took place several weeks later on August 4, the meeting was very successful. It helped us to reach out to additional members of the Korean-American community and to build the Citizens Council into a stronger organization.

Sometime in July of 1986, before the "Meet the Candidates Night" took place, I was asked by Dr. Kyo Jhin to attend a political meeting in Silver Spring, Maryland, at a Korean restaurant. I was told by Dr. Jhin that this was a meeting to gather the presidents of all the local Korean organizations, whose support Kyo Jhin wished to win.

The meeting was held in a Korean-style room in the back of the restaurant where everyone sat on the floor. The table was long and especially narrow. If you and the person sitting front of you lowered your heads, your heads would bump. People had to sit rather close to each other. All those attending were males, as was frequently the case. Dr. Jhin introduced me to the group and seated me across the

table from him. The waitress started to bring in various dishes of Korean food and placed the dishes in front of the men, but nothing in front of me. The men, including Kyo Jhin, started to eat their food, slurping soup, and not paying any attention to whether or not the person sitting next to them had food. This angered me, and I spoke up loudly to the waitress.

"Why don't you bring my food? I have been waiting all this time.!"

"Yes, ma'am. I will bring you food as soon as the men are taken care of first, ma'am!" responded the waitress, with a somewhat irritated look. Kyo Jhin looked the other way and ignored what was going on right in front of him.

"You have given food to everybody but me, why?" I insisted, again to the waitress, but Kyo Jhin and all the men were too aloof to get involved with this scene. I insisted on fair service because I knew where the waitress was coming from.

To my surprise, early the next morning, around eight o'clock, Kyo Jhin phoned me at home to apologize for the waitress's obvious sex discrimination.

"Dr. Yu, I am sorry about last night. They don't have good service, that's why their business isn't doing well."

"Uh? Why didn't you speak up last night, if you felt that way?" I challenged his sincerity.

"As you know, Dr. Yu, most Korean men feel that it is normal for men to be treated better than women, and," he continued, "they would censure me if I took the side of a woman."

"Never mind. You did not speak up then, and now you are calling me in private. Please don't ask me to attend such meetings again."

Sex discrimination has entrenched itself so deeply in Korean society that, when one pays attention to the existence of the problem, everyday experiences like this can be unpleasant. Anyone can make speeches on the desirability of sex equality in a most polished fashion; however, until Korean women start pointing out incidents that are discriminatory, Korean women will never be treated differently than they are now.

After the "Meet the Candidates" affair with Linda Chavez on August 4, our committee members worked hard to recruit more people into our organization. In politics, there is nothing like winning. We were even able to find men who would work on the board under a woman president. One male community leader, Jerry Hwang, was especially helpful in recruitment. Jerry introduced me to Steven Han, who later became the president of the Korean Association of Maryland. Steven agreed to serve as secretary general and handle the details of holding our first real organization meeting.

With help from Steven Han and Jerry Hwang, we assembled a list of about fifty influential persons in the Korean-American community to whom we would send invitations to be on our board. Without offering a fancy title, I doubt that any of them would have wanted to attend. The meeting was to be held at a Korean restaurant in Rockville, Maryland, on September 16, 1986.

Of the fifty persons we invited, about forty, all men, actually came to the meeting, but we soon found that they were all not committed to work in our organization. As I learned later, there were many factions among them. Some of the men complained about trivia just to show how important they were. Others had come to see how a woman chair would conduct an all-male board meeting.

My predecessor Dr. Kim, also was invited. At the meeting, when the amount in the treasury was brought up, he told us the unspent amount was $179, and wrote us a check for $179 from his personal account. I supposed at the time, having been told there was no treasury, by Dr. Kim himself, that he was just embarrassed at not having had a treasury during his administration. As was suspected, he mainly gave us that amount to save face, as someone told me later.

Before the meeting, I was advised by Steven Han, the secretary general to sit quietly in the corner and let him do all the work. Being a true sort of feminist, I refused to sit quietly in the corner and watch my secretary general run the board meeting. Later, with the benefit of hindsight, I regretted that I had not taken Han's advice, because all of forty those men only wanted to show off, and did so by criticizing every detail of our program.

Even our proposal to charge $25 annual membership dues was attacked. "Twenty five dollars? People wouldn't come, even if it was free," the shout came from the audience. As I learned later, this was Mr. Choi's opportunity to show his courage to speak

up. Mr. Choi was one of those who complained the most all evening. At this point, Steven Han shouted at Mr. Choi.

"How can we conduct a meeting if you constantly criticize all night long?" Han continued, "Our committee worked very hard for this. We are just a few people." The meeting turned quiet. Steven Han was physically much bigger and was more popular among the macho Korean male community. Later, Steven Han whispered to me,

"Please don't be too concerned ma'am." Then he continued, "There are always fights every time there are meetings among Korean men."

I learned later about how to silence an obnoxious person by simply not backing down. The same Mr. Choi from the board meeting the night before called me the next day at home and began criticizing me about how badly the meeting had gone. He said if I had been a man instead of a woman, I would have been thrown out of the window.

I couldn't be quiet any more. I was losing patience with Mr. Choi. Therefore, I pulled rank.

"Mr. Choi, I want you to know that my committee worked very hard to put the meeting together." To my surprise, Mr. Choi turned instantly quiet and said,

"*Hoejang nihm*! (Honorable chairman), please forgive me." We later became good friends and worked on numerous projects together. This might indicate that Koreans in general, work better under an authoritarian leader than when one tries to be democratic.

Later in my term, I had fewer difficulties. During my tenure as the president of the Council, our efforts to mainstream the Korean-American community included holding voter registration, building a good working relationship with Montgomery County's Minority Affairs Office, and planning for other civic functions.

Still as a part of mainstreaming, the Council held a dinner banquet for Maryland U.S. Congresswoman Connie Morella in April of 1987. The dinner banquet was followed by discussion on matters which concerned the Korean-American community. Connie was superb in interacting with the Koreans. We did well, even financially. Instead of everyone paying his own way, we sold 150 tickets for $25 each. This put some money in our treasury. After deducting all the expenses, we made $864. We needed the money badly as operating cash, since we had been having to scrounge even for postage stamps.

At our last function in May, I encountered another sexist episode just before relinquishing my reign. We held another dinner discussion meeting, this time with Montgomery County Executive, Sidney Kramer, as our honored guest. This was to promote friendship, and to air our Korean community's concerns. About twenty-five people attended, all sitting on chairs at a long narrow table. Sid Kramer, our Jewish Montgomery County Executive, had brought along De Vance Walker, his Black minority affairs officer for Montgomery County, Maryland. I had brought my husband, a Caucasian. Except these three, everyone else was Korean.

One of the Korean men present was Dr. James Chun, a Ph.D., a minister of a Korean church. Dr. Chun gave the blessing in fluent English.

At one end of the table sat Mr. Kramer, with me on his left and Dr. Chun on his right. Several gas grills were located on the table for cooking *bulgogi* (Korean barbecue). The waitress brought out many dishes including the marinated meat which she had spread out on the hot grills. One side of the meat was ready to be turned over. The waitress was nowhere in sight, so Dr. Chun looked at me and said, in Korean,

"Dr. Yu, you must cook the meat." I might add that he wasn't busy at that time.

A small rebellion against sex discrimination was about to begin. Since I knew where he was coming from, I said in English, "Why can't you? You are as close to the grill as I am." I had been busy talking to the honored guest and thinking about my agenda. In a split second, my head went into a fast calculation that if the head of the organization had been a man, he would not have been asked to attend to cooking while conducting a meeting.

Mr. Kramer, picked it right up, sensing the awkwardness of the moment, and helped me out with a reply I would always remember.

"I have a daughter who is a lawyer." He continued, "If she were in this situation, she would have responded to it in exactly the same way as you did." What a support! I would never forget the whole episode.

My term ended on June 19, 1987, with a complete written report. The meeting was well

attended by about 25 board members and newspaper reporters from the Korean-American community in the Washington D.C. area.

Outreach organizations such as the Citizens Council are important to the Korean-American community. They overcome the natural tendency of Korean organizations to focus too much on back home in Korea. Through the outreach type of organizations, Korean-Americans make useful contacts with the mainstream American community. Outreach type organizations are sometimes the best tools for combatting and preventing discrimination against Koreans in American society. Such organizations are also free to focus on what is necessary but not sufficiently obvious to many Korean-Americans: showing members of our community how to be good citizens and participants in the affairs of their new country which is America.

Asian-American Political Action Committee (ASPAC)

The third outreach organization with which I have had personal experience is the Asian-American Political Action Committee (ASPAC). This organization was founded in 1987 with a membership drawn from eleven different Asian ethnic communities in the D.C. area. On the founding night, I was elected the first president, and a gentleman from Laos was elected vice president. The current president in 1990 is Dr. Chris Mathur, an Indo-American political

science professor at the University of the District of Columbia. Membership from the beginning has been split more or less evenly between men and women.

The purpose of this organization is to reach outside the ethnic community of the respective members, and to promote political fellowship among Asian Americans. Being Asians, all members have somewhat similar backgrounds and cultures, and are potentially stronger politically when coordinating with each other. The organization is designed to provide Asian Americans with an educational opportunity in the American political process, to support political candidates who are in sympathy with Asian-American needs as spelled out in its by-laws. The organization also promotes good American citizenship.

This is intentionally a bipartisan organization, since Asian Americans ought to be helped by both major political parties. Monthly meetings feature speakers on various political topics of interest to the members. Programs have included talks on politics and strategies by coalition directors from the Republican and Democratic parties. Other speakers have given programs on understanding the American Constitution, voter registration, and on getting personally involved in American grassroots politics. A monthly newsletter, ASPAC News, is the major means of communication among the members.

Conclusion

Most of the current Korean-American community organizations started with one principal

goal in mind, to furnish a "home away from home" for individuals who, without these organizations, would have felt lonely and isolated. It remains a valid principle today that the gathering of like-minded individuals into community organizations can obtain results which the individuals operating alone could not have achieved for themselves.

With the increasing Americanization of the Korean-American community, however, necessary changes are gradually developing in the way the various community organizations have to operate. In the area of language usage, for example, most meetings in the churches, the civic and business associations and the women's associations used to be conducted entirely in Korean. Today, English is used with greater frequency.

Indeed, in church school classes for children, use of English has been necessary from the beginning since most of the children born in America are fluent *only* in English. Without English, the church school classes would not exist! And what is true of language usage in church school classes today will in time, of course, be the case for language usage in Korean-American community organizations. It is almost impossible, and probably not desirable, to live in America and not be influenced in very basic ways by the mainstream culture.

A great benefit to all women who live in America is the increasing equality between men and women. One could call this an "entitlement" of American women. Such equality also needs to be made a part of the way in which Korean-American

community organizations are run. If other American women are entitled to equality with men, then Korean-American women should not compromise for less.

One of the first steps in empowering women should be that women be allowed to fill more major posts in Korean-American community organizations. Besides simple fairness to women, there is another benefit to the community from this practice. Women naturally have different perspectives from men. By using more women in some of the policy-making positions, organizations may be able to have more balanced and comprehensive programs than in the past.

A special responsibility is borne by women in the current all-women organizations since these groups can conduct consciousness-raising sessions among their membership. These organizations have important work to do that cannot be done as well by any other groups. They should be the agencies that inform their members as to where sex discrimination exists. They can also help form strategies to bring about constructive and needed changes.

Notes

1. The Korean community in Los Angeles appears to be largely independent of American mainstream society. Harry H. L. Kitano and Lynn Kyung Chai, "Korean Interracial Marriage," *Intermarriage in the United States,* eds. Gary A. Cretser and Joseph J. Leon (New York and London: The Haworth Press, 1984), p. 78.

2. *The Greater Washington Area Korean Directory*
 (Annandale, Virginia: Korean Association of Greater
 Washington, 1988).

3. Eui-Young Yu, "The Activities of Women in Southern
 California Korean Community Organizations," eds. Yu
 and Phillips, *Korean Women in Transition: At Home and
 Abroad* (Los Angeles: Center for Korean-American and
 Korean Studies, California State University, 1987), p.
 289.

4. Churches in the Korean immigrant community are the
 institutions which wield the most power and have the
 strongest influence. "The Future of the Immigrant
 Church," *Sae Gae Ilbo*, Washington, D.C. edition, July
 14, 1990. Korean-American churches are today almost
 2,000 in number. The record-breaking growth of
 churches in the Korean-American community provides
 places of worship for the immigrants, but it also brings
 many problems. *Dong A-Ilbo*, Washington, D.C.
 edition, March 9, 1989, p. 3.

5. "Immigrant Churches need to be Active for the
 Immigrant Community Welfare," *Sae Gae Ilbo*,
 Washington, D.C. edition, August 8, 1989.

6. Many of the small churches have little money, forcing
 their ministers to hold down outside secular jobs to
 support their families. Yong-Choon Kim, "The Nature
 and Destiny of Korean Churches in the United States,"
 ed. Seong-Hyong Lee and Tae-Hwan Kwak, *Koreans in
 North America: New Perspectives* (Seoul: Kyungnam
 University Press, 1988), p. 226.

7. May 19, 1989, interview with Dr. Hosan Kim, Vice
 President of Administration, St. Andrew Kim Catholic
 Church. Dr. Kim revealed that his church has grown so

rapidly during last few years, it is moving to a new 50-acre new location in Montgomery County, Maryland. His congregation collected $200,000 towards the new church home.

8. The early Korean-American churches often functioned as the religious arm of patriotic political organizations. A number of ministers also were presidents of the Korean National Association. These churches became forums for nationalistic education, sponsoring debates on topics such as, "Jesus Christ and the Future of Korea," and "The Duty of Koreans Abroad." Ronald Takaki, *Strangers from a Different Shore* (Boston, Toronto and London: Little, Brown and Company, 1989), p. 279.

9. Using English is necessary in many of the church programs, especially in regard to activities of the 1.5 generation. A Korean minister sees Korean-American churches are going through change, but a gradual one. Interview with Rev. David Chai, Korean Presbyterian Church of Rockville, Md., March 15, 1989.

10. A recent survey of four selected Korean churches by the author, representing three different denominations in the Washington D.C. area, indicated that few to no females were to be found in the top echelon of Korean church governing bodies. Two of those churches were Presbyterian, one was Baptist, and the fourth was Seventh Day Adventist. Typically, Korean-American churches are conservative, hierarchical, and male-dominant. Yu and Phillips, *Korean Women in Transition*, p. 289.

11. Interview with David Chai, Minister, Rockville Korean Presbyterian Church, Rockville, Md. on March 15, 1989.

12. In Korean churches located in cities where there are not many Koreans, services are already being conducted both in English and Korean. In Phoenix, Arizona, the downtown Korean Methodist church utilizes a system of headphones with simultaneous translation. A Phoenix Presbyterian church with many caucasian spouse members features sermons given first in English, then in Korean. The same system is used in singing hymns and the printing of the Sunday morning program.

13. Interviews with Minister David Chai on March 15, 1989 and Minister Won-Joo Yang, Minister, Korean Seventh Day Adventist Church in Spenceville, Md., March 31, 1989.

14. A Korean teacher noticed that most of the students were not interested in learning about Korea. Some did not even open their books, while some talked to each other in English during the class. Bong-Youn Choy, *Koreans in America* (Chicago: Nelson-Hall, 1979) p. 329; At a Korean church school in Raleigh, North Carolina, I personally noticed the indifference of the children to learning Korean. The class was composed of twenty students, all but one ages 10 to 12. All of the children were wandering around outside the school building with friends during the time when they were supposed to be in class. The only person who remained in his place was a caucasian gentleman who was eager to learn his wife's native culture.

15. *Chosun Ilbo*, Washington, D.C. edition, March 7, 1989.

16. Interviews with Hwangbo Chul, President of Washington Chapter, Korean Schools Federation in America, March 15, 1989.

17. Yu, "The Activities of Women in Southern California Korean Community Organizations," p. 290.

18. According to a Korean minister in the Washington, D.C. area, the charter of his denomination, the Presbyterian Church of America, permitted only a man to be ordained as a minister or an elder; A Baptist minister confirmed that in some Baptist churches, women were not allowed on the pastoral ministry committee or to be deacons.

19. Interview with Chai, March 15, 1989.

20. Ibid.

21. It has been said that too many Korean clergymen waste time and energy in petty denominational disputes to make their own positions secure. As a result, they have established many churches with small memberships. Many Korean churches have isolated themselves from the mainstream of Korean community life and have been converted into do-nothing social clubs. Choy, *Koreans in America*, p. 272.

22. During the long Korean store boycott by New York Blacks, three New York Korean organizations: the Korean Association, the Korean Produce Association, and the Korean Merchants Group have sent as much as $8,000 per month to each store. "An American Nightmare," *Washington Times*, July 18, 1990.

23. Yu, "The Activities of Women in Southern California Korean Community Organizations," p. 287.

24. Interview with Henry Shin, President, The Korean American Chamber of Commerce of Washington, D.C. area, March 18, 1989.

25. Ibid.

26. Ibid.

27. During the early period of the Korean community in America, a number of Korean Women's organizations were founded. Their major aims were similar: to assist the Korean immigrant society and to support the Korean independence movement from the Japanese occupation of their native country. The Korean Women's Patriotic League *(Daehan Yoja Aekook Dan)* was formed by a merger of three older women's organizations: The Korean Women's Society which came into being on May 23, 1908, in San Francisco; the Korean Women's Association organized by a group of women in the Sacramento area on March 29, 1917; and the Women's Friendship Association, organized by a group of women in Los Angeles on March 28, 1919. Choy, *Koreans in America*, pp. 119-20.

28. Interview with June Dawson, former President, The Korean American Women's, Inc. of Washington, D.C. Area, March 10, 1989.

29. Ibid.

30. Ibid.

31. Interview with Jong-Ki Moon, Founder and former President, The Korean-American Women's Association *(Daehan Booin Hoe)* of Washington, D.C. Area, March 16, 1989.

32. Interview with Sang-Hi Chu, President of The Korean-American Women's Association *(Daehan Booin Hoe)*, of Washington, D.C. Area, March 1989.

33. Ibid.

34. Ibid.

35. In particular, there is still a tendency for animosity to break out between the one Korean-American women's organization in the Washington D.C. area that disapproves of interracial marriages and the two that approve. For example, at a recent meeting held on February 10, 1989, for the presidents of about forty key Korean organizations in the Washington D.C. area, Mrs. Chu, the president of the Korean Women's Association, made what was taken to be a slighting reference to the interracial marriages of the members of the other two women's clubs in the area.

Mrs. Chu referred in her speech to various Korean organizations by their proper organizational names, but she called her sister organizations the "interracially married women's organizations." This reference to them was taken as a bit of intended rudeness by the other two women's organizations.

Mrs. Chu refused to make any official apology for her language in her capacity as club president, apparently on the ground that her remarks were her own personal remarks, and that her club had no need to apologize for them. Instead, through an interview she gave to the Korean newspaper, she confined any apology that she was going to make to her own apology as an individual. *Dong A-Ilbo,* Washington, D.C. edition, February 15 and 21, 1989.

This incident is a good illustration of the kind of petty hostility that is sometimes expressed against interracially-married women in the Korean community. Mrs. June Dawson, of the Korean-American Wives Club, stated, "The remarks by Mrs. Chu show the everyday negative attitudes of Koreans towards interracially-married Korean women, and it is a regrettable situation because we work so hard to help the Korean immigrant community."

Such unkind comments, especially when made by an organization's chairperson, tend to undercut the harmony of the Korean-American community. These unfortunate happenings occur because of the prejudicial attitudes that many individuals in the Korean immigrant community continue to hold towards Korean women who are married to non-Koreans.

CHAPTER 12

Conclusion

From an early age, under the influence of my grandfather, Yu Kyung-Duk, I have never had any doubts that females were at least equal to males in such important respects as intelligence, perseverance, and the general ability to succeed in life. Grandfather was an iconoclast. He had no use for women who spent all day, as he frequently said, "dusting and cleaning." The Confucian ideal of a mindless woman was repugnant to him. He wanted women to "read newspapers to know what was going on in the world." Because of him, I have always known there was something very wrong about treating females less respectfully than males because of their gender.

Not only traditional-minded women in Korea, but also Korean women in America, have allowed themselves to be influenced far too much by outdated Confucian practices that are anti-woman. Not only should women in Korea work to change this situation, but Korean women in America should also work to

elevate the status and worth of women in the Korean-American community. In both Korea and America, most of these practices are "excess baggage" and should be gotten rid of as soon as possible.

In American society, women's rights have been recognized to a greater extent than most other societies in the world. America is a land of freedom and democracy. By law everyone is given the right to succeed regardless of social class, national origin, wealth or sex. America is a place where women can try their wings, make some mistakes, pick up the pieces, try again, and even succeed. Success is not guaranteed, but the opportunity to try is available.

On first consideration, one might think that the liberation of Korean women would be more advanced in America than in Korea. Unfortunately, Korean women in America have seen themselves primarily as members of the Korean-American community, and have viewed themselves as rather powerless. Like traditional women in Korea, they have been far too ready to retreat inside their own houses, and to let the men take care of running the community. The result has been that Korean women often have been treated as second-class citizens within that community. Nor has it helped Korean men to be regarded with such awe since it has not made them any better off. In fact, Korean women have helped to create a Frankenstein. They have encouraged Korean men to believe, simply because they are males, that they are better than they are. When their manhood is challenged in stressful situations, sometimes domestic violence results. By flattering men, however, women encourage men to be self-aggrandizing.

Korean-American women need not discard all aspects of their own culture, but they need to begin regarding themselves also as part of the American women's movement, and not just exclusively belonging to the Korean-American community. As such, they will receive needed support and encouragement for ending discrimination against women in the Korean-American community, and they will bring about healthful changes in the sex-discriminatory attitudes that are currently so prevalent.

Often American women have looked at the gender problem as more than just their own personal problem. They have organized and turned unfair discrimination against women into a public issue, and have won their battles in an increasing number of cases. From T.V. anchor women to office workers, they have simply insisted that their rights be heard. Above all, many American women through the women's movement have learned to stick together.

The question might be asked as to why Korean-American women are so passive. Doubtless it is because the women have been conditioned to believe that they must behave in a subordinate way to be acceptable for the Korean male-dominant society. Korean women have conveniently relinquished their responsibility to complain and to fight the inhuman treatment against them. Korean women might be knowledgeable about the Yim Young-Shin story, but if the women do nothing to fight male domination, it remains only a story having nothing to do with reality. In America, it is impossible to overstate the importance of constitutional law and legislation against discrimination in establishing and

working towards the rights of women and minorities. One of the main ideals of Western civilization has been ordering society through the rule of law, rather than by the rule of men. Women have a special place in the legal profession since they need to understand how to protect themselves, and not rely on others for protection. It is plausible that women would have special insights into the application of justice in sex discrimination cases, more so than men. Fully half of the students in American law schools today are women.

In America, Korean-American women have more of a choice than their counterparts in Korea about the types of men they will marry. Thanks to the American women's movement, the "macho male" ideal is diminishing.

The time has come for Korean-American women to take a more active part in the life of the community. In general, too many women are confined to repetitive homebound chores with many brought up to acquiesce in what men want them to do, and not to "rock the boat." In some cases, community participation by women can be through activity in traditional women's organizations, both Korean and American. At least some women also can become interested in local grassroots politics or other community activities. By running for office themselves, or helping others to do so, they will do much to put the Korean-American community more into the mainstream of American life today.

Women in Korea and in America as well now have the law on their side to fight discrimination against them. Ironically, too often women create stumbling blocks to their own progress. By clinging to the

security of traditional practices. This requires reeducation at the grassroots level. Individuals and women's organizations must press for equality both in Korea and in the United States.

APPENDIX

Case Interviews:
Biracial Korean Daughters

What follows is a listing of the questions asked in the interviews conducted with twelve daughters of biracial Korean-American couples, together with a summary of the responses recorded in each of the interviews. Pseudonyms were used and locations were changed to protect the identities of the respondents. The interviews were carried out in an informal and relaxed manner. Following are the questions used, some being developed during the interviews themselves.

1. *Do you feel a part of the Korean community?*
2. *Have you considered marrying a Korean man?*
3. *Do you have any advice for the Korean-American community?*
4. *Do you speak any Korean?*
5. *What was the influence in your life of having a Korean mother?*
6. *What contacts did you have with your Korean relatives?*
7. *What was the influence in your life of having Korean relatives?*

Case Summaries

(1) **Debbie**, twenty-one years old, born in Fort Meade, Md., 4th year Microbiology major at Tufts University. Planning on working for a hospital or genetic research company. Debbie likes school. She prefers studying to not studying. Both parents have college degrees. Father from the University of Maryland, mother from Ewha Women's University in Korea.

> **No negative aspects about being a Korean-American, half-and-half child. When I was about six or seven, I was teased a lot. Name calling, sometimes. Positive influence of Far Eastern culture is strong emphasis on education. Education is highest priority among Koreans. This country needs that kind of education because it is important to you. If I had American parents, there would not be as much emphasis on getting Ph.D. and all. My mother encourages me to get Ph.D. That's been honorable for me.**

Feel a part of Korean community?

> **No, because all my friends are Americans. Mother's friends often visit our home, but I don't feel like part of the Korean community. I have lived in Korea. I consider myself as half Korean and half American. I lived in Scotland for a year, and I tend to have a more socialist orientation, like the Europeans.**

Considered marrying a Korean man?

No, having Koreans as friends might be O.K. But Korean men from Korea seem too old-fashioned, like male chauvinists. I have minimum contact with Koreans except mother's friends.

Any advice to Korean American community?

Yes, Korean kids, especially the daughters, seem introverted and study all the time. Maybe the parents are pushing too much. Korean kids are very intelligent anyway.

2. **Mary**, twenty-two years old, born in Michigan. Sociology major at University of Maryland.

My parents met in Korea. My father has a bachelor's degree in accounting and works for the U.S. government. My mother didn't go to college. My parents have been married for twenty-five years and I am the only child.

When children are younger, it might be negative to be half-and-half because other children see it as a negative. They call you Chinese, even though you are not Chinese. They didn't know what a Korean was. I didn't like the stereotyping, but I didn't have a lot of trouble, and had nothing dramatic enough to remember. We lived in this neighborhood for almost my whole life. I always had a lot of friends.

There are a lot of positive aspects of being half-and-half - Korean and American. Wouldn't want it any other way. I feel more American than Korean, though.

Feel part of the Korean community?

I have never been involved in the Korean community. I am not a member of the Korean Student Association at school, even though they have one. I just don't feel comfortable. Most of the members are more Korean than I am. They might not feel comfortable with me either.

Considered marrying a Korean man?

No, Korean men give the impression that they feel that women are lower than they are. My roommate in college is a full Korean. She wouldn't go out with Korean men.

(3) **Patricia**, twenty-six, born in Korea, Ph.D. candidate, Stanford University. Works at NASA as an aerospace engineer. B.S. from Notre Dame University, M.S. from MIT. Both parents have college educations.

Negative thing about being a Half-and-Half child is that I noticed that I stand out.

Among caucasians, not everybody likes orientals. Some Americans don't understand and they treat you somewhat

differently, especially in the Midwest. When I went to Notre Dame, I was a loner in the class.

Even in Maryland, I got teased a lot. The kids in school called me "chinks" and all. I have gotten hit and pushed around when I was about ten or twelve. One time in my classroom, this kid was leaning back in his chair towards me. He was about eleven and bigger than I was. He pushed back at me several times. I started to push him, too, to stop him doing it so much. We were both called to the principal's office. The principal, instead of scolding him, said that we both were wrong. When my father later went to see the boy's parents, my dad found out that his mother was trying to raise him alone and they were very poor.

When I was little I just wanted to be like other children, and not different, but when I went to college, people said I was exotic, and I liked it. Now I don't mind what I am called. There is not anything that's major that stands out as negative or positive, now. As an engineer, I am thinking mainly of the fact of being a woman in a man's world.

The positive thing about being a Korean-American child is that while I got to learn about oriental culture, Mother didn't raise us to be typical Korean females.

Feel part of the Korean community?

Korean people don't consider me a Korean. Koreans think I am an American. Americans think I am a Korean. Americans

don't accept you as totally American and
Koreans don't accept you as totally Korean.
But I think I am a perfect blend. I love
being in California. I don't stick out like
when I was in South Bend (Indiana). You
really stand out there. They were not sure
what I was. In Notre Dame, they used to call
me, "The Korean girl," or "The little Korean
girl."

Marry a Korean man?

No, I have never met a Korean man I
wanted to marry. At MIT, when I was
working on my masters degree, there
was this Korean guy in one of my classes. He
told me one day that I would never be
accepted in the Korean community. There
were several guys from Korea at MIT. Those
guys were very traditional and clung
together. My mother is not a typical Korean.
She told me that she never wanted to marry a
Korean man ever since she was a young girl.

(4) **Joan**, twenty-seven years old, student in
Business Administration at a university in California.
Both parents have been educated at American colleges.

My frustration comes with the
limited perception that many Americans have
of Asian women. As a very young child, I
was frequently being asked if my father had
been in the army. The answer is, yes, and
that is what I would say. I didn't realize for
quite some time that I was confirming the
mistaken assumption that my mother had

married a G.I., and then came to live in America.

Years later, when I worked as a waitress in San Francisco, was asked by a loud, drunken man if I had been a "war baby." Only then did I see the negative stereotypes being attributed, not only to me, but to my family, simply because of my mixed race. I didn't bother explaining or even responding to this particular man, but I felt a peculiar discomfort as I wondered what other assumptions had been made by people unwilling to think beyond their limited experience.

As a woman, the most unwelcome assumption I face is from the few men who give their uninvited approval amidst reminiscences of those "Oriental girls who really knew how to please their men." This is so far removed from the best that I have to offer that I've even come to see some humor in it. I know that, when I choose to, I can correct this assumption without wasting much time or many words.

These incidents have been a frustration but not a disadvantage. Maybe some credit should be given to those who have so thoughtlessly brought their misconceptions to my attention. Their conspicuous error has helped make me more aware of the strengths and weaknesses of my individualness. I have learned the importance of not only presenting myself as I would like to be perceived, but of perceiving others in the uniqueness of their situation, giving a good effort to not let my past experiences interfere with the newness of each person I encounter.

In almost every respect, I consider being a Korean-American woman an advantage. I was raised with both the Korean sense of self-discipline and the American freedom of thought and opportunity. This stroke of good fortune has only been strengthened by the physical and mental prowess of both my parents. In fact, I consider myself advantaged with a sense of pride that borders on prejudice.

The negative thing about being a half-and-half child is that people assume I am a 'war baby.' My mother came to America to go to school and met my father in college, not in Korea. Mother came on a full scholarship and now has a Ph.D., but my father has only a bachelor's degree. My mother and father were divorced some fifteen years ago, when I was twelve. Later, my mother remarried to a very nice American lawyer. My stepfather raised me more than my biological father did. I consider my stepfather to be my real father.

When I meet people around ages 50 and 60, all they want to talk about is the Korean War. "Korean women are sexy," and "Kids are cheap laborers." I briefly worked as a bartender in Washington. Some customers would call me 'Kim' even after I told them my name was not "Kim." That used to bother me.

Just about everything else about being racially mixed is positive. Being half-and-half is more interesting than not being interracial. Being partly Korean is good because Koreans have a good reputation for being smart and hard working people. I interact with my mother's side of the family

more than I do with my father's side.
Mother's family is really nice. They are
really sweet.

Feel Part of Korean community?

I consider my nationality as mixed
Korean and American, but if I have to pick
one, I will have to pick American. I don't
want to leave out half Korean, though.

Considered marrying a Korean?

I didn't think about marrying a
Korean because I haven't thought too much
about marrying anyone. I think the Korean
men make better uncles than husbands,
though. I did have a Korean boyfriend in
school, one time. We weren't going steady,
or anything. He was two years older and in
graduate school. He would come to see me
after classes and would carry my books. That
was O.K., but he was too possessive. He
didn't want me to talk to other people,
especially boys. He got on my nerves. He
clung to me too much. I finally told him to
get lost and never to bother me again. He
felt sorry for himself and said, "Why me?
Why this has to happen to me?"

(5) **Kathy,** twenty-seven years old, born in
California, majored in General Studies at The George
Washington University, Washington, D.C. Special
Assistant to the President of one of the lobbying
associations in Washington, D.C. Parents met in

college in America. Both parents have college degree.

I really hate it when I tell somebody that I am part Korean, and they assume I must be a subservient female. This is the reason, occasionally, that I don't tell people that I am part Korean. I resent those people, but I don't resent the Koreaness in me.

For me, personally, I don't like it when I tell a Korean person that I am part Korean but they dismiss it. "You are not Korean. The Koreaness is all gone because you look more like an American."

I hope for opportunities to let people know about my specific background such as how my parents met. If people met during the war in Korea, it's O.K., but my parents met in college, because my mother decided to come to America totally on her own initiative. Her family was socially prominent in Korea, not wealthy, although financially capable.

I grew up in a suburb of Phoenix, Arizona. I had no prejudicial experience there because of being half-and-half Korean-American. But when I lived in North Carolina in a small town briefly, I felt a general lack of acceptance, no matter what I did.

Just like my American relatives, I felt there was a general lack of acceptance from them, too. This might have operated in both directions. I didn't accept them because they didn't accept my mother.

When I was a kid about age five or seven, there was a little bit of kidding from other kids. "Chinese Checkers," they would

call me. I never thought it was bad, but that it was a nickname, or something. Whenever any bad sayings were made about my being Korean, I never took them as negative toward me, but as a bad reflection on them. In fact, it made me special. I never thought I was inferior. I just thought, too bad for them -- like my Southern Baptist paternal grandfather. I never felt like anyone on my father's side was part of my family. They are just some people I know.

I have a lot of pride in being Korean. The Korean culture has a lot of dignity. I like their value system. I have lots of pride in being a Korean. It's a very general thing. I love Korean food. I eat a lot of Korean food, and I share with my American friends. I often go to one of the good Korean restaurants in the Washington area, and there are lots of them.

Part of the Korean community?

I don't mingle with Koreans very much, although I have lots to do with my mother. I don't feel part of the Korean community because I don't really feel I would be welcomed, but I really haven't pursued it. While I respect the culture, I doubt I would have a lot in common with Koreans my age, maybe because I grew up in America.

Considered marrying a Korean?

Absolutely not! I don't want to have anything to do with Korean guys. Even if I did know a lot of Korean men, no. But,

there must be exceptions.

Speak any Korean?

No, but I love it when I hear it. When I hear it some place, it makes me feel at home, like smelling my favorite food. I have a very good relationship with my mother. We can share a lot, as peers. I confide a lot about my relationships, including my relationships with men. I am lucky about that."

Influence of Korean mother?

Definitely, I hold my mother in high esteem. At the same time, I look up to her as my mother. I am also protective of her. I'd rather somebody would hurt me than say unkind things about her. There is a lot of affection between us. My mother is not like most Korean mothers. She is like a Korean, because she is driven for education, but she has a healthy 'American' yearning for independence, and she looks realistically at my relationships and my lifestyle as a young American woman.

To sum up, her primary influence on me, if I may describe it in some key words: loyalty, drive, and balance. As individuals, she and I both have a lot of loyalty. We both are very loyal to our friends. That's a Korean characteristic. It's recently proven to me that I am a perfectionist. Both my parents are that way, but my mother was the one that influenced me most in this direction. She sets an example for me to drive to do

extremely well at whatever I am doing.

Contacts with Korean relatives?

Mother's family, they pop in and out. Occasionally, somebody will appear. One of the uncles keeps reappearing, and occasionally I have contacts with him. He speaks English well. He went to college in America. He is a prominent member of the Korean parliament. I have been to Korea once, when I graduated from college. I met all my uncles and many of my cousins.

My grandfather, mother's father, died when I was eleven. He had come to visit us when I was little, about five years old. He was a famous congressman in Korea. He used to tour around the world as part of his job, my mother said, but I don't remember very much about him. My grandmother died about two years ago. She came and stayed with us when I was very small. She was a very sweet person. I am somebody who almost never regrets, but I regret I didn't know her better when I got older.

(6) **Jacky,** twenty-nine years old, born in Michigan. Father and mother met at the American embassy where both worked. Father has a Ph.D. Mother has some college but not a degree.

There are many good things about being a mixture of Korean and American, but sometimes I don't feel I am accepted 100% by either side. I had one bad experience. I was about 15 years old and I

had this friend named Mark. Mark is caucasian and we had known each other casually for about a couple of years. Mark tried to introduce me to one of his friends he had just met. This person turned out to be a Korean male who went to our same high school, and he was about seventeen.

"Here, I want you to meet my Korean friend!" I heard Mark say to the Korean guy standing next to him. As I looked up, this Korean guy was looking at me. As soon as he saw me, he literally ran away. I don't know why.

On the American side, I experienced more incidents because I have more frequent interactions with the American community. I was out with a group of friends celebrating a birthday party at a restaurant. A group of rowdy people walked in and sat at the next table. One of them came to me and said loudly, 'You know, my brother was killed in the Viet Nam War.' Everybody was watching me to see what I was going to do. I didn't say anything. Continuing to look at me, he slowly walked back to his place. Things turned normal, and we had our birthday celebration as we had planned. At the end of the evening, as we were getting ready to leave, the same guy came to me and said, "pleased to meet you," and I said, "The pleasure was all yours."

I had some other bad experiences when my family moved to Fort Myers, Florida, in 1974. My brother and I were faced with some horrors. We didn't know what things were like there racially because we had lived in other countries for fifteen years. I was fourteen years old and in 9th

grade. One morning, my brother and I were waiting at a school bus stop for the bus. When the yellow school bus arrived, the children already were yelling out, "The Chinese are invading us! The Chinese are invading us!" When finally we got on the bus, nobody would give us a seat. The bus driver wouldn't do anything. My brother and I were the only orientals on the bus. After a good fifteen minutes of trying to find seats, a blonde girl moved over on her seat and made room for us out of pity.

Often, some people don't believe I am half-and-half. Once, I worked at a theater, selling tickets. A person shouted at me, "Don't you speak English?" I knew he said that because I look oriental.

I am a commercial artist, so art is important to me. When teachers see my work, they say it has an oriental flare, so that has been an advantage of a Korean heritage for me. I majored in marketing at George Mason University, but I wasn't enjoying it until I switched to art, instead.

I love Korean food. My mom cooks Korean food all the time.

Part of the Korean community?

When people ask me whether I consider myself Korean or American, I tell them "neither, both."

Considered marrying a Korean?

I have never considered marrying a Korean man because my mother always

pushed me away from that. I only dated one Korean guy, and it was a disaster. His mother had raised him alone. Looking back, I can see now that he had a very lower-class upbringing. He took me to a homecoming dance, but we didn't interact well because of our class differences. A day or so later, we ran into each other at school. He just looked the other way and pretended that I didn't exist. One evening, though, he dropped by my house and wanted to know if I would go to movie with him. I said, "Are you kidding?" and slammed the door on him. My mother didn't say anything. He was just a punk. Korean boys like him sometimes try to act rough and tough. They think they are cool. They are punks.

Influence of Korean mother?

When I was about twenty-one I was invited to give a short talk to a Korean women's organization in the Washington D.C. area. All of the ladies were married to Americans. Talking with them, I learned a lot about myself. Many ladies desired to widen their eyes by surgery. There was a male American psychologist at the meeting also. He thought it was good idea to get their eyes widened. I disagreed with him openly at the meeting. My mother had been pressuring me to have my eyes widened, too. I fought with Mother about this for a long time, but now she leaves me alone. Just before we left Thailand to come to the U.S. to live, Mother was almost paranoid about having my eyes widened. She was really adamant about it.

Probably if I looked more like an American, Mother thought, no one would give me any problems. The operation wasn't to make me look prettier, but just to blend in better. I understood her point, but never gave in.

(7) **Marguerite**, twenty-nine years old, born in Alabama. First year law student. Parents met in America as students.

My mother came to America to go to college. My mother majored in music and my father majored in geology. Both parents now have graduate degrees from American universities.

If there is a negative side of being a half-and-half Korean and American, it is that I feel a lack of identification with either side - - my mother's side or my father's side. I feel as if I am Korean inside because I like Korean culture, but most people see me as an American. Another thing, I don't like when people find out I am half Korean is if they assume I am a war baby, a child of a war bride.

I had an experience when I was younger, in 9th grade. That experience still stays with me. My parents had just moved from Scottsdale, Arizona, to Clayton, North Carolina. My father had gotten tired of suburban life and wanted to move to a farm.

Scottsdale is a beautiful and sophisticated suburb of Phoenix, and is very cosmopolitan. Clayton is, on the other hand, a farming community outside of Raleigh, N.C. There was a lot of contrast between the two communities. People in Clayton were

mostly natives of the area and had lived in the same location for generations. Most people from Clayton wouldn't think lightly of traveling out of the state unless they were enrolled in the military, or something. On the other hand, the people in Scottsdale had come mostly from somewhere other than Arizona. It was difficult to find natives there -- which is also typical of many other cities in the American west.

One day at school in Clayton, my science teacher, Mrs. Allen, called me over to a corner in our science lab and asked me, 'What are you?' I knew what she meant. I had been through quite a bit of this kind of thing. So I said, "I am half Korean, and part Scottish, Irish, and English."

"And you are not ashamed of that?" she said to me, while looking at me with a curious look in her enlarged blue eyes and turned red white skin. "Why should I?" I told her. Still looking at her directly, I continued, "When, someday, everybody is going to look like me, if they are lucky, that is!" and I walked to my seat and sat down. About the same time, I noticed Mrs. Allen slowly walking towards her desk with a still puzzled look on her flushed red face.

This incident still flashes back to me from time to time. Had I not had the entire range of experience between the two widely different cultures like Korean and American, I wouldn't have been able to handle that situation. Someone who has had rather limited cultural experience would have been quite crushed to be approached by an adult like that, not to mention coming from a teacher. I later found out, though, from one

of my classmates, that the science teacher, Mrs. Allen, was concerned because her 27-year-old son had just gotten engaged to be married to a Japanese girl. She was genuinely concerned and curious. I didn't know that at the time.

The advantage of being half-and-half is that you appreciate more than one culture. And I am in the forefront of what the world is going to be. In time, the world will be more like me, all the intercultural marriages and all.

Being born as a Korean-American child, my social awareness is broader by having had to alternate from Korean to American. I see this as an asset to be half-and-half, a Korean-American child. I can deal with a lot more in life than I otherwise could have.

Part of the Korean community?

Not really.

Considered marrying a Korean?

Except for meeting my uncles, I never met or dated an Oriental man. Most Oriental men give me the impression that they are put off by assertive women. So, that explains where I stand on that question.

Influence of Korean relatives?

I have visited Korea, and my grandparents and cousins have visited us in

America. I like being emotionally close to my mother's family. They are really nice and hospitable to me. I remember when I was in second grade, my grandmother visited us and brought us Korean dresses, the kind children wear for holidays, colorful silk, and one of the jackets was trimmed with white fur. I loved wearing these clothes around my friends, and they were so envious. I even was given a small 24-carat gold ring, and I insisted on wearing it to play, but I lost it in the sand box. My mother's family was always bringing us a lot of gifts when they came to visit us.

(8) **Josephine**, twenty-nine years old, born in Japan to a Korean woman who had met and married a U.S. soldier in Korea. Father finished high school. Mother only had elementary school education in Korea. Now married to a Black American soldier, Josephine has two children and has rank of Sergeant in the U. S. Army.

I know that Korean-American children are being really discriminated against in Korea. They don't have Korean citizenship, for example. Growing up as a Korean-American didn't affect me much. We lived on military bases around the world and in the U.S.

I grew up in Tucson, Arizona, during the junior and senior high school years. Some kids called me a "spic" or a "wet back," because I look more like a Mexican than a Korean.

I guess I had a normal childhood,

but when you are intensely exposed to two different cultures, you are more willing to help people who are different. Half-and-half parentage made us see different things. We are very tolerant of people with peculiarities.

Part of the Korean community?

I have never gotten involved in the Korean-American community. When we lived in New Mexico, we were involved in Asian-American Club activities, but the members were all Chinese, so we did Chinese things.

I like Korea. I love going there. When people ask me what I am, I tell them, "I am a Korean." I consider myself a Korean. I know that there has been a lot of prejudice in Korea against Korean women who were married to American soldiers, but not by all Koreans. One time, my husband and I went to eat at a restaurant in Osan, Korea. An elderly man who was the father of the owner waited on us. He brought out just the regular menu at first, but when my husband said, "My wife is a Korean," the old man looked at me, searching my face, and said, "Why not speak Korean?" The little old man looked at me with his dark twinkling brown eyes.

"Well, sorry," I answered apologetically, "but my father was American, and we forgot all the Korean my mom taught us." The old man was so nice. He ran to the back of the restaurant and brought us all this Korean food, many dishes. We loved it, especially my husband loved the food.

The next day, remembering the pleasant experience with the old man in the restaurant, my husband and I took some friends to a different Korean restaurant. This place was even smaller than the one before. The owner, a thin lady about sixty years old, came out to take our order. As she started to write down our order in her small yellow pad, my husband said, "My wife is a Korean." The lady gave me a quick glance and continued to scribble on her pad. My husband started again, "She is a half Korean. Her mother is Korean." At that point, the lady became indignant. She ran fast away from us and never served us. She sent a young girl out to take our order. This made me think a lot.

I had another incident in Osan. We saw this beautiful girl, obviously an Amerasian. She was about twenty years of age, selling some scarves and other small things on the side of the road. I went up to her and said, "You are beautiful! Are you part American?" She ran out the back of store and disappeared. She disappointed me, and I still wonder why she ran away.

Considered marrying a Korean?

No, never thought about that, because for a long time I was not interested in getting married. My parents did not have a good marriage. Later on, I married a Black man, and we have been married for the last six years.

Influence of Korean relatives?

> I never met any of mother's side of the family. She had one elder brother, but he never got in touch. My mother used to send money to my grandmother, not a large sum, but she tried to help grandmother out for a long time. When mother didn't hear from grandmother for a long while, she found out that Grandmother had passed away some time before. Mother's brother didn't even let Mom know and had been keeping the money that came for Grandmother. Mother and her brother have not kept up with each other.

Influence of Korean mother?

> Bringing home good grades was important when we were in school. Most of my friends had more freedom than I did, and they didn't have to do as much work around the house. My mother was strict. There were four children -- two boys and two girls. We ate Korean food all the time. My mother would cook one kind of meal for my dad and she would cook Korean food for us kids. For bed time, mother would read to us about Korean turtle ships, whereas other kids got sweet children stories.

(9) **Donna,** thirty-one years old, born in Seoul. Has B.A. in Asian Studies from a small private college in New York state. Self-employed. Parents met in Korea. Mother has college degree from Korea. Father has attended college in the United

States, but does not hold a degree.

> I think we all have negatives. We lived in Nigeria and Thailand and came to the U.S. when I was sixteen. I remember two occasions I would consider racial discrimination. In both cases, I didn't take it against myself, personally. There is sex discrimination in Korea against women.
>
> My mother had been married to a Korean man that my grandfather found a job for before they were married. Mother's Korean husband, according to my mother, used to beat her up a lot. One day, when she was pregnant, he beat her up and she lost her baby. My mother went to her mom and told her that she wanted to get a divorce from her first husband, a Korean. And when she wanted to marry my father, who was an American, her mother said, "You know what it means? You will have to go to America and learn all the American ways of life." After the talk, my grandparents gave Mom consent to marry my father.
>
> There are many beneficial reasons to be half-and-half. I am very proud of the fact that I am a mixture of Korean and American. Not as much Korean as Korean-American.

Feel part of the Korean community?

> No, I don't feel part of the Korean community, but I like Korean food very much, and I like our Korean family friends. My mother is very Korean, whereas her children are more American.

Considered marrying a Korean?

Yes, I have considered it, but I would never marry a Korean man because of what I have seen in Korea. I lived close to a Korean family in Seoul when I taught English at Yonsei University. I didn't like what I saw about how Korean men treat women. My uncle beat my mother up one evening when he was drunk. My mother is the oldest child in the family, but her younger brother would do things like that. Korean men are inherently and extremely sexist. In every case, it's the mother's fault (for permitting it.) However, I would marry a half-and-half Korean-American man.

Influence of Korean mother?

My mother is a traditional Korean in many ways, but she has adjusted to occidental ideas. Thinking about her relations with my brother, I wish she could like his girlfriends more. She never likes any of his friends, even Korean ones. She is really possessive.

My mother is very manipulative. If she didn't like what I was doing, she would take it personally, but I would be doing just what was normal for an American child. One time, Mom took what I was doing as personal defiance of her, and she became hysterical. She walked out of the bedroom window onto a ledge. I felt bad.

Mother is very business-orientated. Mother, at sixty-six started a second career,

an insurance business targeted to the Korean market in New York. Mother was my dominant parent. Father brought in the paycheck, and mother did whatever she wanted to do. Mother's family in Korea is in politics and they are a very prominent family in Korea.

Influence of Korean relatives?

I have never met such uniformly entrepreneurial people. They are intelligent and very motivated people. Mother's father was a very famous and respected politician in Korea. There are two children in my family, and I am the younger one. My brother is a lawyer. He graduated from law school in Washington, D.C.

(10) **Stephanie**, thirty-two years old, born in Korea. Junior in Brigham Young University, Provo, Utah. Father had high school, mother only had 6th grade education. Married to a formerly Jewish Mormon. Husband works at a computer software company in Los Angeles as a sales representative. Has two-year-old daughter.

I lived in Korea when I was young. I know that, in Korea, half-Koreans get rough treatment. Mother always told me not to act like them. My mother was strict. I had many good friends. Came back to America when very still young at age of eleven. I look very American, so I never had racial discrimination.

Because of my Oriental background, I see things differently and feel open to other

people. My mother always said, "Be
considerate of others."

Feel part of Korean community?

I consider myself as a Korean.
Outside, I look white but inside Korean. I
am what people call 'banana.' My house is
decorated more in Korean style than
American. I live near Koreatown and shop
regularly at several Korean stores. I uphold
Korean customs. I take little gifts to people
when I visit them, like the Koreans do. I
love Korean food. I think Korean culture is
wonderful -- long history. It's old and
ancient.

Considered marrying a Korean?

I have never been attracted to
Korean men. I wouldn't mind having a good
friend, but marry, no.

(11) **Roseanne,** thirty-four years old, born in
France, has B.A. from Louisiana University in
Monroe, Louisiana. Married with two children, ages
3 and 7. First assistant to owner of business in
Washington D.C. area, agency for providing
temporary operating room nurses. Father has high
school education and Mother went through the sixth
grade in Korea.

I was born in Paris. My father was
stationed there. I am the second child in the
family. I grew up in the Northern part of

Virginia. We were teased and chased a lot as "Chinese," and sometimes people called us, "Niggers." We grew up in the 1960s when race was an issue. Black women said things to us like "Mongoloids!," or "What is she? Black or What?" Race, that was our only problem. Black women are jealous.

Growing up in a bilingual family, I found that we all have problems with our spelling. Mother's broken English did seem to have affected us. Certain words we have a problem pronouncing and spelling, like the ending of "ing" and the sound of "l" in library. My mother couldn't ever pronounce "l" and "ing" right. My sister and I both have the same problem.

I didn't live in Korea, but I feel very much Korean. Being a mixed child is the best of both worlds. It helps me with the ability to interact with most nationalities. America is the melting pot of the world. The world is small, especially in business. We have to interact with people from many places. When I tell the Koreans I run into that I am Korean, I get favorable treatment. I am also able to understand their broken English.

Feel part of the Korean community?

No, but I feel kinship when seeing Koreans coming in to my office. We have good working relationship. My mother taught me if you can be respectful you don't have to have manners.

Considered marrying a Korean man?

> **Mother didn't stress it, but I knew that she wanted us to cater to Korean males. This included some male relatives that mother had brought over to America who were always all over at our home. Most of time, mother spent time getting them acclimated to the American life -- getting them drivers license, jobs and finding places to live and so on.**

(12) **Norma**, thirty-six years old, born on a military base in Virginia. Supervisor, Government Ticketing Department, at a major airline. Parents met in Korea while the father was in the military. The parents do not have college educations, although both attended college.

> **Growing up in northern Virginia towns, I have been called, "Nigger," "Chinese," and other names. This didn't happen on a daily basis, but it affected me. All the experience I had to endure as a child helped to strengthen my character later. I almost had to build a wall around me.**
> **As a child, you don't realize that you are different until other people look at you as different. I remember one time when I was eleven years old, I was playing in our neighborhood playground with my sister who was nine. There was this big guy, a neighborhood bully, calling me, "Hey, nigger girl, nigger girl!" He was just provoking me. I had told him that I was not a nigger, but he kept it up. A little later, his father**

came to pick him up and I went to his father and said, "Mr. Perkins, he calls me a nigger." At that, Mr. Perkins said, "Well, ain't you a Nigger? He is calling you what you are! Ain't he?" and drove off. This, I cannot forget. After incidents like that, you learn to be tolerant of other cultures and people who are different from the majority.

Korean people are prejudiced against other people, though. They don't feel that they belong with them when there is a large cultural and language gap.

My father's family didn't welcome my mom and we didn't blend in with our cousins. All our cousins in Blacksburg, Virginia, were light-skinned and blonde. We are very close with each other. My mother told us that we had to be good to each other because we only had each other. I live five minutes from my parents now. I did this deliberately for my daughter. I wanted my daughter to grow up with her grandma near by. I didn't have that when I was growing up.

Being Korean-American has a lot of benefits. Among the benefits are that you have a really good feeling for people of all different nationalities. You know how to relate to people with broken English. You make a well-rounded person. You are not prejudiced against people, not even against Blacks.

I feel good about being Korean-American. My very best friend was a blonde-haired and blue-eyed American. Mom always told me that I would be glad someday that I looked different, that I would stand out in a crowd. In looks, I think the Korean-

Americans have the best of both worlds. They are beautiful people.

Feel part of the Korean community?

I like to consider myself as a part of the Korean community. We want to show that how far the Korean culture is being reached by us. We are carrying our part of their culture.

I think of myself as a Korean, because I value that part of myself. Korean is predominant in me. When people ask me what I am, I always say, "I am half Korean," and often I don't even get to answer the other part.

About eight years ago, in 1981, I went to Korea. It was so exciting to see all my aunts and uncles. When I was checking out at the airport, I saw lots and lots people. I have never seen so many almond-shaped eyes before, but I could pick out my aunts and uncles from all those people looking at me. I felt comfortable with my Korean relatives. At home, we always took our shoes off before going into our house. When I got to my uncle's, they did that, too.

Ever considered marrying a Korean man?

I never had an opportunity to date Korean men. I have dated a Japanese man, though. Korean men tend to be male chauvinists. I remember that once a Korean policeman stayed at my parent's home in Maryland. This man was in the U.S. attending some kind of criminology seminar.

He once said, "Life in America is boring, because there is no bar to hang out late in. In Korea, I will drink all night with friends."

Influence of Korean mother?

My mother was a new type of mother. Not a typical Korean mother, not a typical American mother either. She has so much common sense. Mom is very business-oriented. I have the utmost respect for my mom. Marrying a GI with no money, coming to a new country, she knew she would be rejected. She worked very hard all the time. She sold Avon cosmetic products, worked as a florist, and also as a hair dresser. She did all this so we could go to college. She was determined, and made it. My sister and I both have graduated from college. Mom is a great role model. You tend to follow your mother's footsteps.

INDEX

About the Author

A NATIVE OF CHINSAN, Korea, Diana Yu comes from a family with a long tradition of public service. Her father Yu Chin-San, was a long-time member of the National Assembly. A statesman, he was also Chairman of the major opposition party, the Shin Min Dang. Her brother, Yu Han-Yul was recently elected to the National Assembly for his fourth term from the Kumsan District.

Before going abroad to America at age 20 to study, Diana had been educated at Ewha Girls' High School and Ewha Women's University. In America she earned a B.A. and an M.A. from Arizona State University and a doctorate from the George Washington University.

Diana Yu continued the family tradition of public service by being active in the Asian-American community in the Washington D.C. area. Founding president of the Asian-American Political Action Committee, Diana has also served as president of the Korean-American Citizens Council of Maryland. Since 1988 she has been the *komoon* (advisor to the president) of the Korean Association (*Hanin Hoe*) of Maryland.

In addition to writing and organizational work, Diana is an accomplished lecturer on the subject of Korean and Asian Women. Various groups, including graduate students from the George Washington University and the National Organization for Women, have been the audience.

Diana Yu has three daughters, Alisa, Judith and Karen, and lives in Potomac, Maryland with her attorney husband, Tom Tull.

THE WOMEN'S INSTITUTE PRESS is a subsidiary of THE WOMEN'S INSTITUTE, a non-profit, non-partisan organization, founded in 1975, the United Nations INTERNATIONAL WOMEN'S YEAR, the beginning of the United Nations DECADE FOR WOMEN. Its purpose is to address the International Women's Year objectives of EQUALITY, DEVELOPMENT and PEACE.

Other publications of THE WOMEN'S INSTITUTE PRESS have been an historically significant volume containing the *Plan of Action* (1975), *Programme of Action* (1980), and the *Nairobi Forward Looking Strategies* (1985) and the *Convention on the Elimination of All Forms of Discrimination Against Women.*

Yim, Young-Shin (cont'd)
in 1950 election, 177
influence of Christianity on,
169-70
life of, 161, 168-73
lifelong insistence on
equality with men, 169
organized Women's
National Party in 1945,
173
Yin-yang doctrine, 30
as explanation of women's
place in society, 42-43
Yoon, John, 327
Yu, Chin-San, 21, 79-83
Yu, Kwan-Soon, 3, 162-63
Yu, Kyung-Duk, 78, 352,
134-35